CAPTIVE

Jo-Anne McArthur

with contributions from
Virginia McKenna and Lori Gruen

with joy and gratitude
JoMcArts

LANTERN BOOKS • NEW YORK
A DIVISION OF BOOKLIGHT INC

"McArthur sums it all up. We can no longer keep animals like this. Haunting and sad, yet beautifully composed. A must-have book for all who care about animals." —**BRITTA JASCHINSKI**, photographer

"In her stunning images, Jo-Anne McArthur conveys more than words ever can the injustice of confinement, and the arcane idea that we are lords and they are things."—**JONATHAN BALCOMBE**, author, *What a Fish Knows*

"*Captive* may have a positive influence on the reader and serve to steer them away from captive animal shows—including dolphins and other whales—and that's what I like most about the book." —**RIC O'BARRY**, *The Cove*, the Dolphin Project

"*Captive* is a searing reflection of the despair felt by captive wild animals. I hope everyone views the photographs in this great work and dares to recognize themselves in these individuals. We owe it to them." —**LORI MARINO**, neuroscientist

"As a field ethologist, I've been privileged to see animals of all kinds expressing their complex, playful, serious, and fully social selves with their families, friends, and foes in natural settings. McArthur's beautiful, striking, and utterly shocking photographs show zooed animals in settings where they're alone, clearly unhappy and depressed, and unable to express their natural behaviors. I deeply hope that what McArthur reveals here will help to close down these prisons and end our objectification of these magnificent sentient beings." —**MARC BEKOFF**, co-author, *The Animals' Agenda: Freedom, Compassion, and Coexistence in the Human Age*

For you, the compassionate and
courageous, who choose to see

2017
Lantern Books
128 Second Place
Brooklyn, NY 11231
www.lanternbooks.com

Printed in China

Library of Congress Cataloging-in-Publication
information is available upon request.

Cover: Brown Bear, Denmark, 2016
Back cover: Orangutans, Thailand, 2008
Following page: Chimpanzee, Denmark, 2016

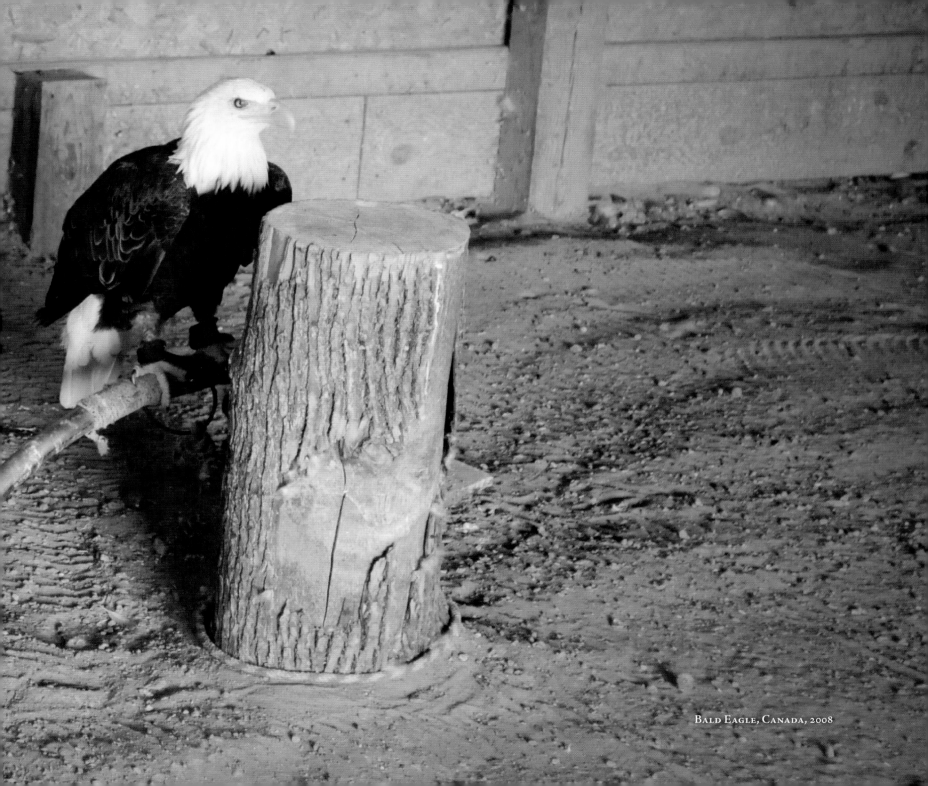

Bald Eagle, Canada, 2008

CONTENTS

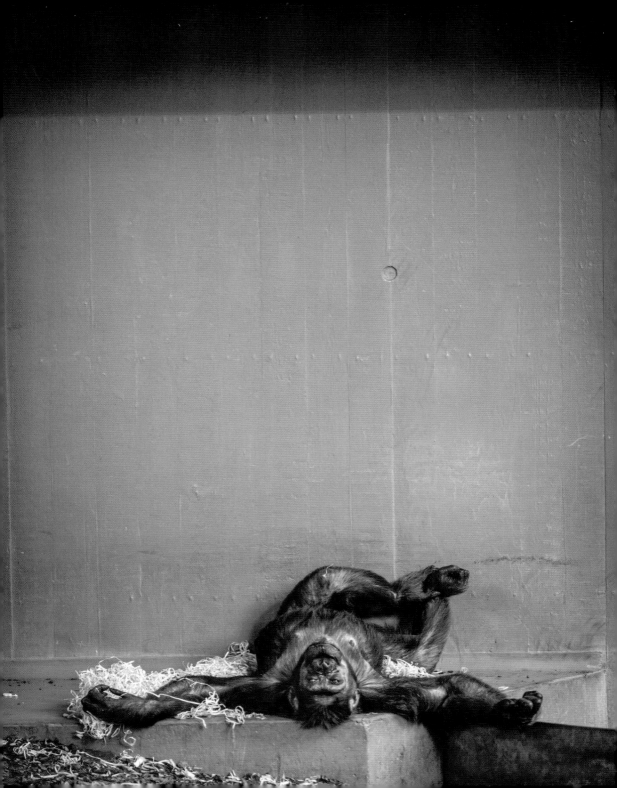

No Greater Legacy

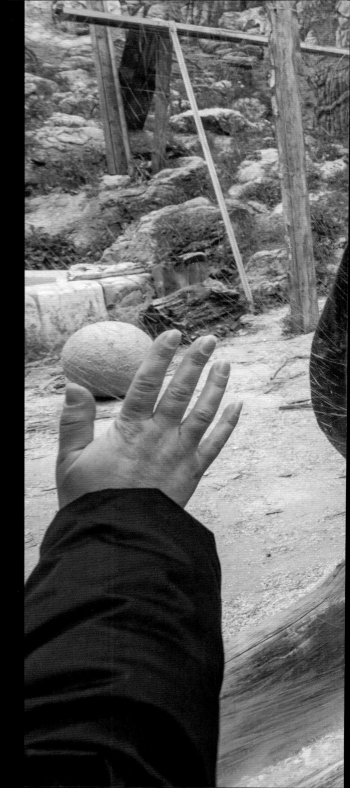

Waste; neglect; futility; loneliness; despair; haunting beauty. These qualities infuse each of Jo-Anne McArthur's images in this book. The motifs are omnipresent, relentless, inescapable. Jo-Anne's work is mesmerising yet unquestionably hard to look at. In the face of the cruel, heartless, needless acts that we inflict on our fragile planet and the living creatures we share it with, the temptation is to give in to despair, to feel overwhelmed by the sheer weight of systematic exploitation. But the power of Jo-Anne's work lies in the inescapable call to action that forms the background to each photo. Her strength and her belief in solutions resonate throughout the pages of *Captive*. Even the most destitute scenes do not simply paint a picture of hopelessness, but rather cry out, "How can we do better?" That must be the message we take away from this important work.

I am passionate about the plight of wild animals in captivity. Since making the film *Born Free*, with my late husband Bill, I have remained fundamentally opposed to the animals' life-long incarceration, a sentence from which there is almost never a reprieve.

The Born Free Foundation, the charity we founded with our eldest son Will in 1984, has made captivity issues—zoos, circuses, the keeping of exotic animals as "pets"—one of our main priorities for over thirty years. The Born Free team exposes suffering, and rescues and re-homes to sanctuaries, whenever possible. And sometimes, just sometimes, we are able to offer animals the chance of a wild and free life.

The animals featured in Jo-Anne's photographs will almost certainly not get that chance. Their fate is one that will linger in my mind, and doubtless the minds of all those who turn the pages of this book. My hope is that, confronted with this gallery of haunting images, those who make the rules, those who license zoos, those who are tempted to go to the zoo, will take note. I hope they will conjure the image of the monkey reaching through bars to grasp at wild shrubs, or the brown bear's eyes staring past the fence that she will never cross, and that they will think again. I can ask for no greater legacy for these animals, or indeed, for Jo-Anne herself.

Virginia McKenna, OBE
Co-Founder, Born Free Foundation
November 2016

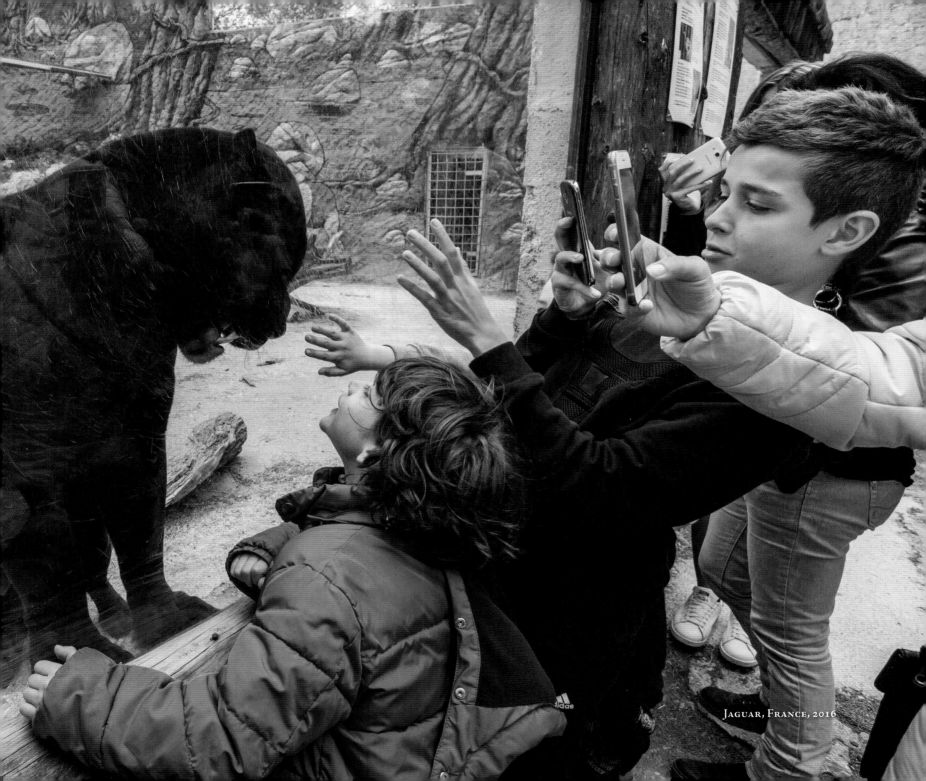

JAGUAR, FRANCE, 2016

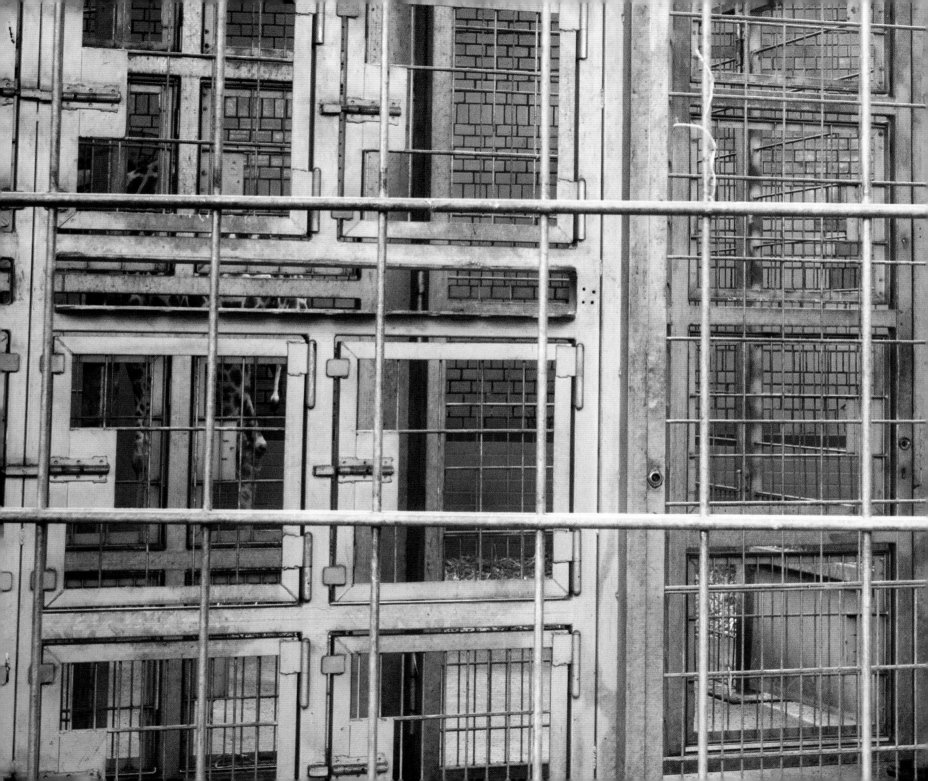

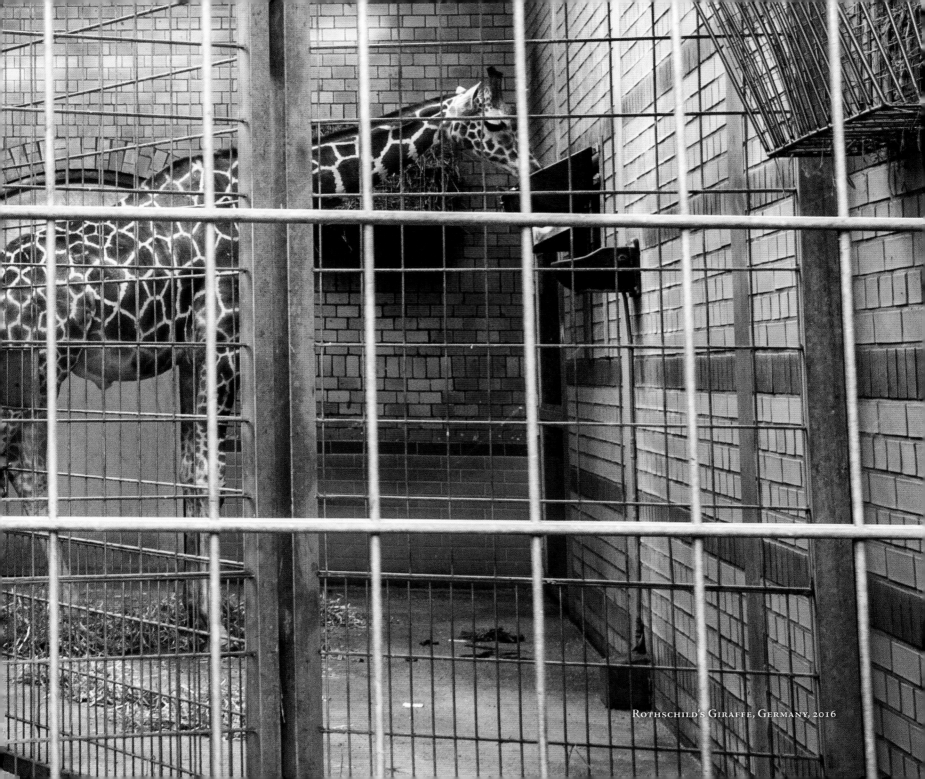

Rothschild's Giraffe, Germany, 2016

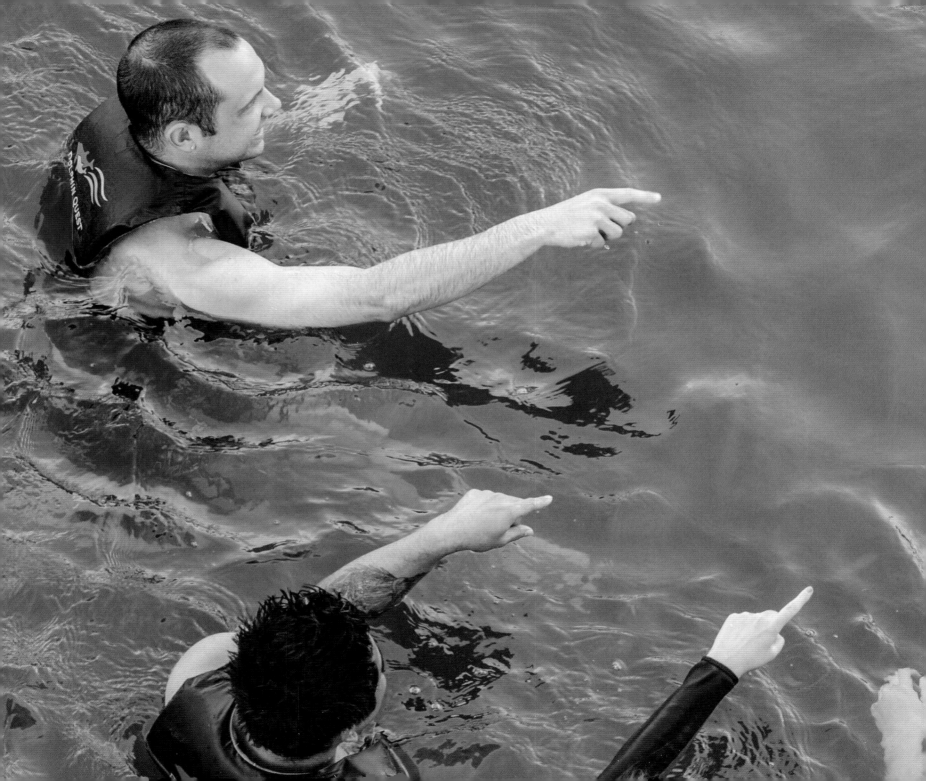

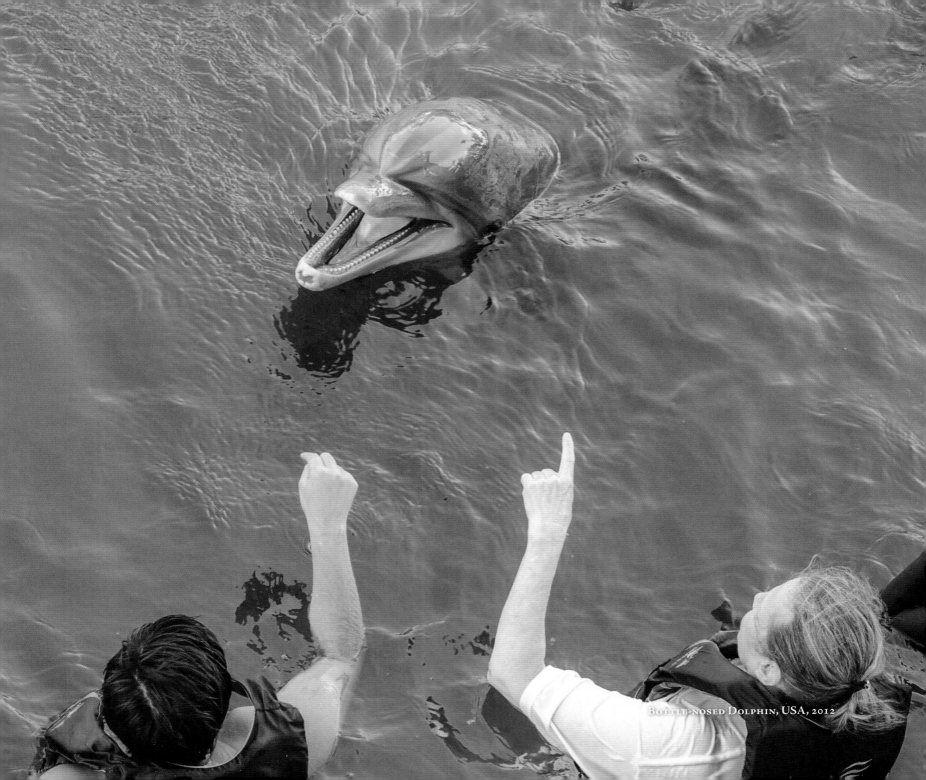

Bottle-nosed Dolphin, USA, 2012

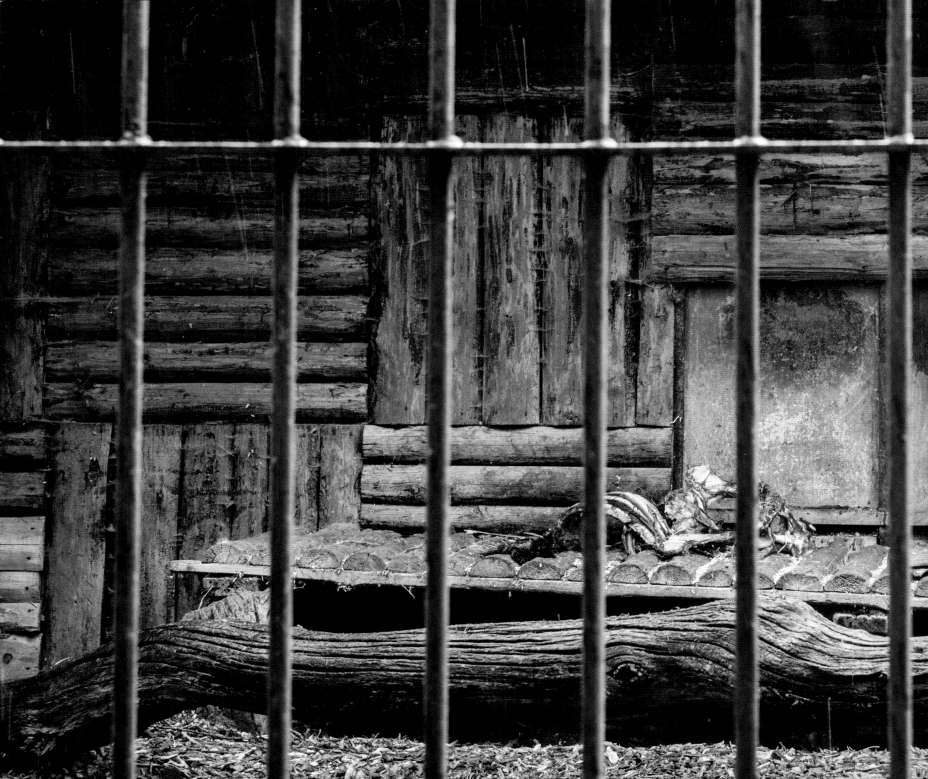

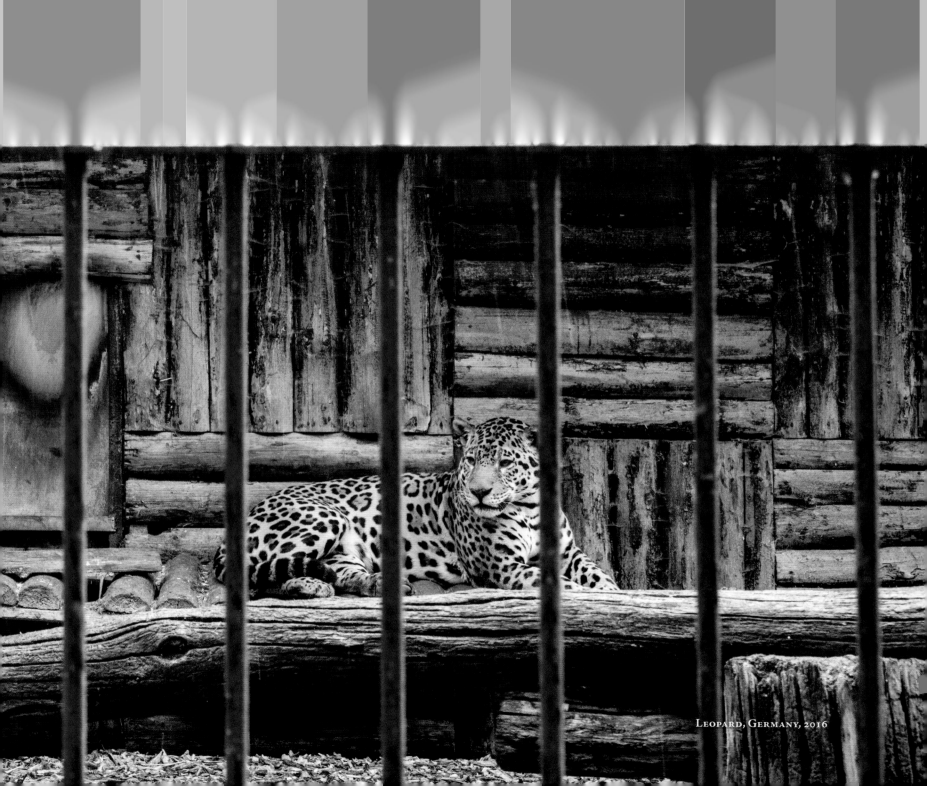

Leopard, Germany, 2016

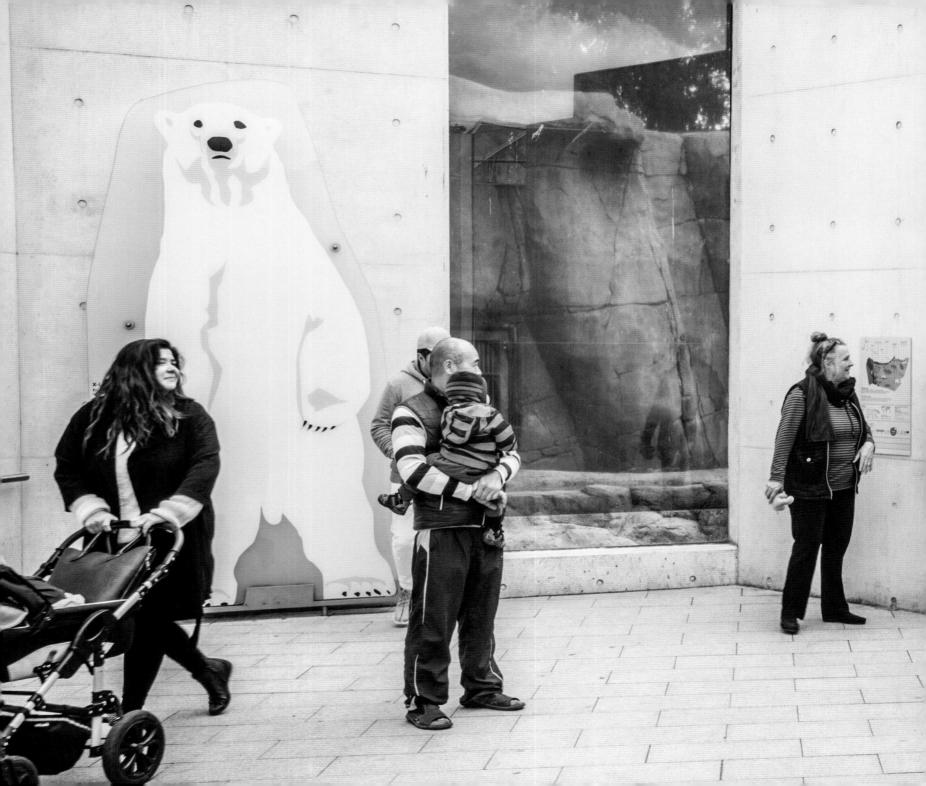

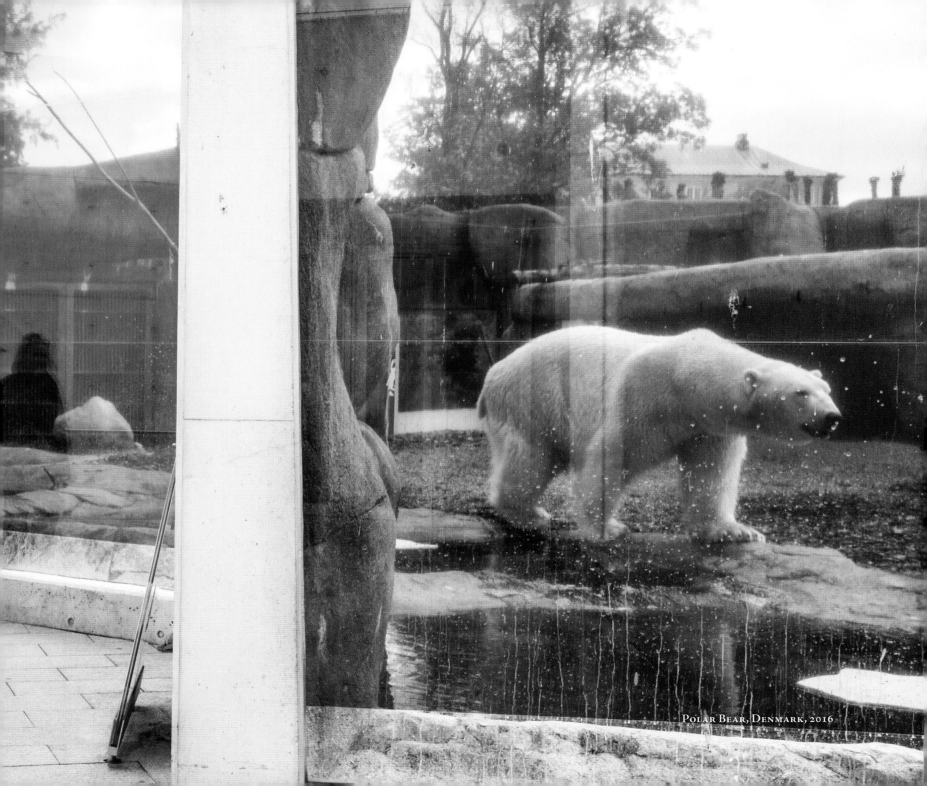

Polar Bear, Denmark, 2016

Ethical Imagining

Imagine you can fly through water. Really try to imagine the joy you experience sharing that thrill with friends. Imagine yourself laughing and playing as you move with great speed, rolling and weaving, both above and below the surface.

Now, imagine that you can fly through the air, over land and sea. Revel in the familiarity of this journey, since it's something you, your partner, and others in your community do every year. You lead the whole flock great distances as the seasons change and you feel that this is your primary purpose in life: getting yourself and your friends to safety.

Next, imagine yourself not at all interested in traversing great territories with others. Instead, you really like to be alone, mostly in a dark, quiet place within the earth, the dampness and musk calming every nerve.

If you were able to feel even just a little of what these non-human experiences are like, you get a glimmer of what is lost in captivity.

Of course, these imaginative acts will inevitably be tinged with a bit of anthropomorphism as we try to "become" an other through our inescapable human lens. But I think it is valuable to conceptualize what it might be like to be another animal, with a very different way of making meaning in the world, in order to empathize with their plight in captivity and to understand the magnitude of what they lose when they are stripped of their freedom to be who they are and do what they do. In captivity, sea mammals, fish, birds, and elephants, for example, are denied the possibility of moving across vast spaces. Big cats and other predators are often denied the opportunity to hunt. Rodents, who like to burrow into small spaces, aren't usually provided that option in zoos across the globe.

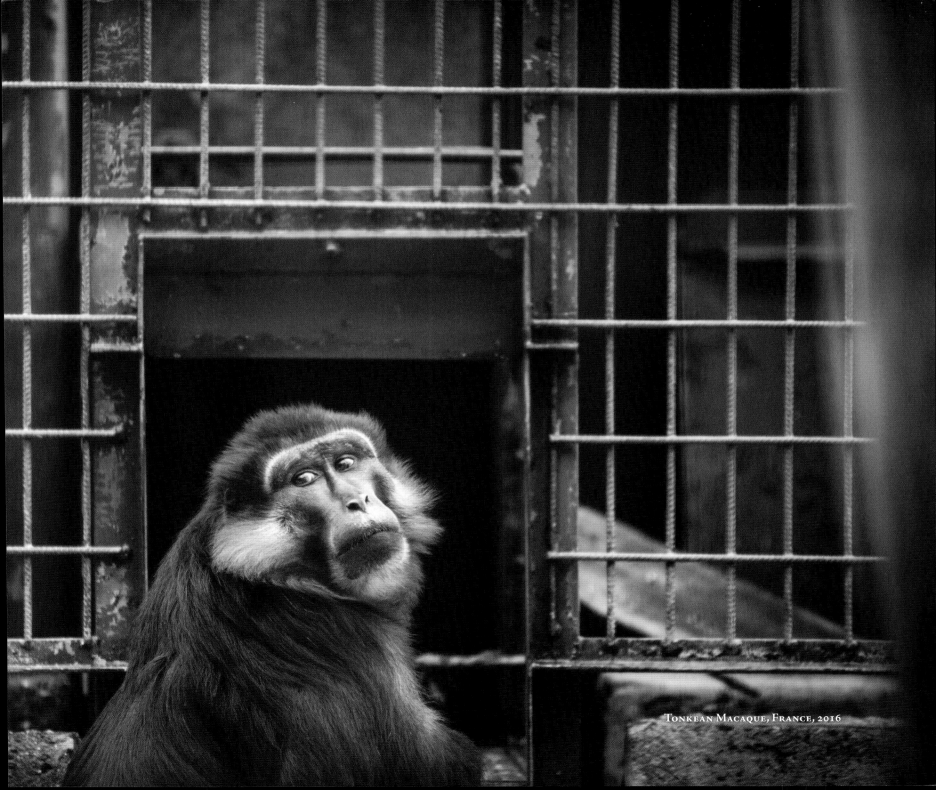

TONKEAN MACAQUE, FRANCE, 2016

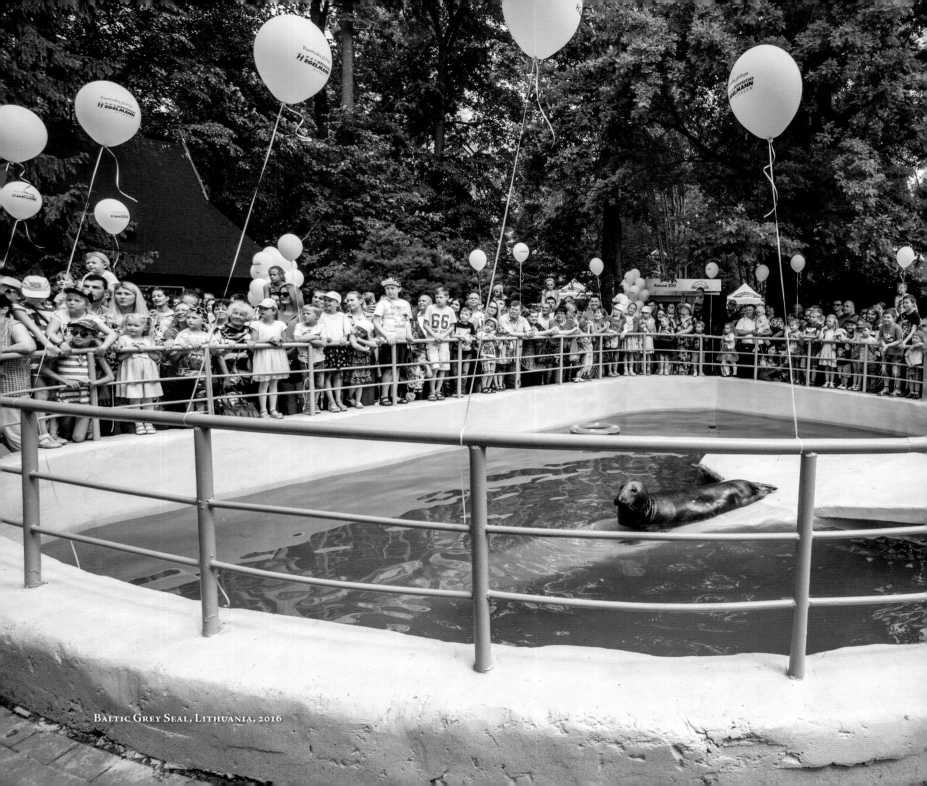

Baltic Grey Seal, Lithuania, 2016

The reach of human activity has expanded across the entire globe and humans are entangled with one another and other animals in myriad ways. The nature and depth of these relationships vary, but our relationships with captives cannot be described as "good." Those of us who are able to reflect on these relationships have an opportunity to rethink them and work to improve them. Given the number of animals held captive in zoos and aquaria, there is an ethical need to conjure and enact change to improve their well-being and allow them opportunities to be who they are and pursue what they care about. We owe these animals our attention as well as some remedy. As ethical beings, when we look at the photographs Jo-Anne has shared, through her bravery as a witness, we can visualize what these animals have lost. Through reflective acts of ethical attention, we can also begin to think about how to repair the harms humans have caused by keeping others captive. ❧

Lori Gruen
Professor of Philosophy, Wesleyan University
November 2016

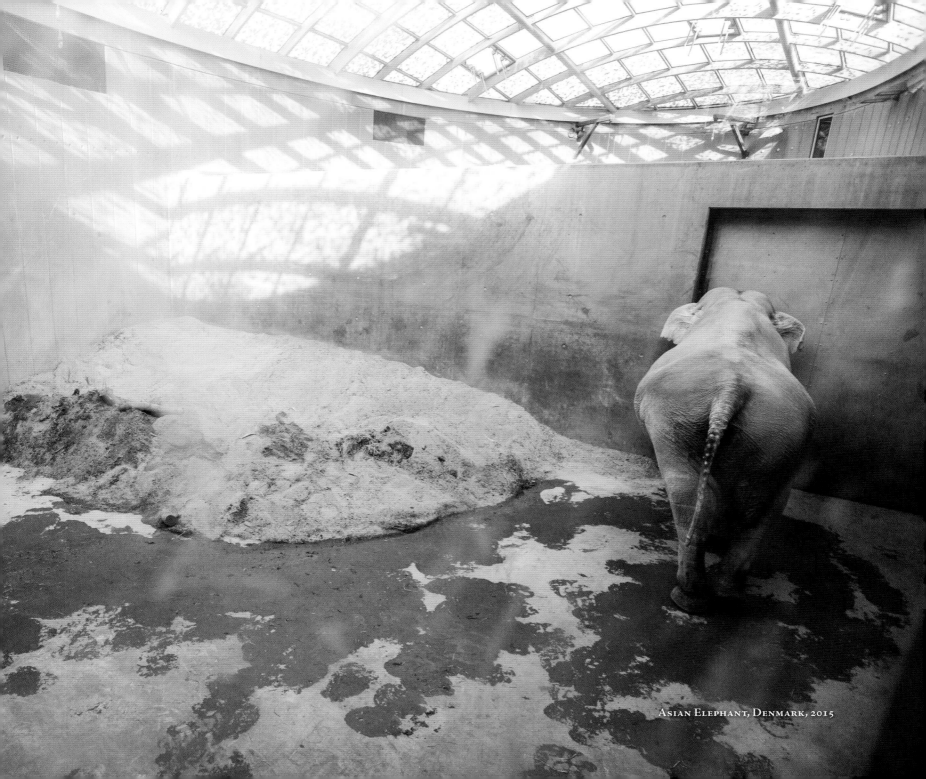

Asian Elephant, Denmark, 2015

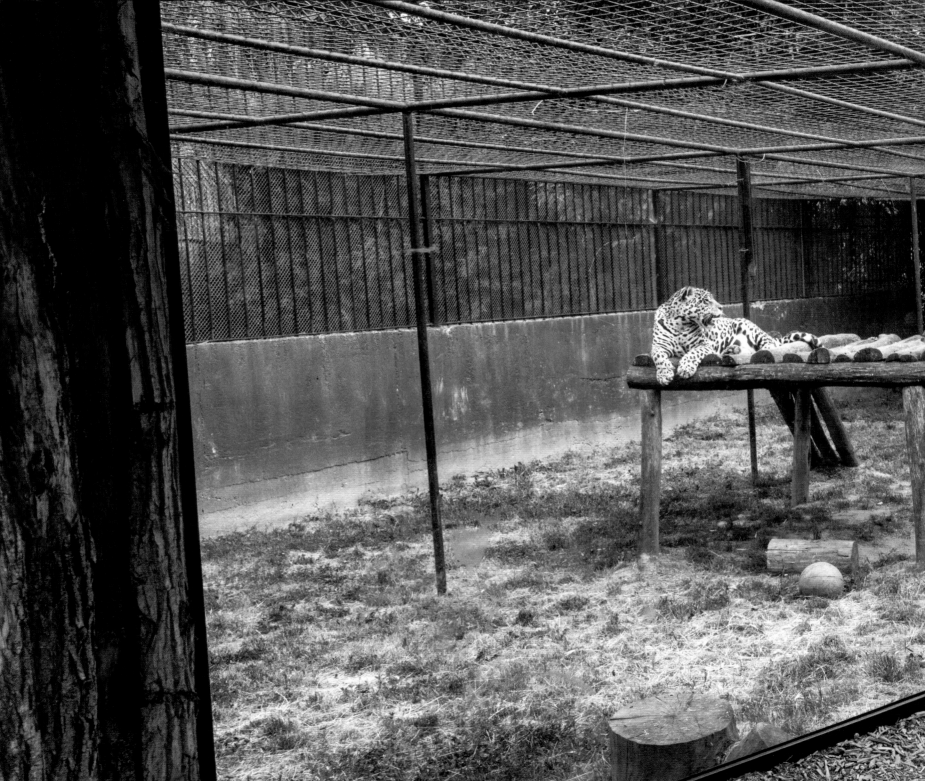

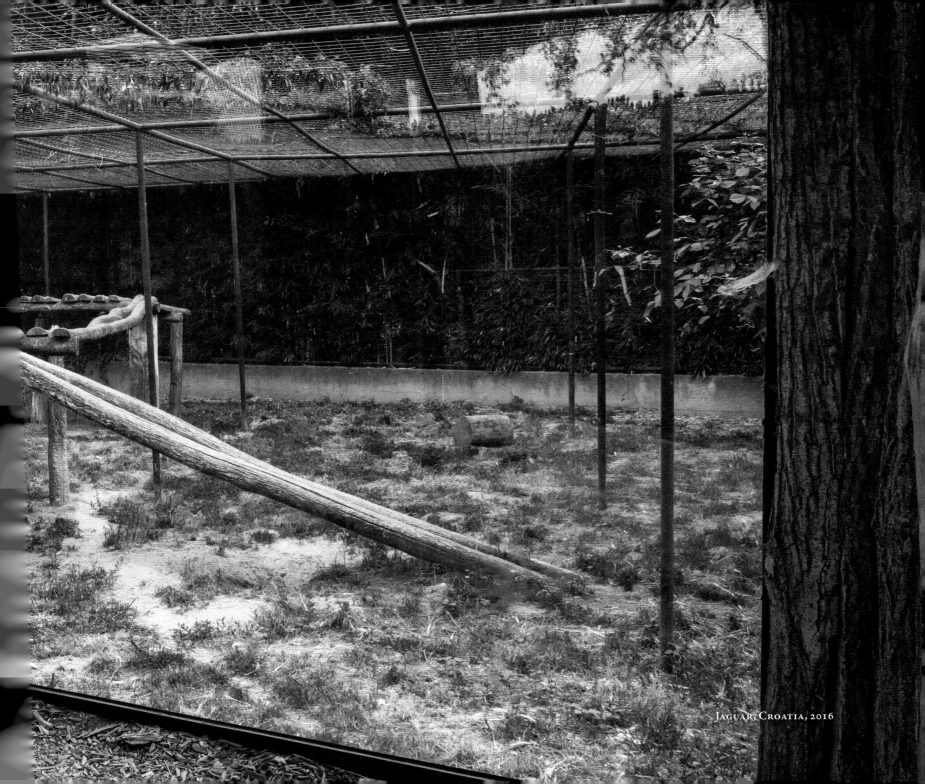

Jaguar, Croatia, 2016

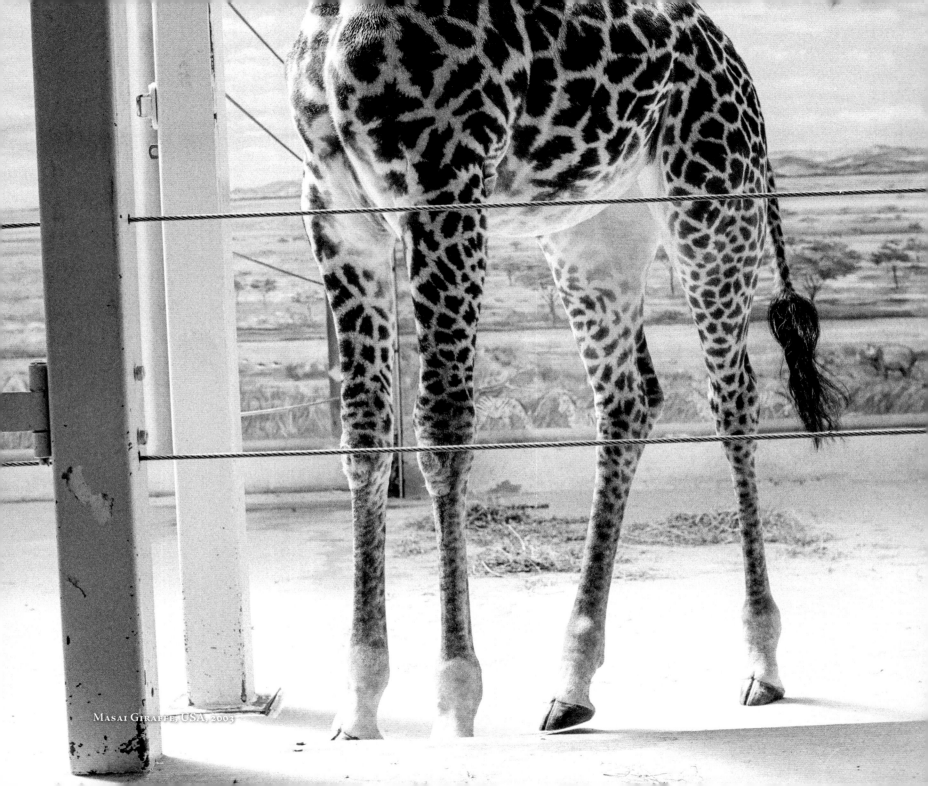

Masai Giraffe, USA, 2003

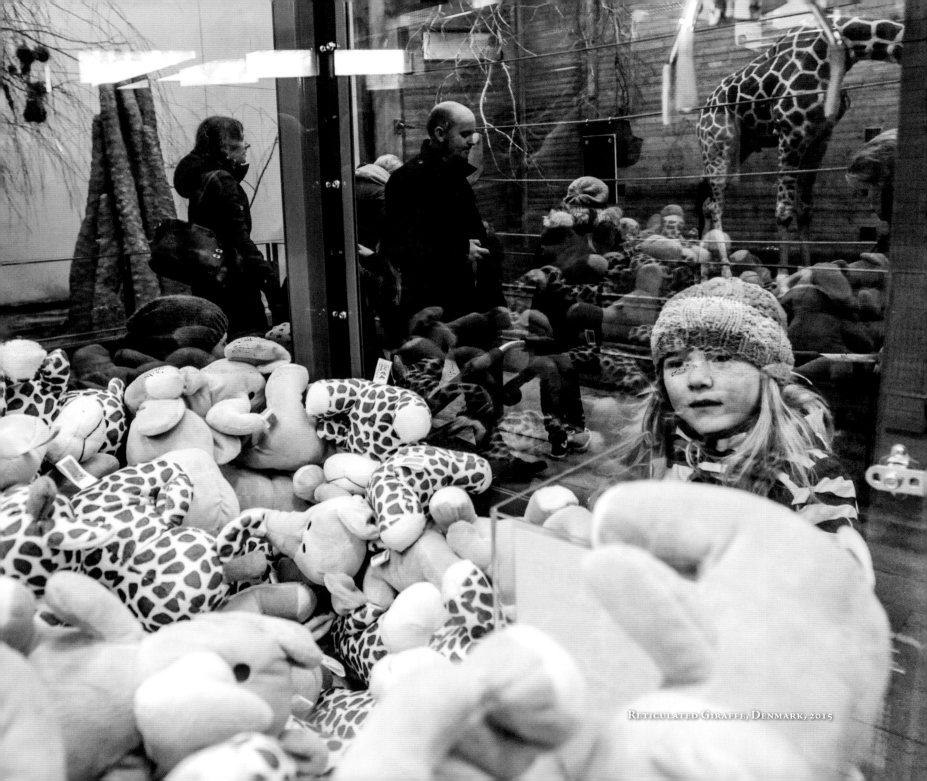

RETICULATED GIRAFFE, DENMARK, 2015

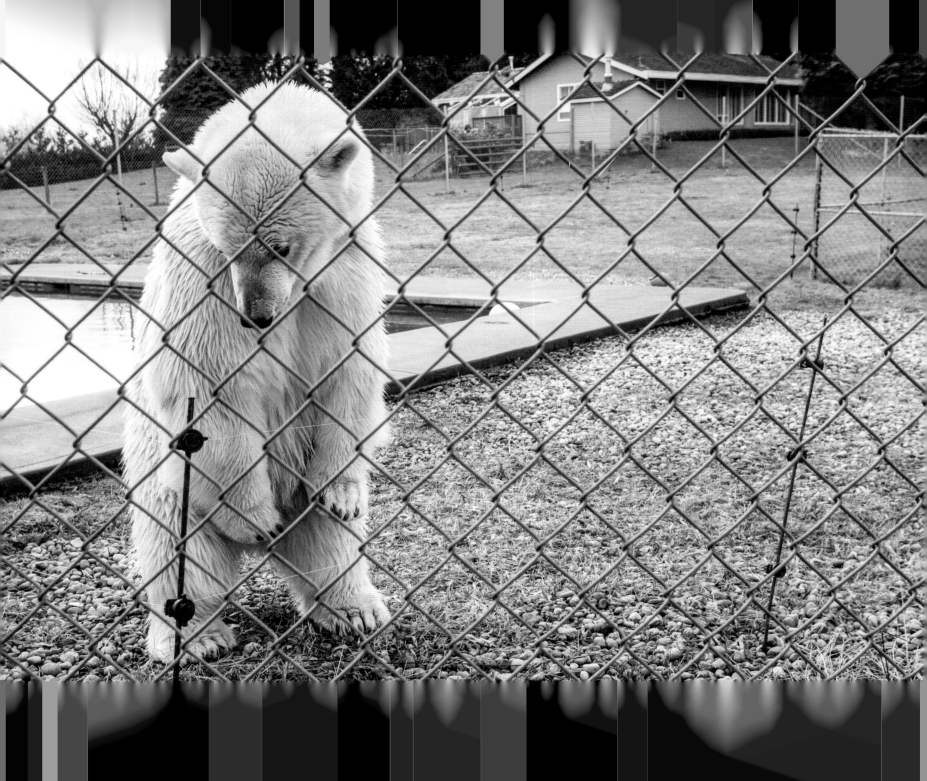

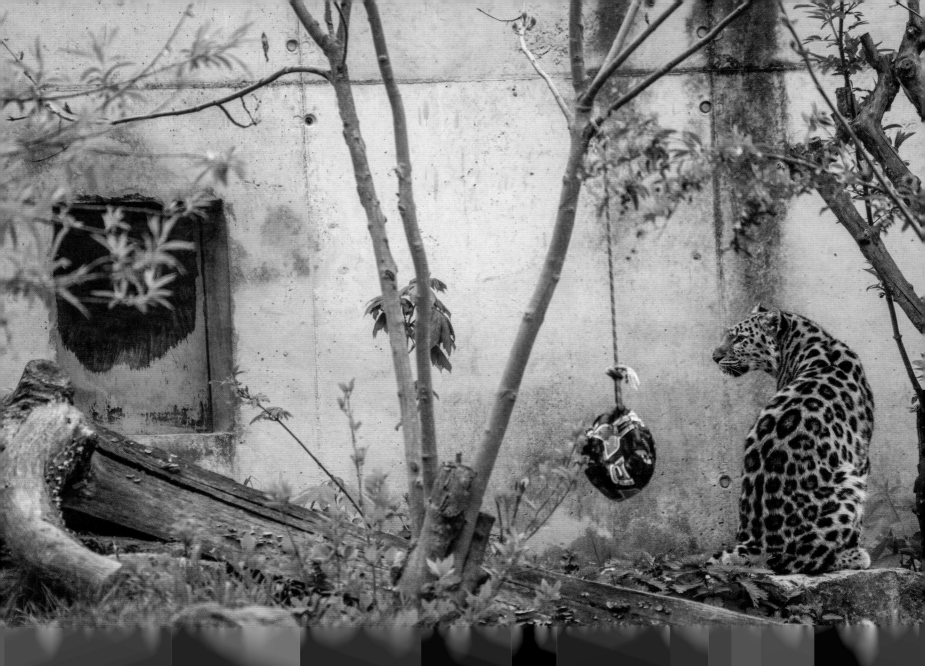

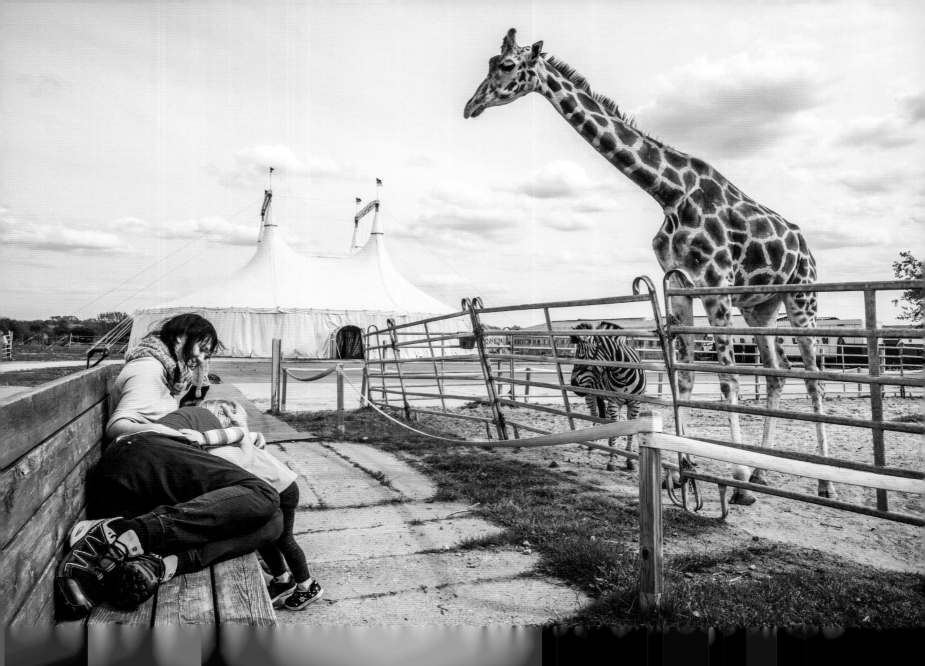

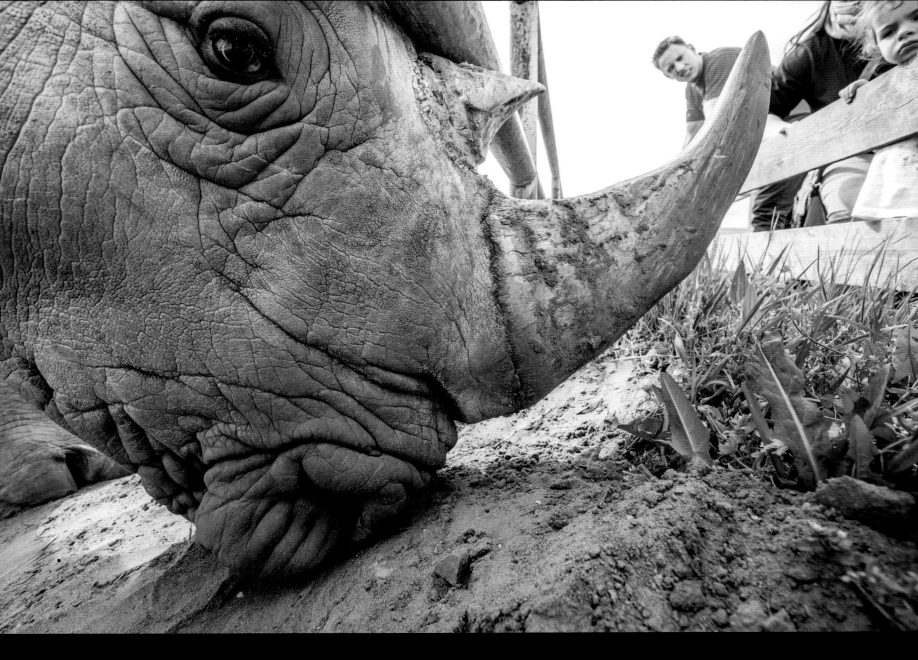

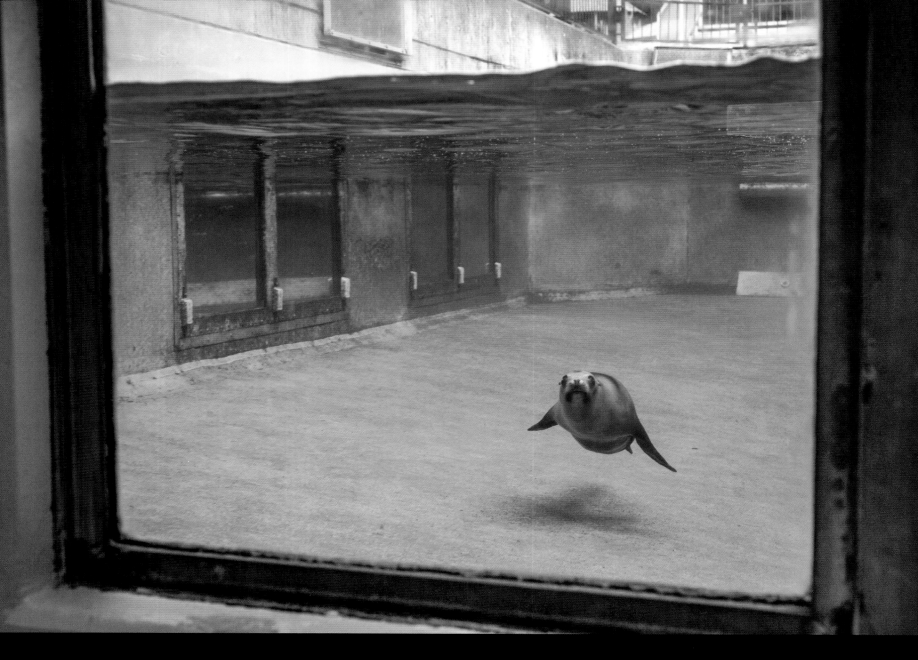

California Sea Lion, Denmark, 2016

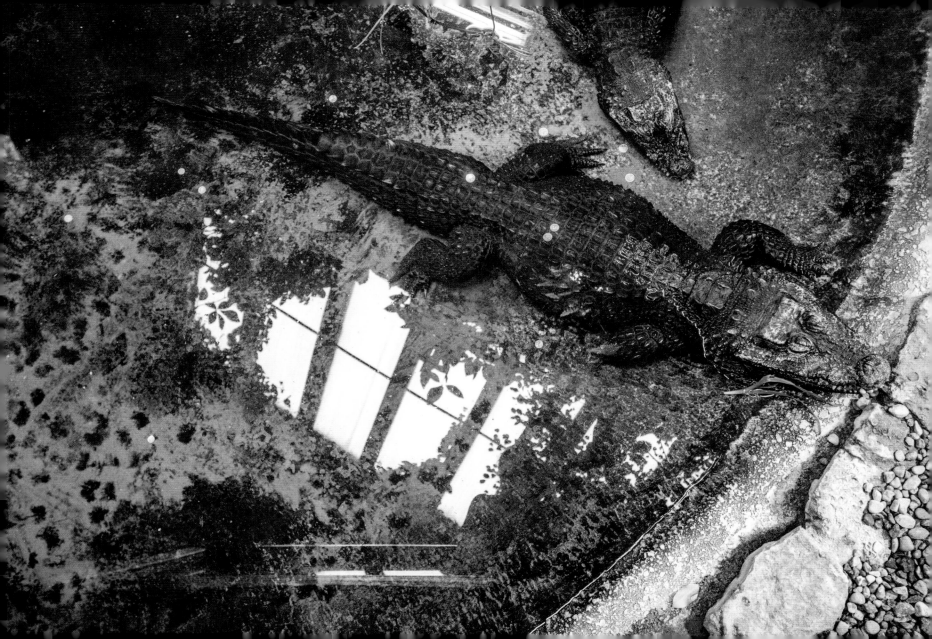

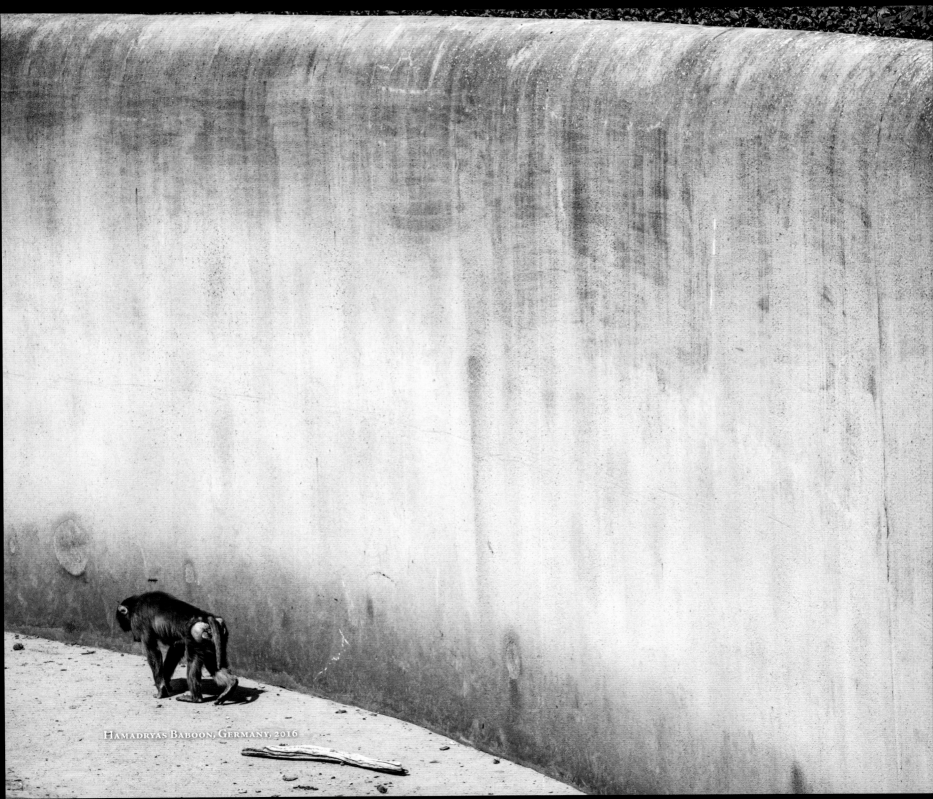

Hamadryas Baboon, Germany, 2016

BEARING WITNESS

L ike many tourists, I visit the local zoo or aquarium when I'm in a new city. Unlike most people, however, I'm there with my camera to document how the (non-human) animals are kept. I use the photographs to shed light on the darker corners of these establishments, and to educate citizens on why keeping animals captive for our amusement needs to change. Sometimes I've been at zoos and aquaria (henceforth zoos) on assignment; for instance, with Zoocheck Canada in 2008 and 2009, and recently for the Born Free Foundation. At the end of my exhausting (though far from exhaustive) work for Born Free, I handed over hundreds of images taken from a cross-section of countries throughout Europe.

With over a decade of zoo photography on five continents in my archive, I felt the time had come to publish a book on the subject. The huge interest in captured orcas generated by the documentary film *Blackfish*, the outcry over the tragic shooting death of Harambe the gorilla at the Cincinnati Zoo, and the shock at the very public cull and dissection of Marius the giraffe at the Copenhagen Zoo are proof that the conversation about zoos and their reform is now in the mainstream. *Captive* is my contribution to that vital public discussion.

I've also seen too much *not* to create this book. My cross-country work with Zoocheck took me to zoos in northern Canada in the deep frost of winter, where I saw animals living outdoors with frozen water, and came across the carcasses of others in various degrees of decay. I've stood before countless bars or moats as animals paced back and forth in barren enclosures or spun in circles in tiny cages in front of me.

Too often, creatures who in the wild inhabit large and complex social groups are forced to live alone; or the friendships and family bonds these captives may have forged are broken when they're sold or moved

to other zoos. Frequently, animals from different groups or communities are paired solely so they'll breed and maintain genetic diversity, an unnatural selection that leads to stress, suffering and even death. At other times, as in the case of Marius, they are simply deemed "genetic surplus" and killed. It's an all-too-frequent experience at zoos that failed species conservation occurs at the expense of the individual animal.

Unfortunately, the claims that zoos make that they are concerned with conservation and education are rarely the reality. I've photographed animals whom zoos have rented out for fashion shoots, where they must stay on the set, tethered and stressed, under bright, hot lights. Zoo professionals and veterinarian friends have shared stories with me in confidence about mishaps and preventable deaths. I've catalogued the cramped, indoor cinderblock enclosures, where animals native to warm climates must exist indoors and on cement floors until the spring.

Most ubiquitously of all, however, I've seen our apathy, indifference and ignorance. Although my intention is to shoot the conditions these sentient beings must endure, it's undoubtedly true that my lens focuses with equal intensity on us. *We* animals. After all, captivity is our perverse creation.

Some readers of *Captive* may accuse me of trying to manipulate people into holding a negative opinion of zoos. It's true that the images in *Captive* are jarring and uncomfortable. We see animals as they are, literally exposed and on display. I cannot be a neutral observer: these animals' vulnerability and helplessness, the result of their being held against their will, fill me with shame and a desire to help. It's also true that all photographs frame a subject, crop out some elements to focus on others, and thereby guide you, literally, toward a point of view.

However, it's worth emphasizing that zoos attempt to do the same. The serene environments of manicured gardens, tree-lined walkways and the recorded sounds of soothing music or wild birds are designed to distract and please us. Built as parks, zoos aim to draw our eyes *away* from captivity, away from the boredom and loneliness of the animals on display. Instead of discerning or understanding just how small an enclosure for a wild, often wide-ranging animal may be, our eyes wander amidst the *trompe-l'oeil* motifs of the jungle or savannah painted on the walls of the enclosures. These paintings are for us, the viewer. I'll hazard a guess they don't mean much to the animals.

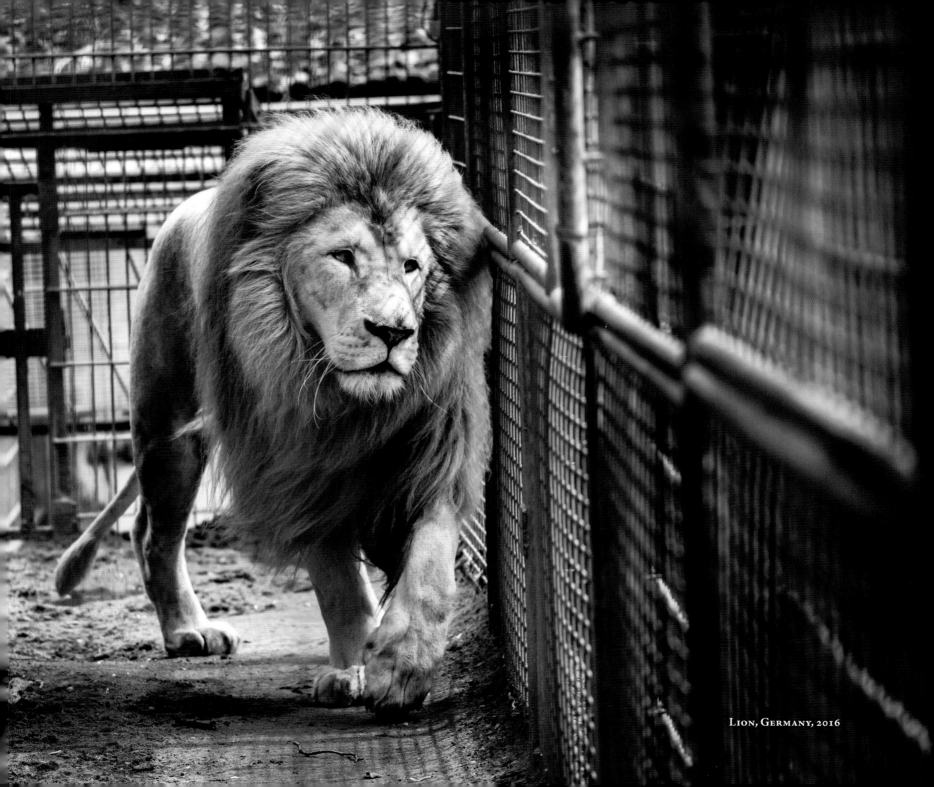

LION, GERMANY, 2016

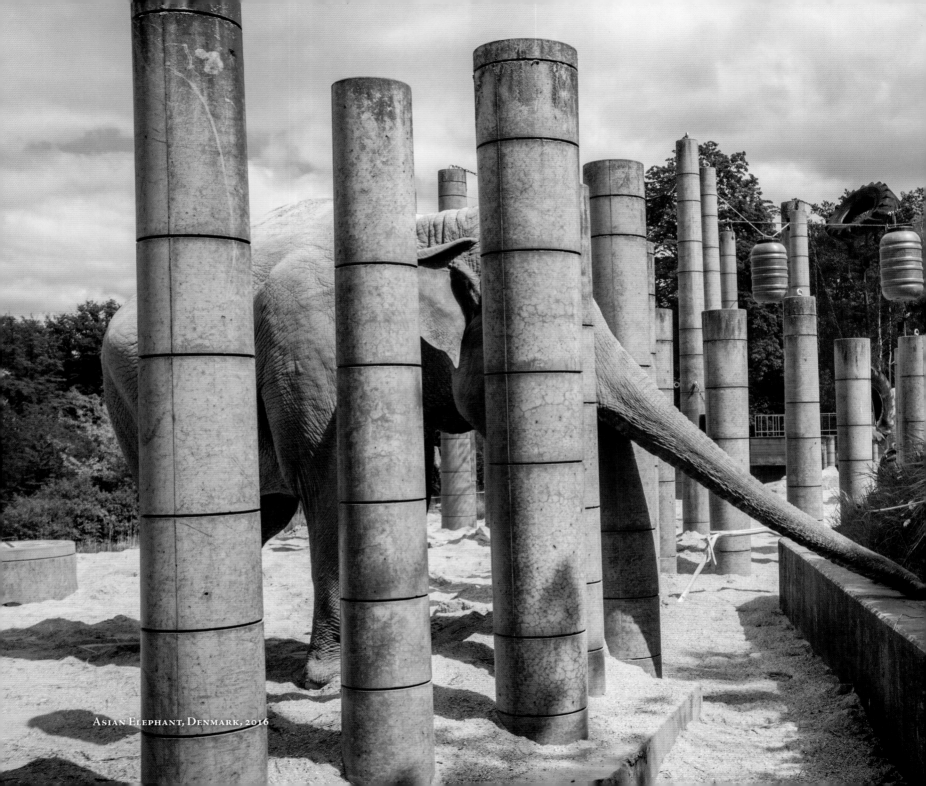

Asian Elephant, Denmark, 2016

So, I've avoided the groomed greenery and potted plants between enclosures, and focused on the enclosures themselves. It's precisely because our attention is directed away from the animal's condition that, in addition to capturing the experience of the animals and we who watch them, I focus on the bars and chains, the corners and ropes, and the walls and thick glass between us. Zoo visitors don't seem to consider those deeply unnatural aspects of the animal's experience. By including these elements within the frame, I want us to focus on not only how real they are for the animals, but also how we tend to ignore them.

I'm aware that observing the darker sides of captivity is the opposite of a walk in the (zoological) park. After all, why would we go to a zoo if we could really see or feel what it's like for the animal? When we visit new places, we like to take photographs of beaches and cathedrals, and not the crumbling houses or the homeless people living on the sidewalks. We tend to choose to look at what pleases us, what challenges us the least. We see what we like, and record experiences that affirm our participation in something interesting, or fun. We do this technically as well: less-than-savoury aspects of our experiences disappear when we choose a long lens and a shallow depth of field with which to focus on what we like, leaving the rest to fall away. This, however, doesn't change the reality of those we've turned our backs on—whether human or non-human. They remain, invisible and generally forgotten by us. This is why I choose a wide lens and a smaller aperture.

Let me say a few words about the pictures that *aren't* in this book; ironically, these are perhaps the worst a zoo has to offer. My photos can't distinguish *which* animals were caught in the wild and transported overseas. Recent examples include the fourteen wild elephants from Swaziland, transported to zoos in the United States; and sharks removed from the Atlantic Ocean who now swim in tiny circles at an aquarium in Canada. Furthermore, I can't show *how* those animals were caught in the wild, taken from their mothers or family groups. I have no images of the animals who didn't survive the journey to the zoo (such as the sharks who died in transit to Canada). I wasn't around to capture the moment that an animal arrived to spend the rest of his or her life in that completely alien and alienating environment.

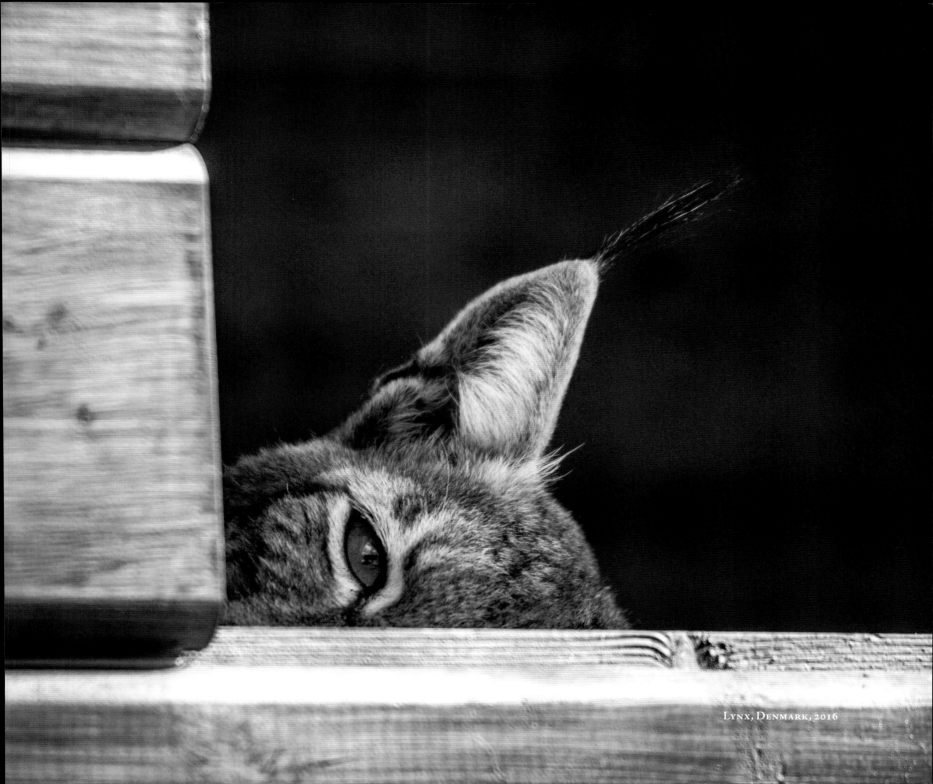

Lynx, Denmark, 2016

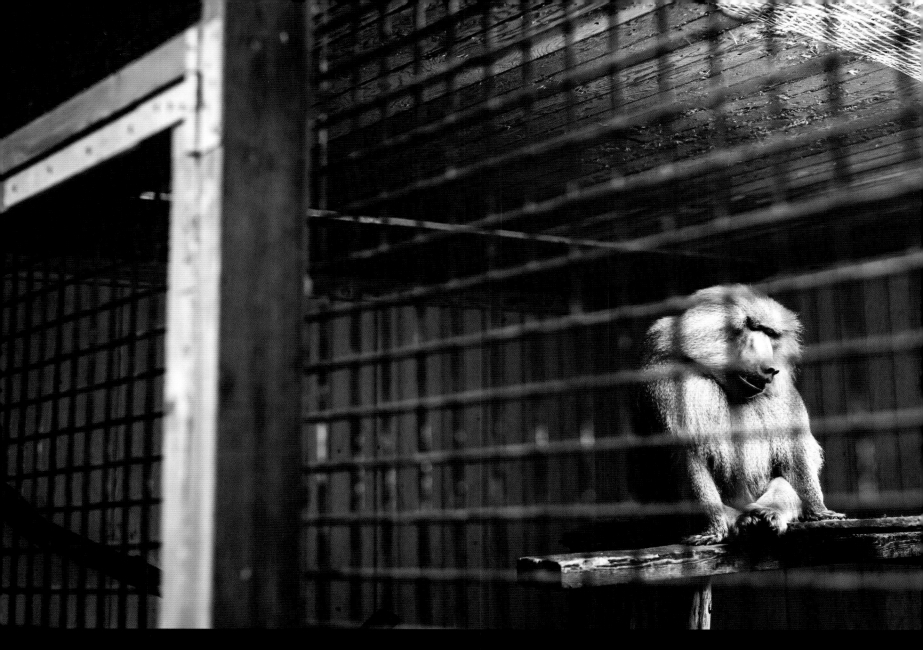

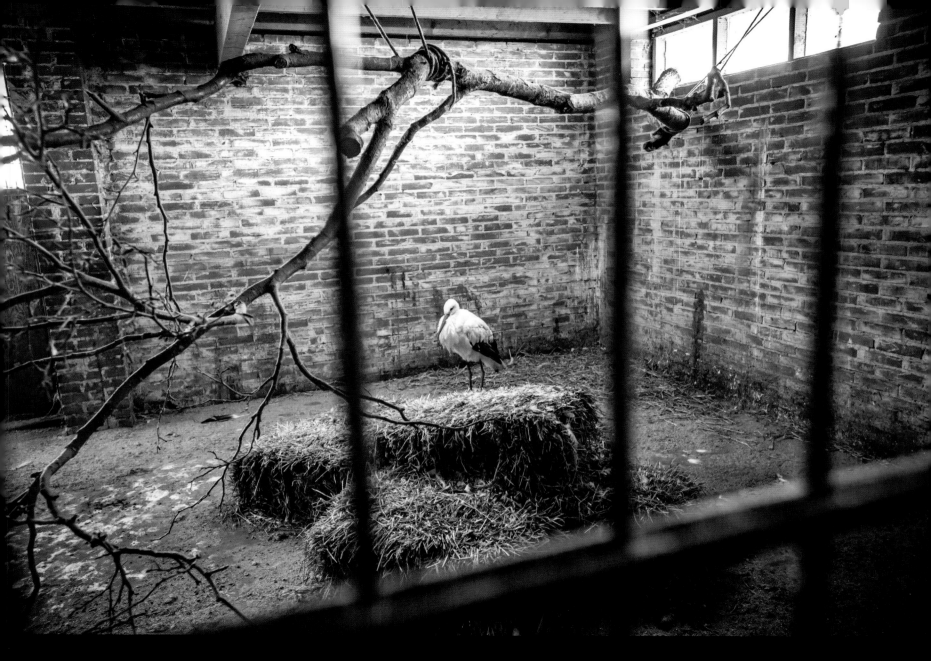

White Stork, Denmark, 2016

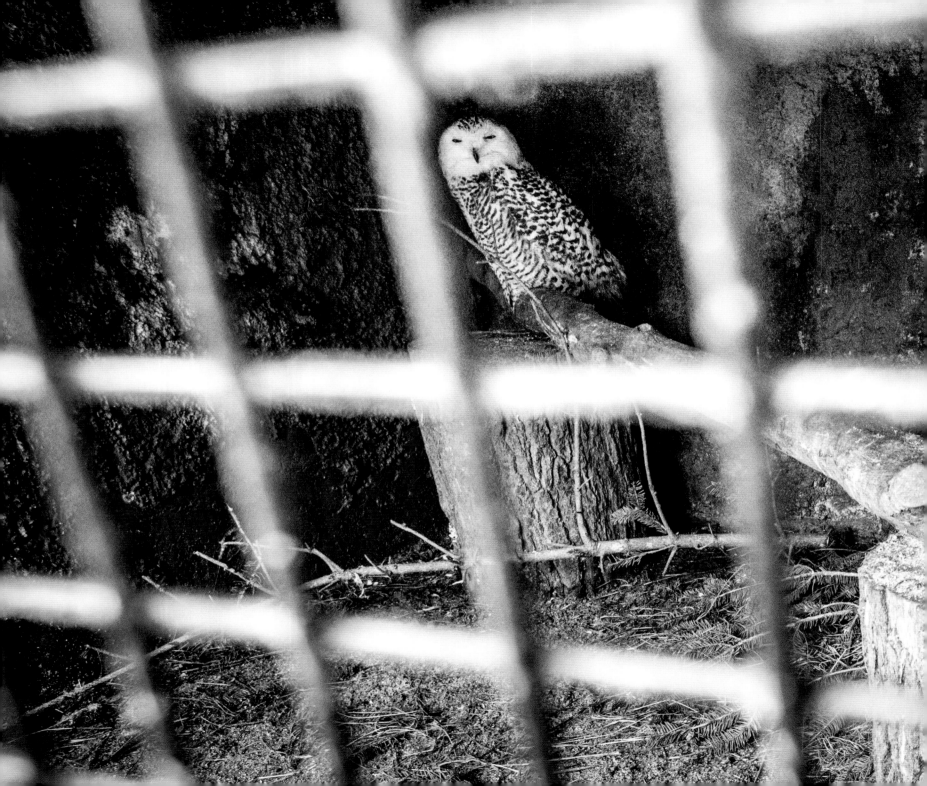

SNOWY OWL AND AMAZONIAN
RACCOON, SLOVENIA, 2016

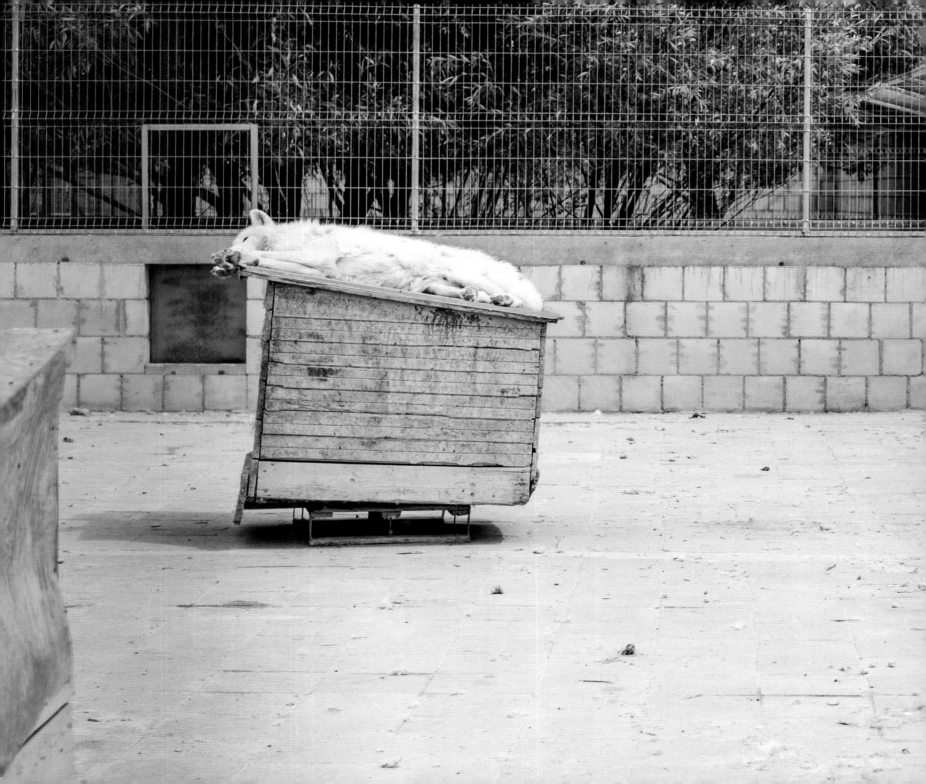

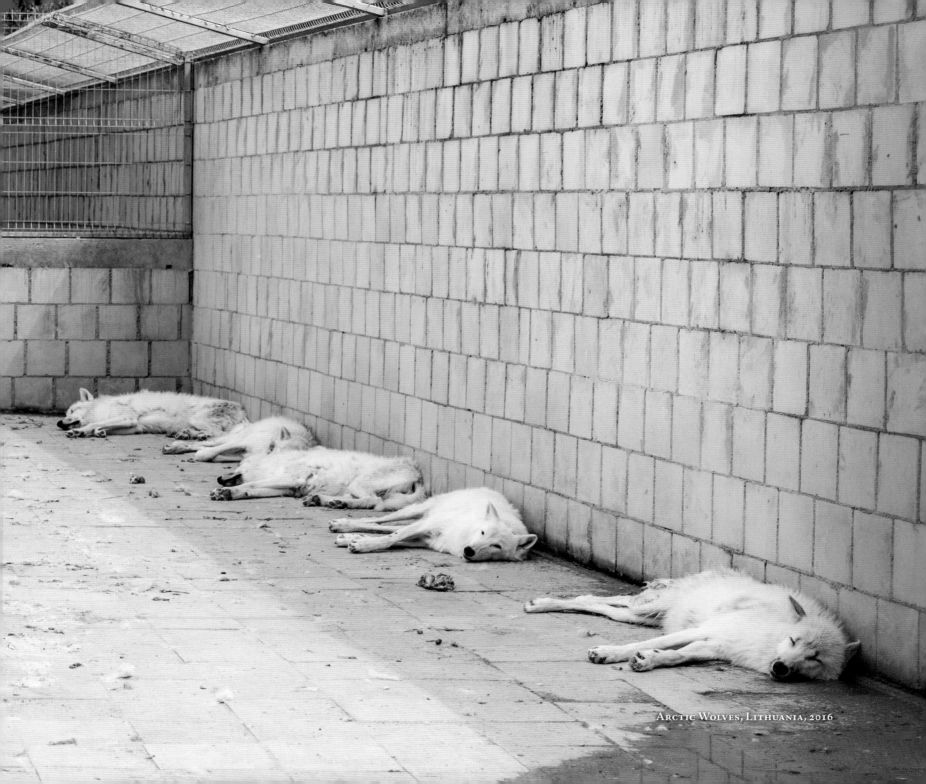

Arctic Wolves, Lithuania, 2016

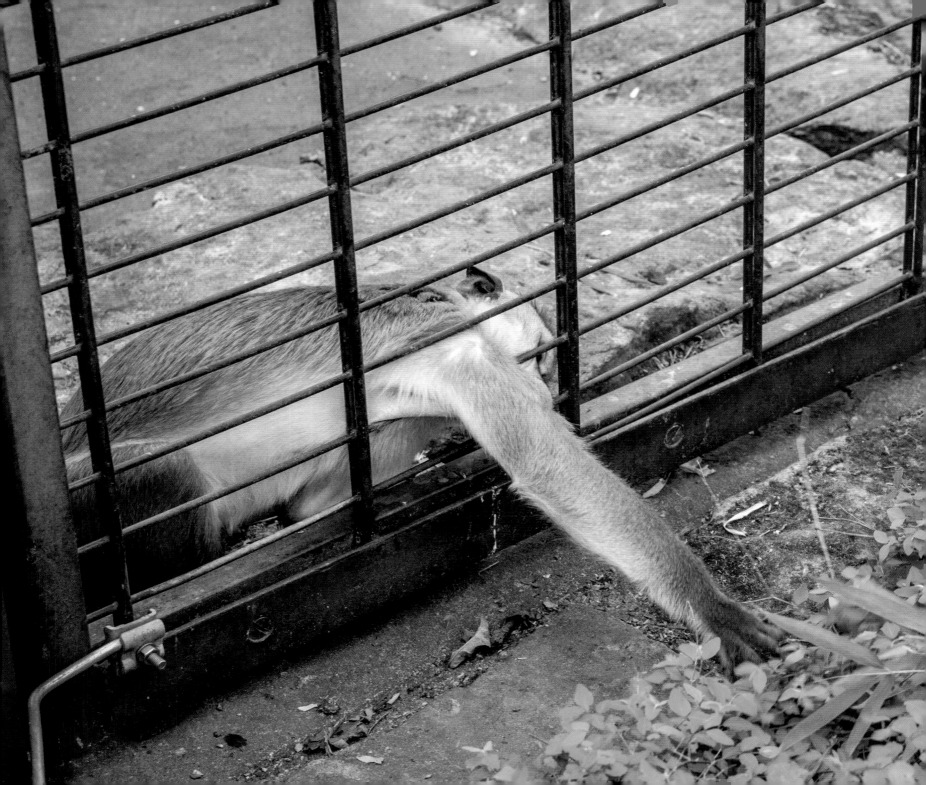

Toque Macaque, Germany, 2016

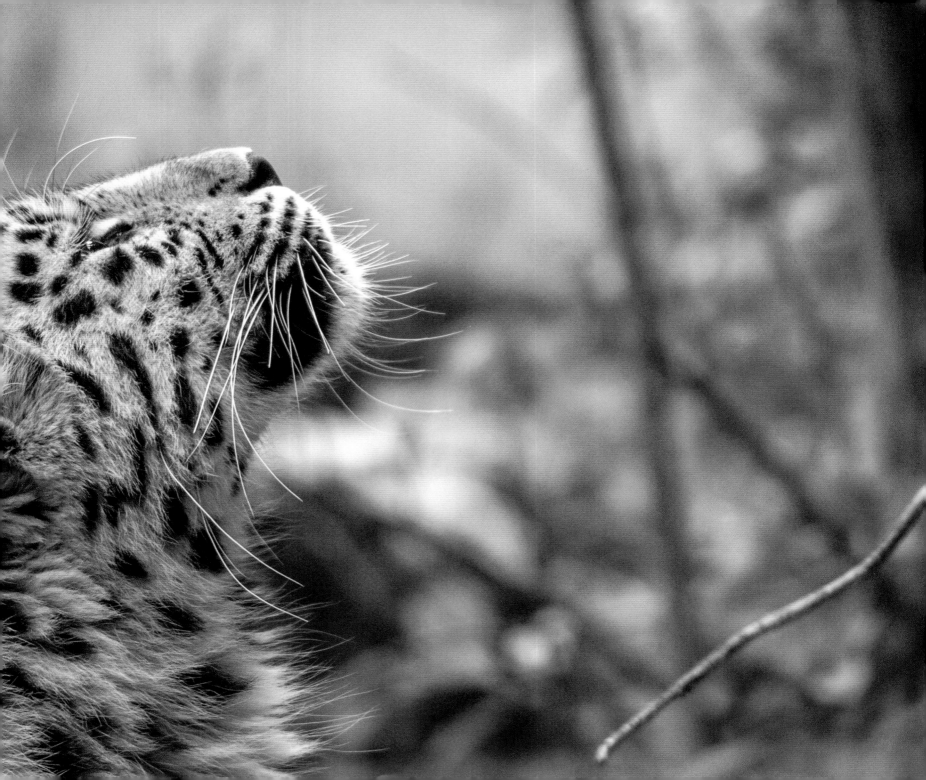

Amur Leopard, France, 2016

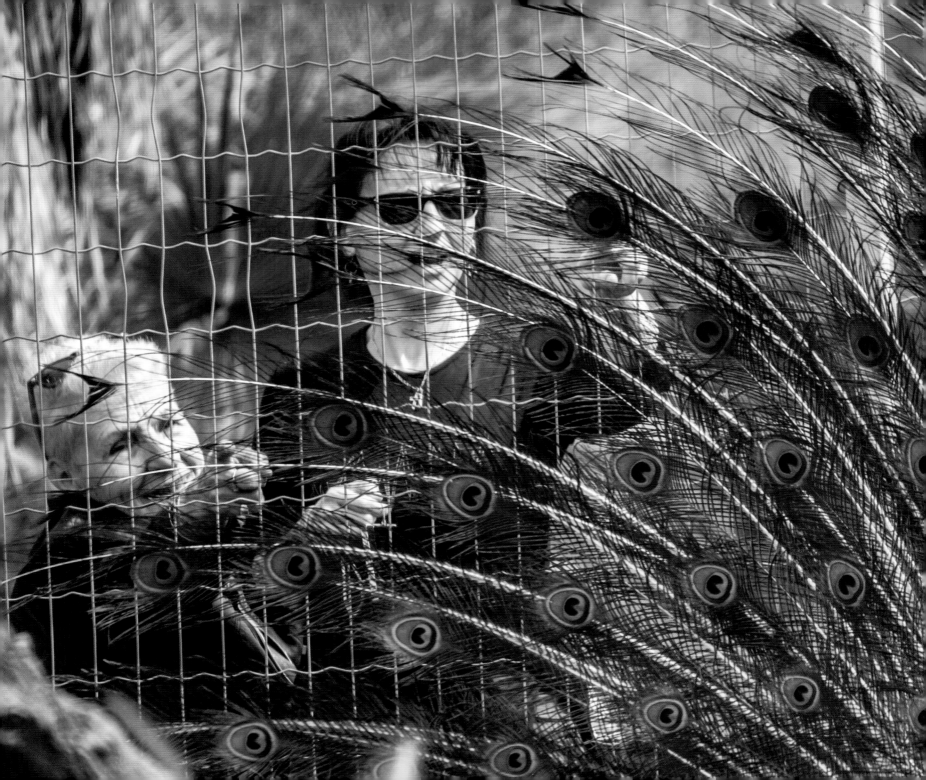

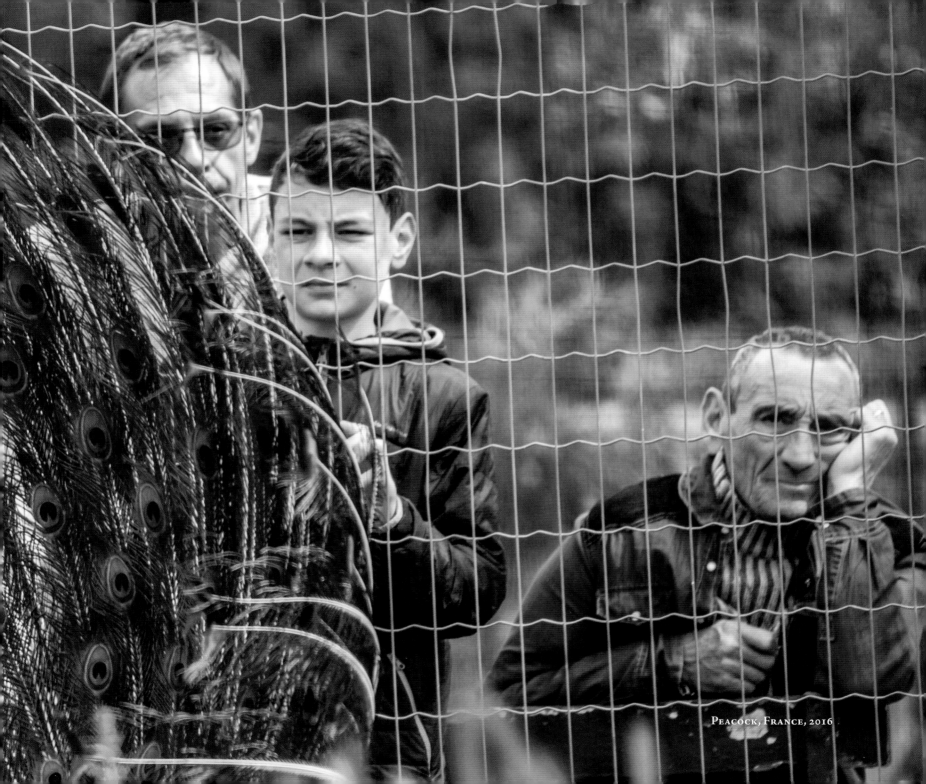

Peacock, France, 2016

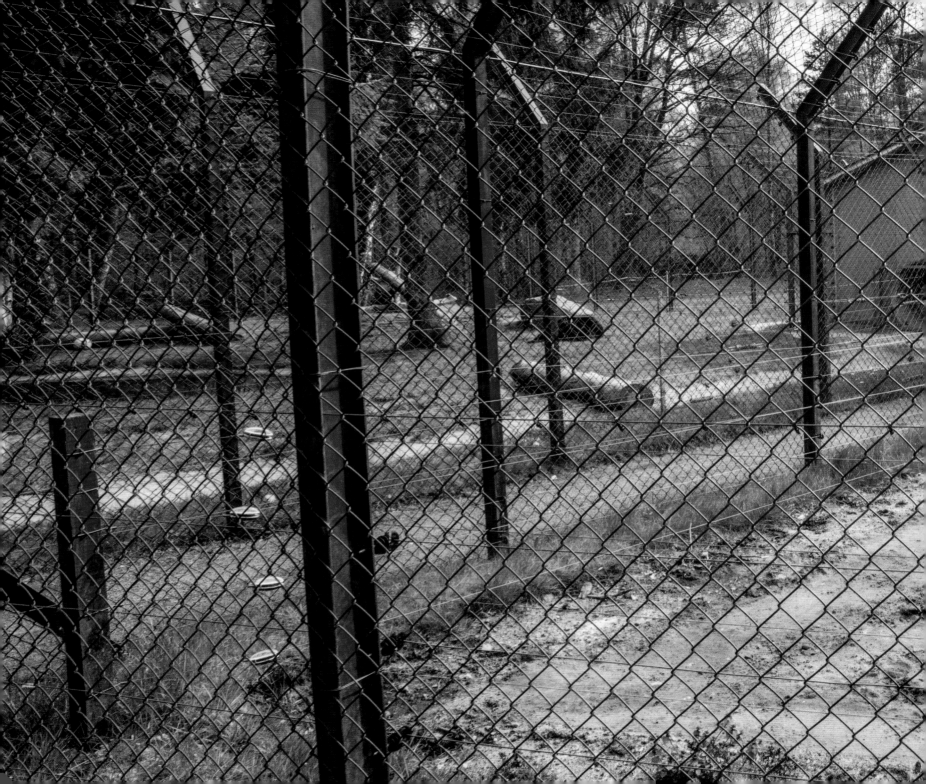

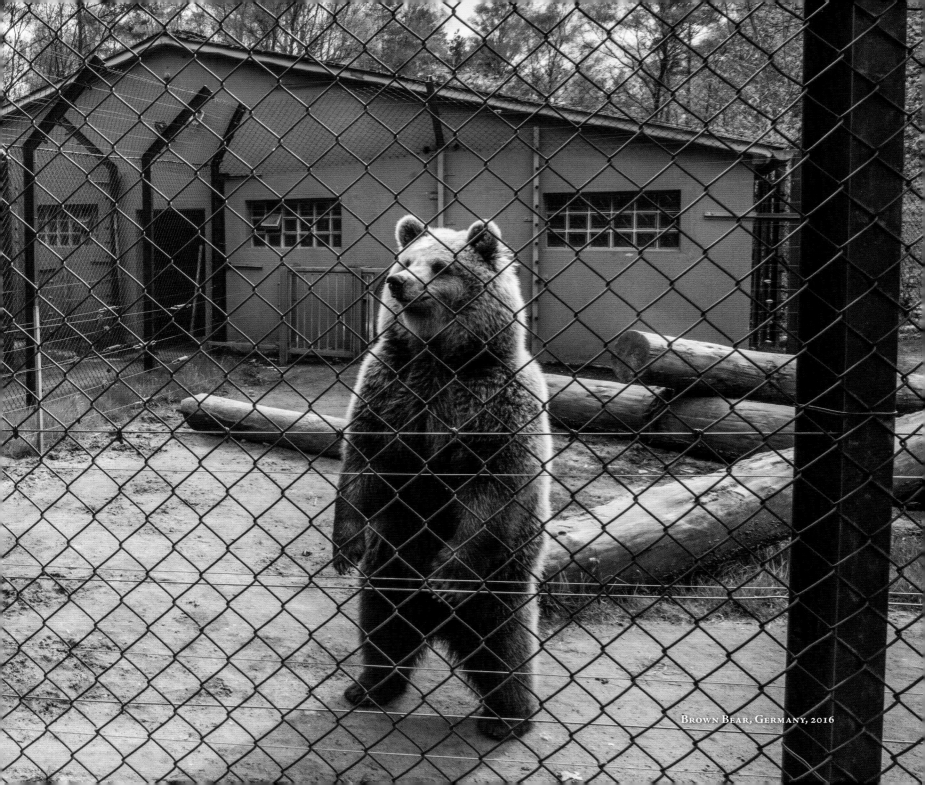

Brown Bear, Germany, 2016

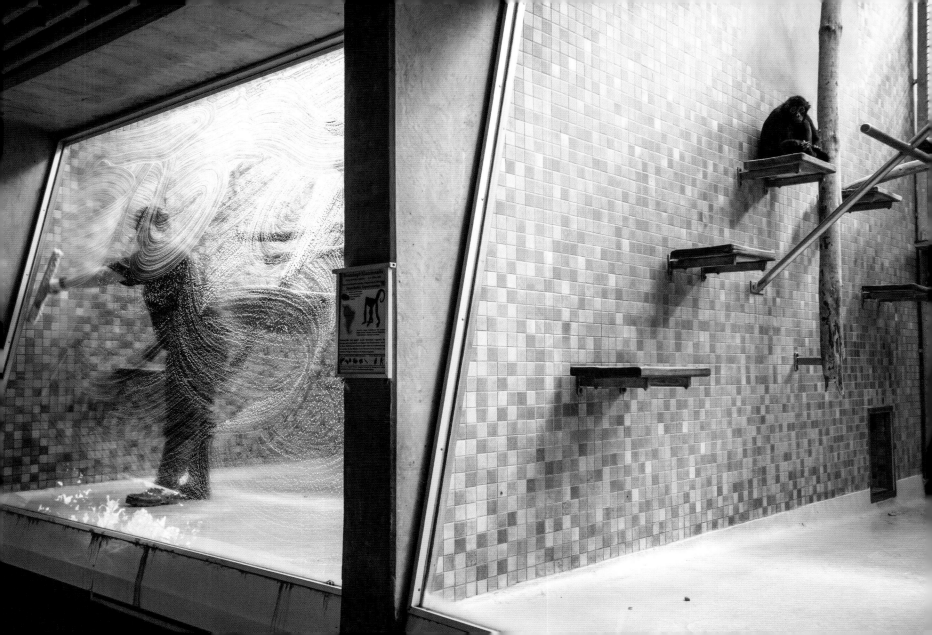

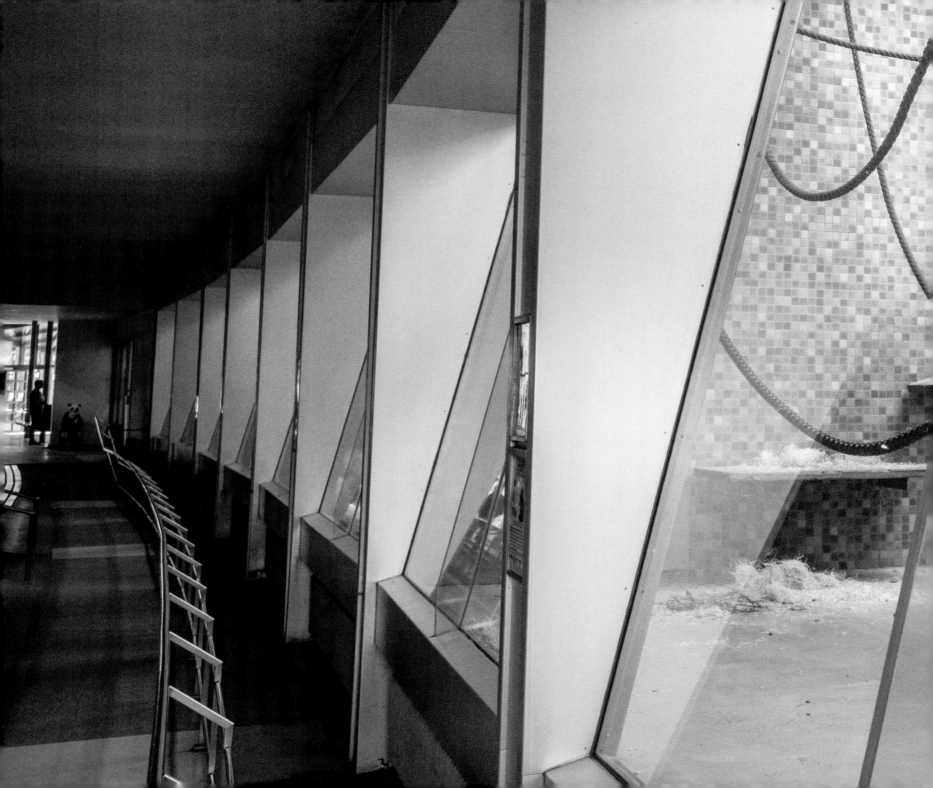

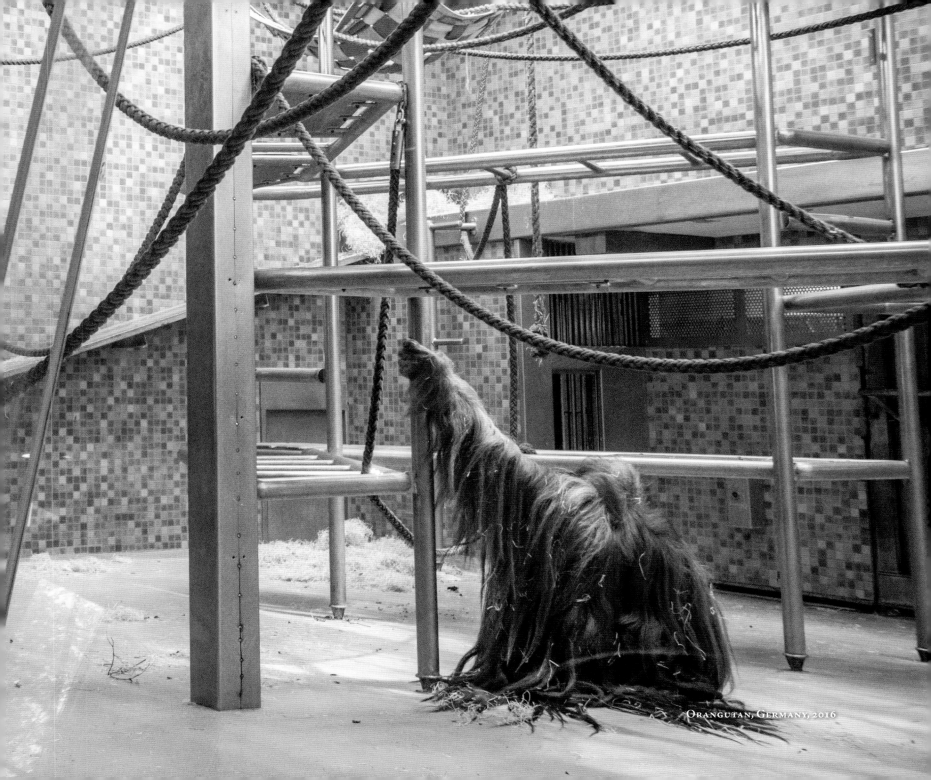

Orangutan, Germany, 2016

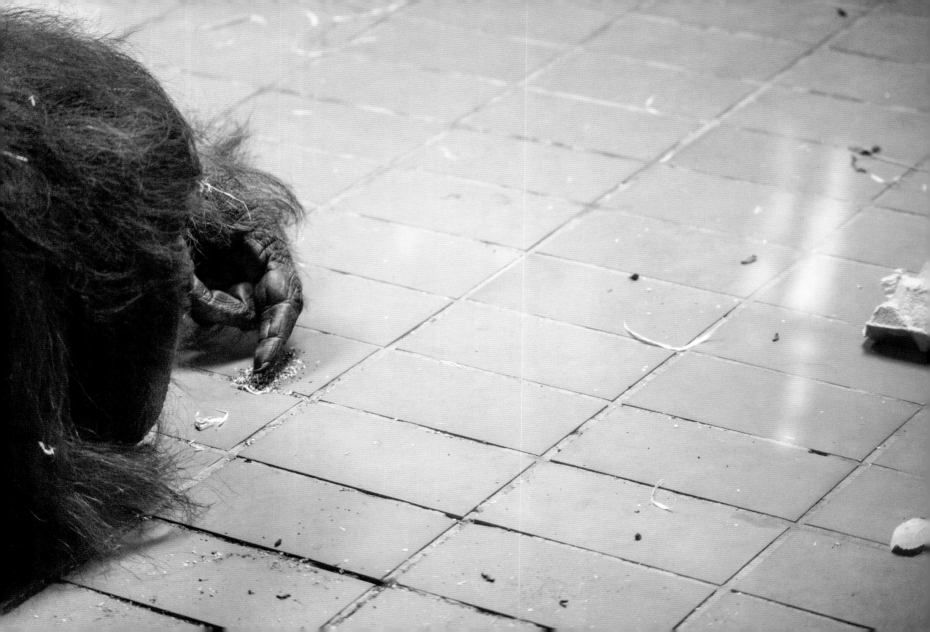

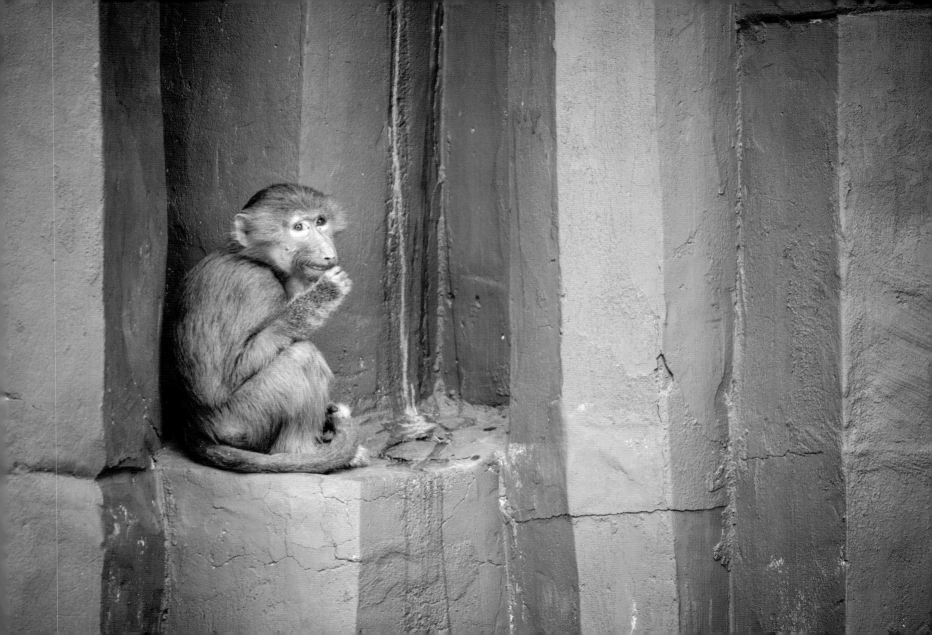

JAGUAR, GERMANY, 2016

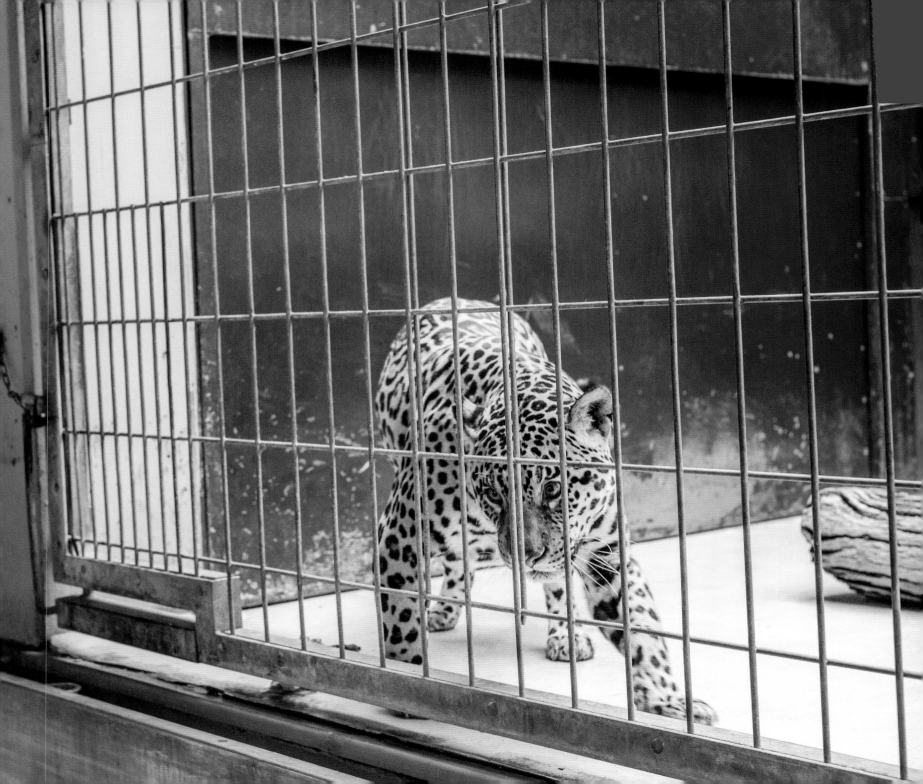

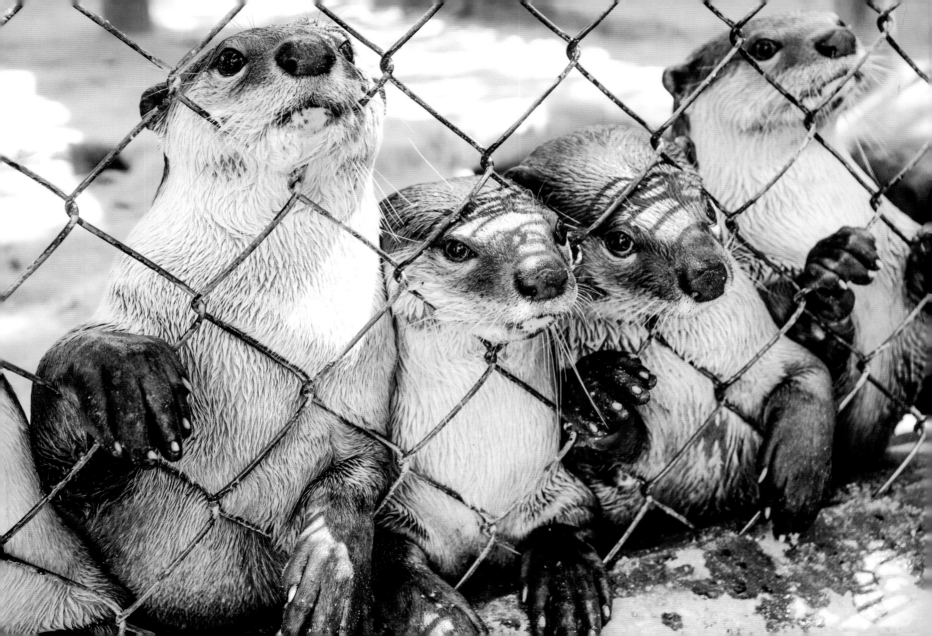

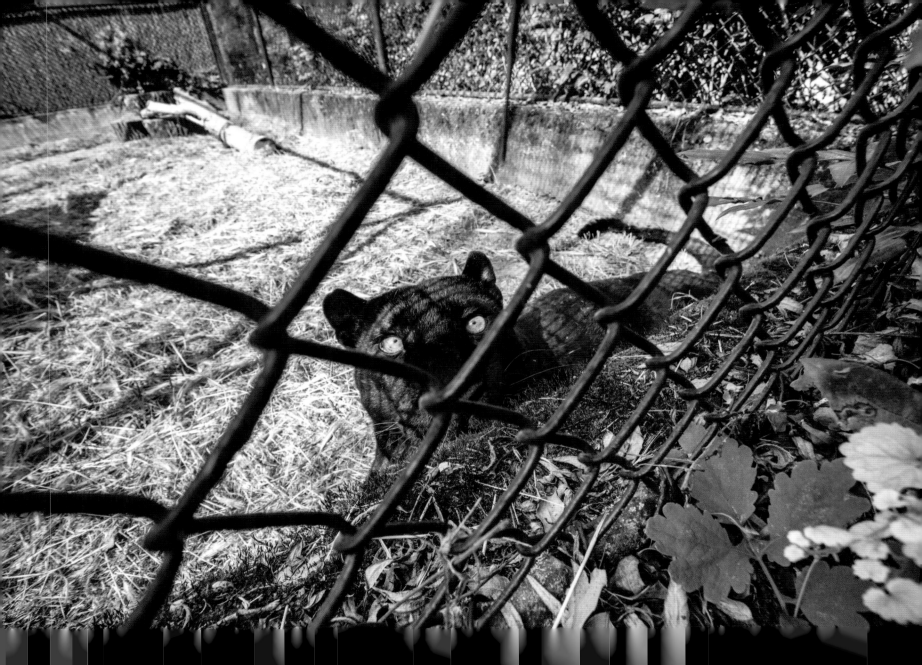

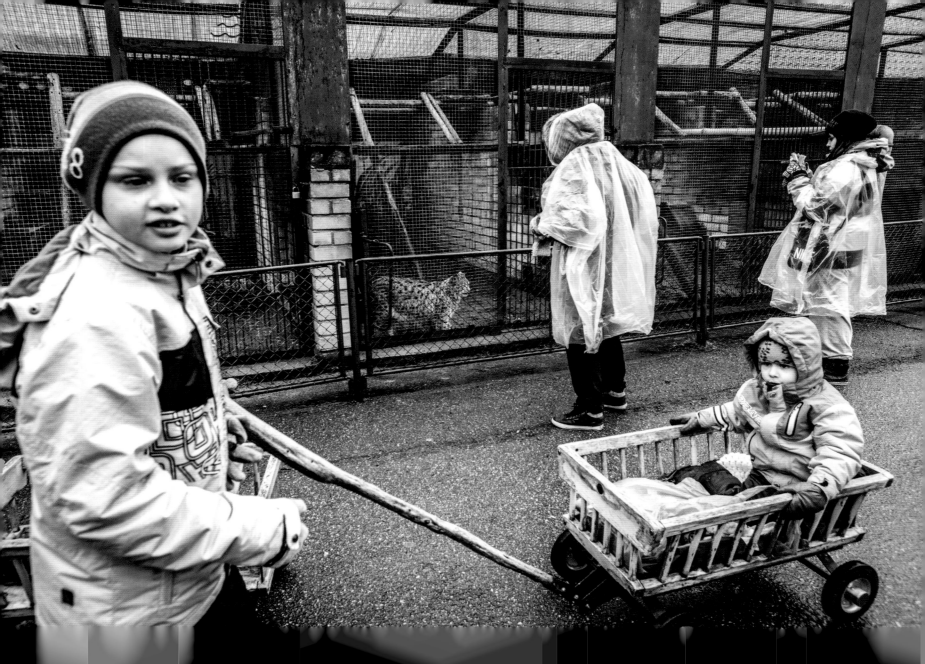

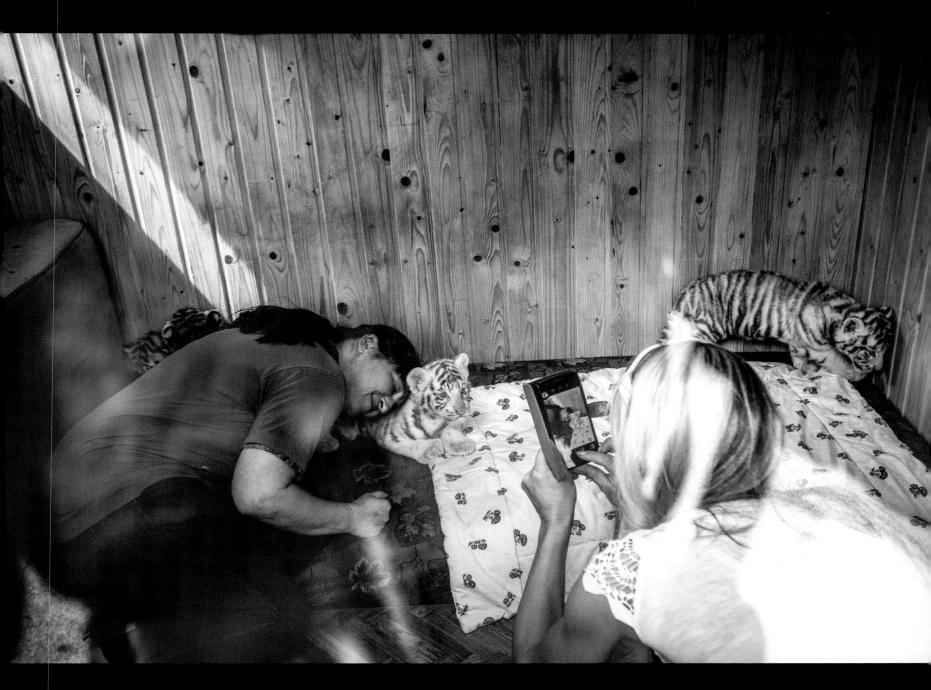

TIGER CUBS, LITHUANIA, 2016

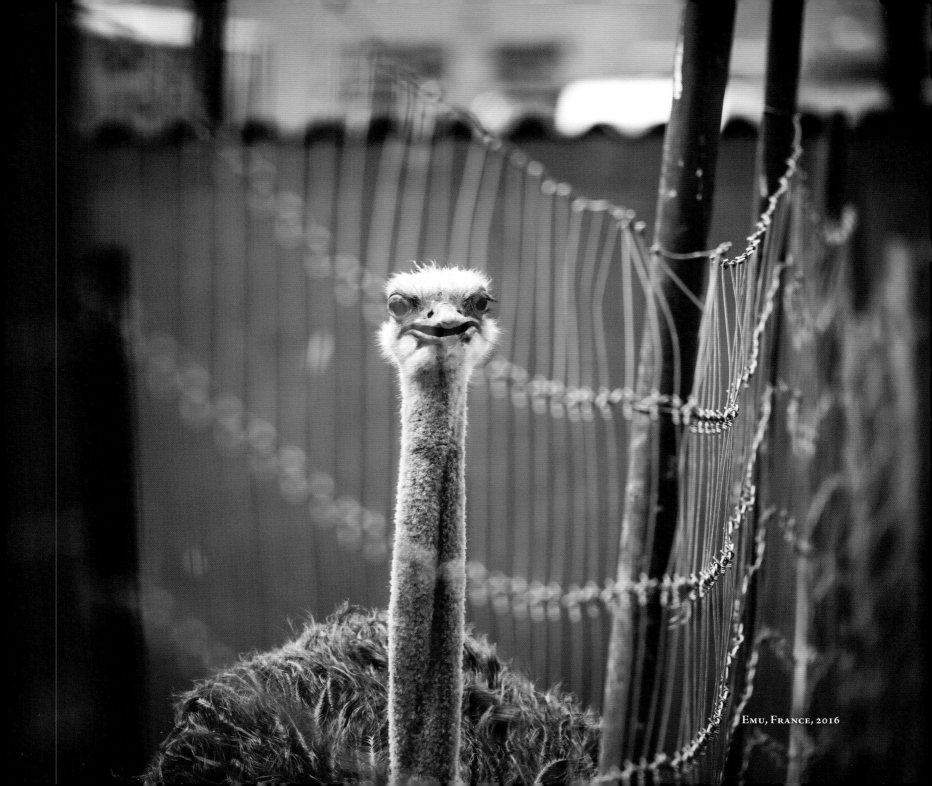

Emu, France, 2016

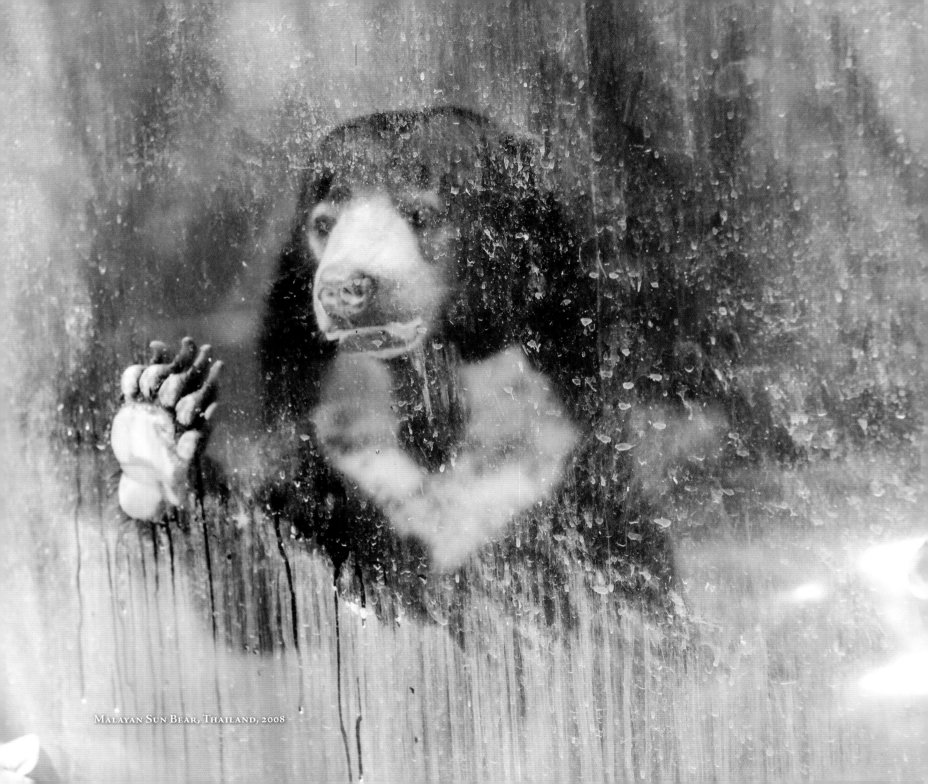

Malayan Sun Bear, Thailand, 2008

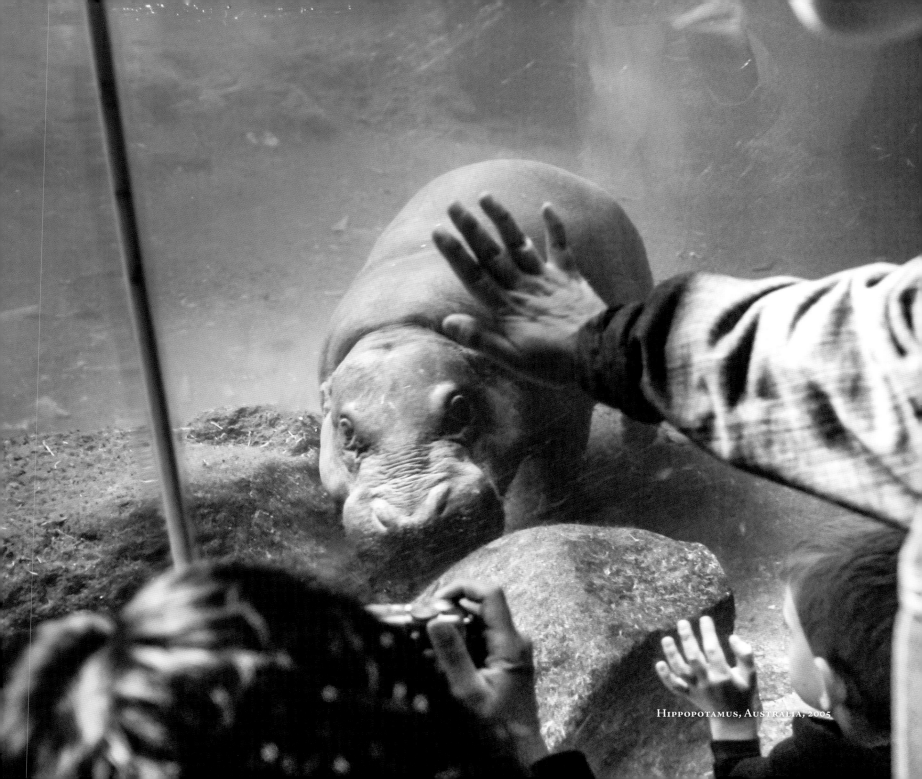

Hippopotamus, Australia, 2005

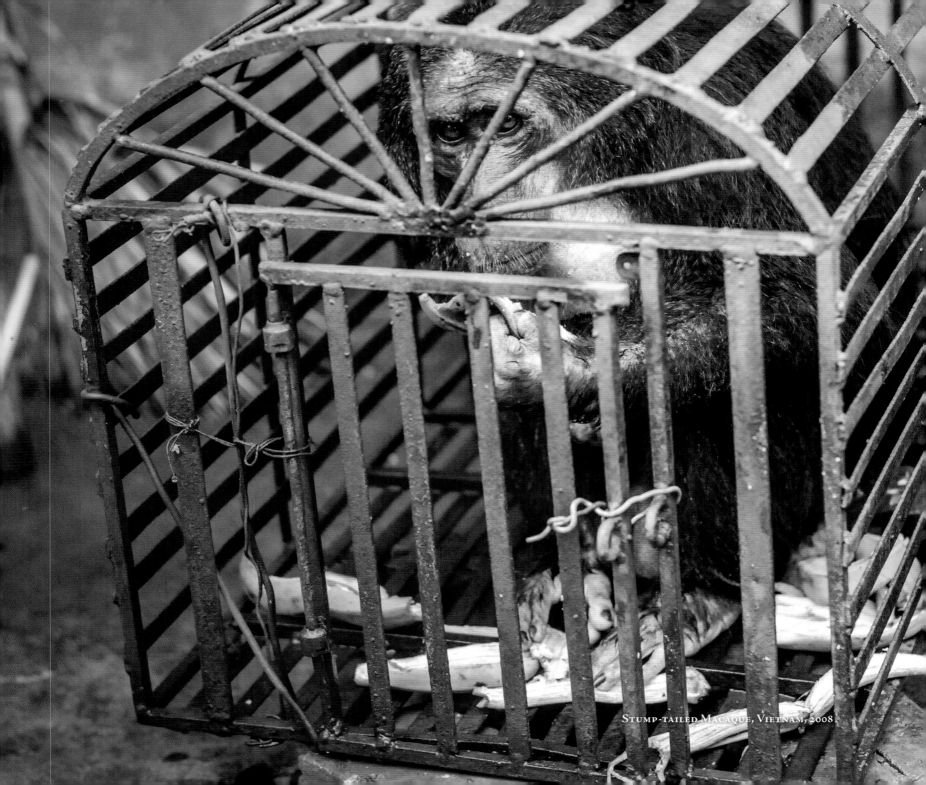

Stump-tailed Macaque, Vietnam, 2008

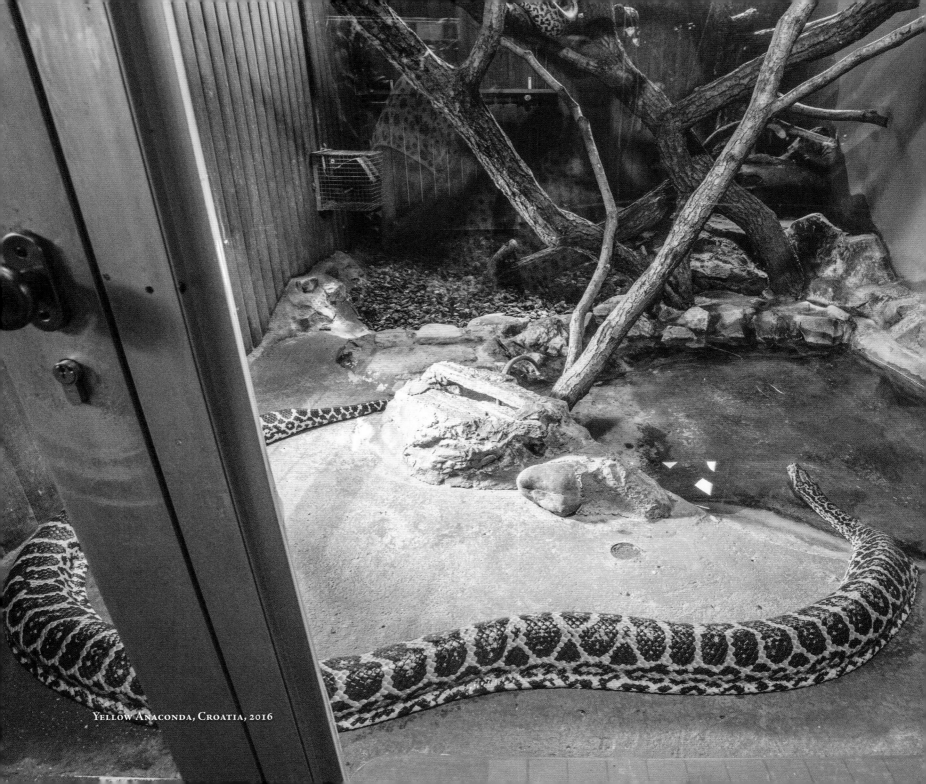

Yellow Anaconda, Croatia, 2016

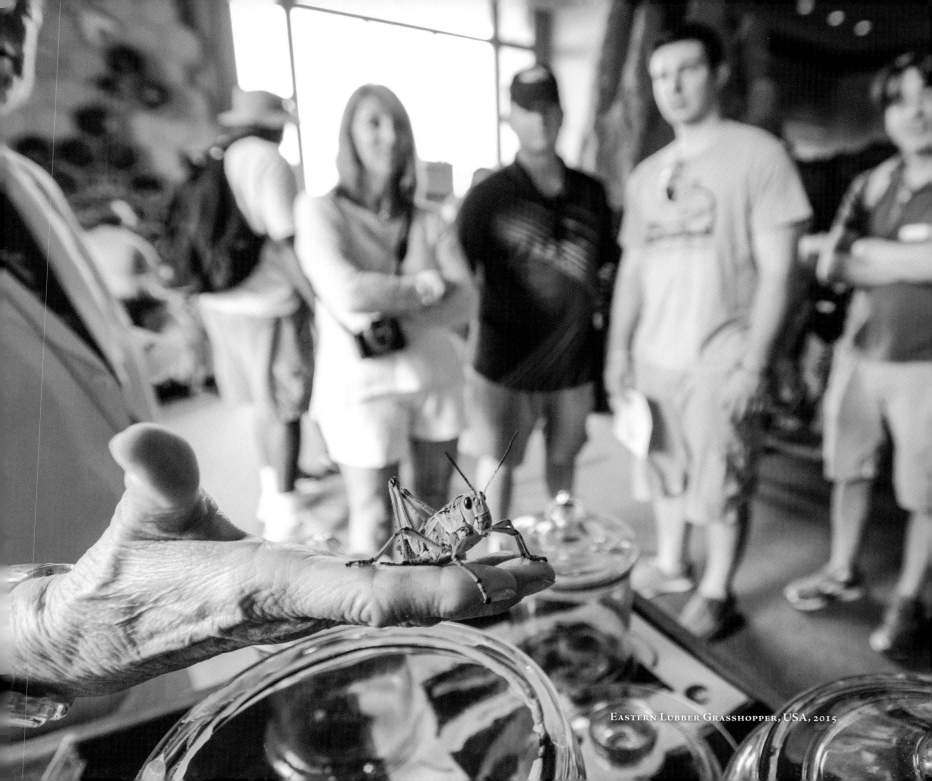

Eastern Lubber Grasshopper, USA, 2015

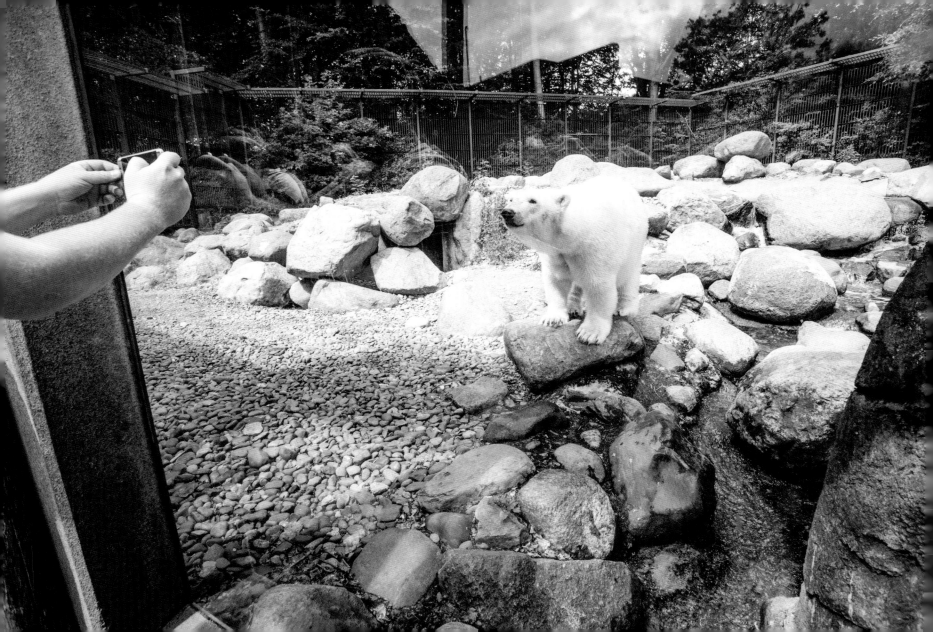

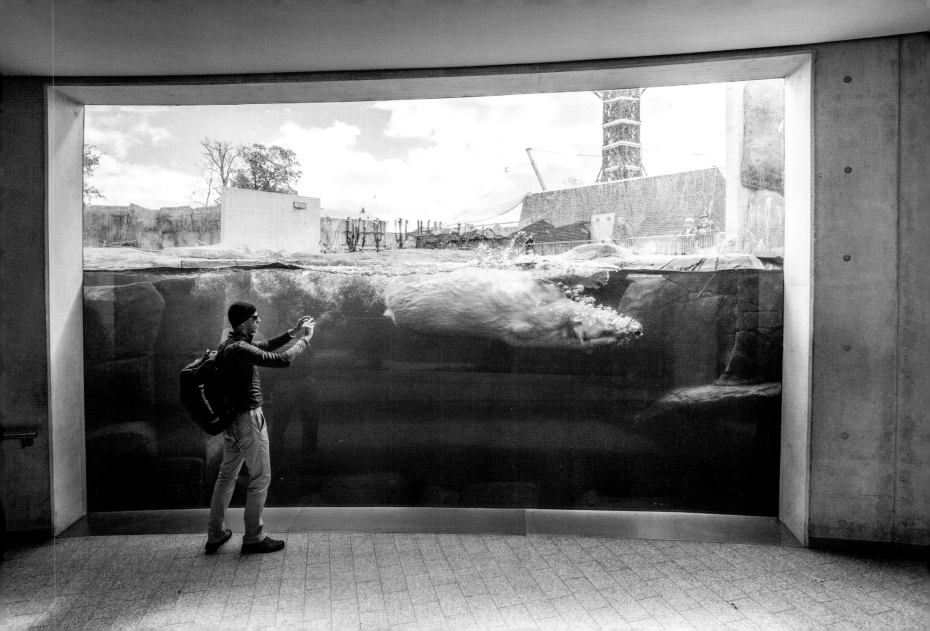

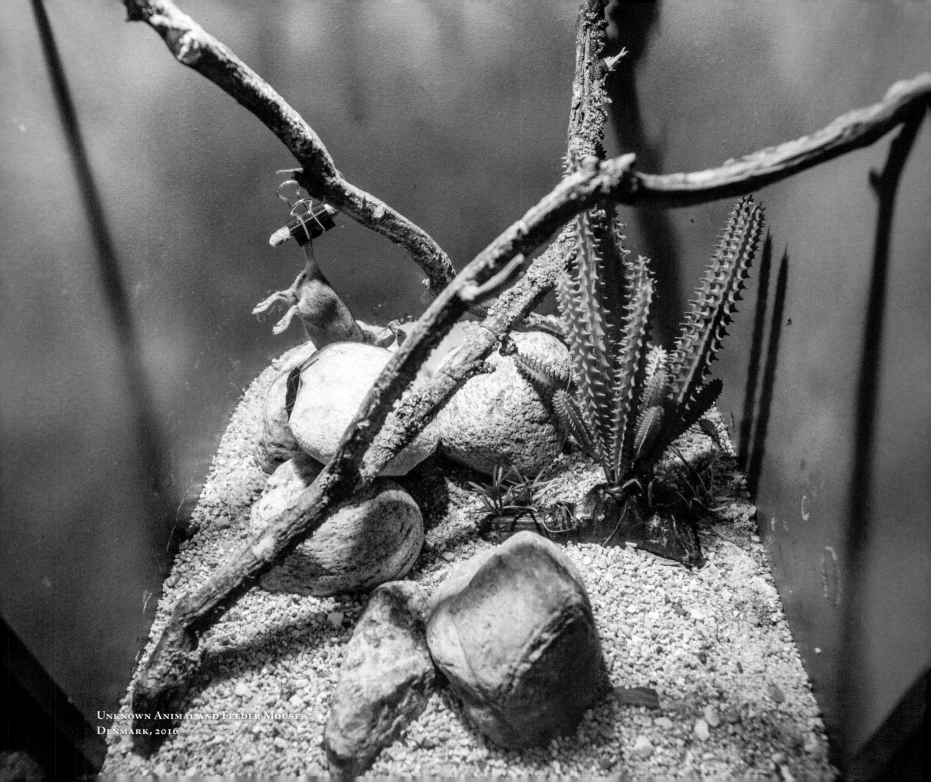

Unknown Animal and Feeder Mouse,
Denmark, 2016

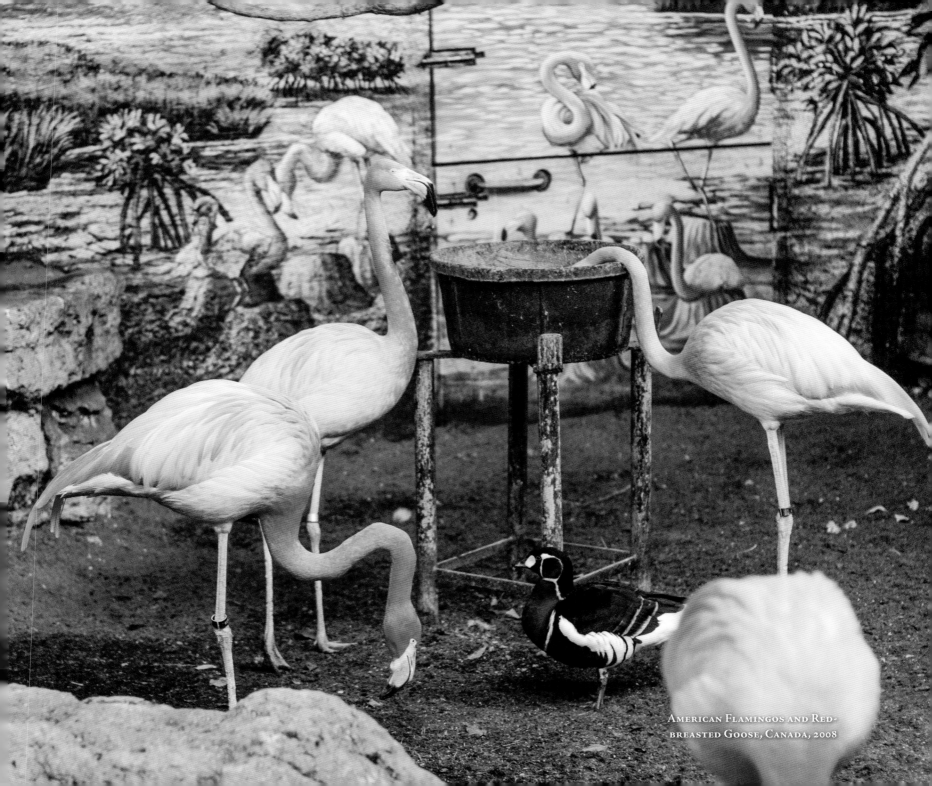

American Flamingos and Red-breasted Goose, Canada, 2008

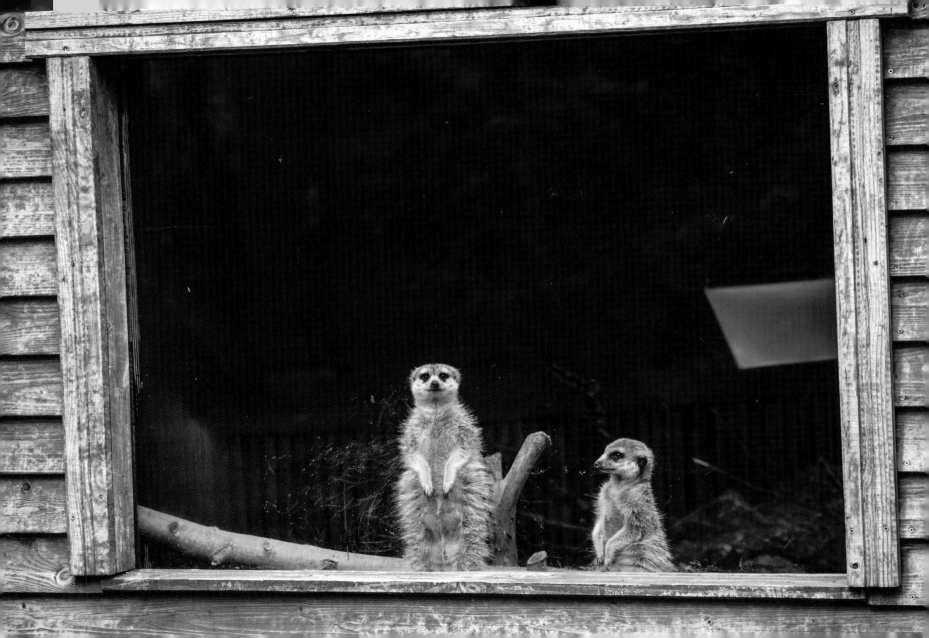

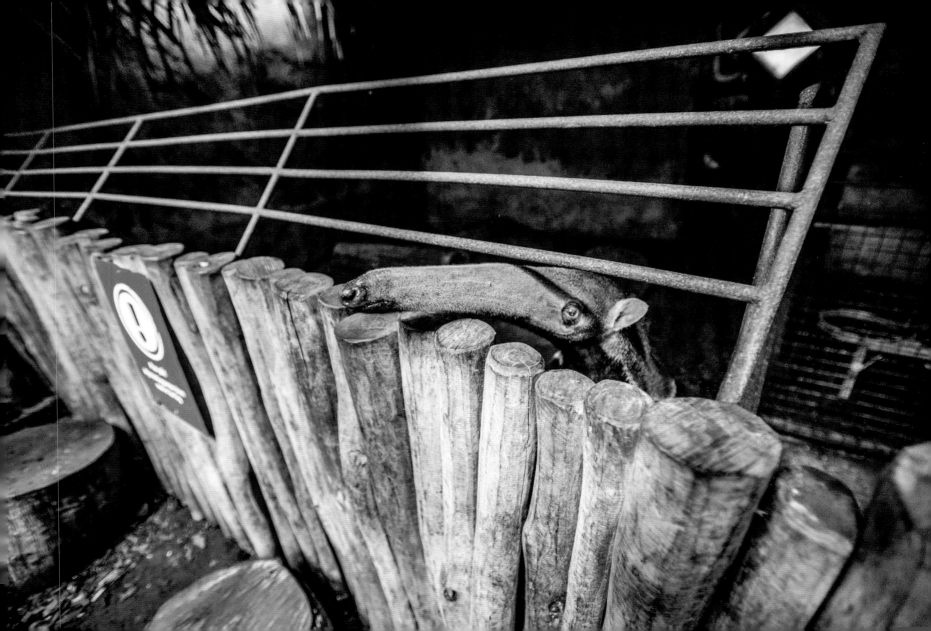

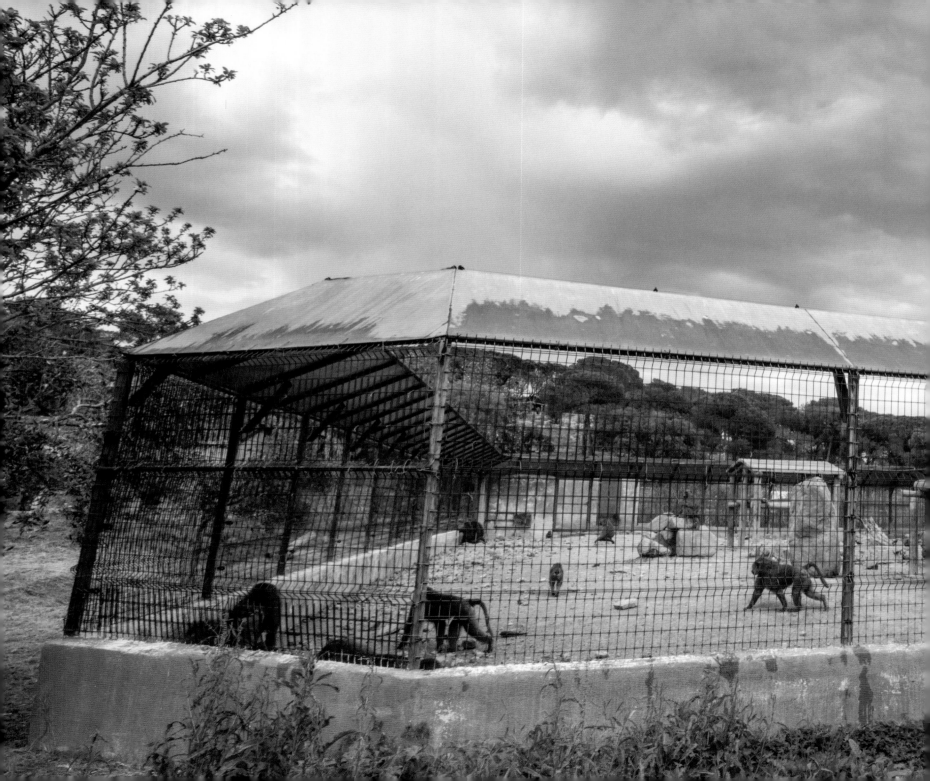

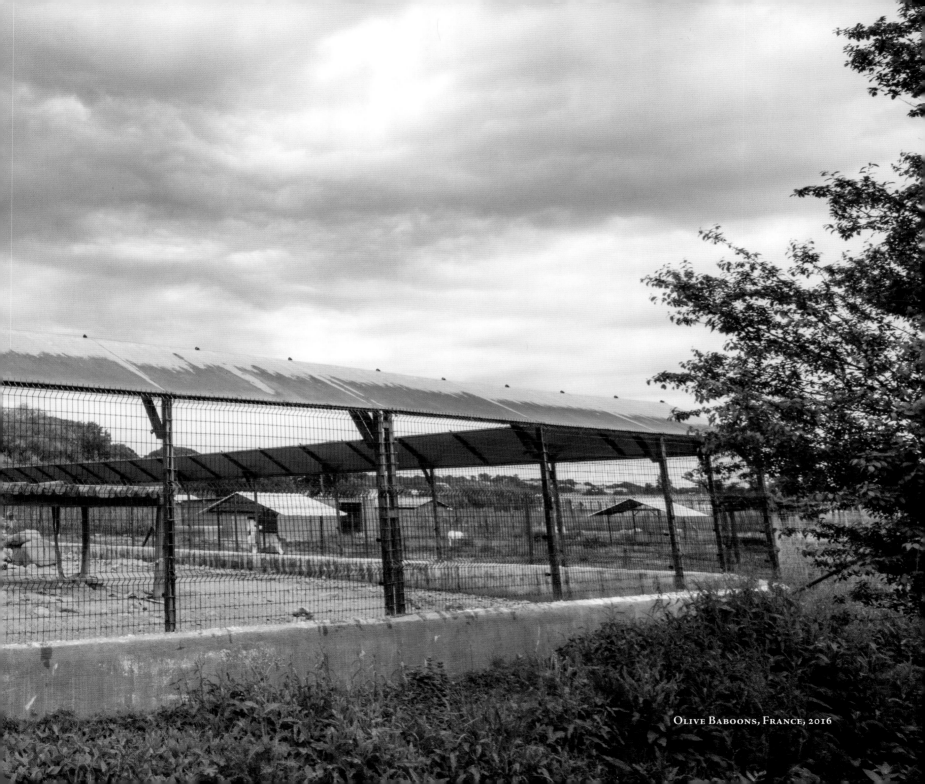

OLIVE BABOONS, FRANCE, 2016

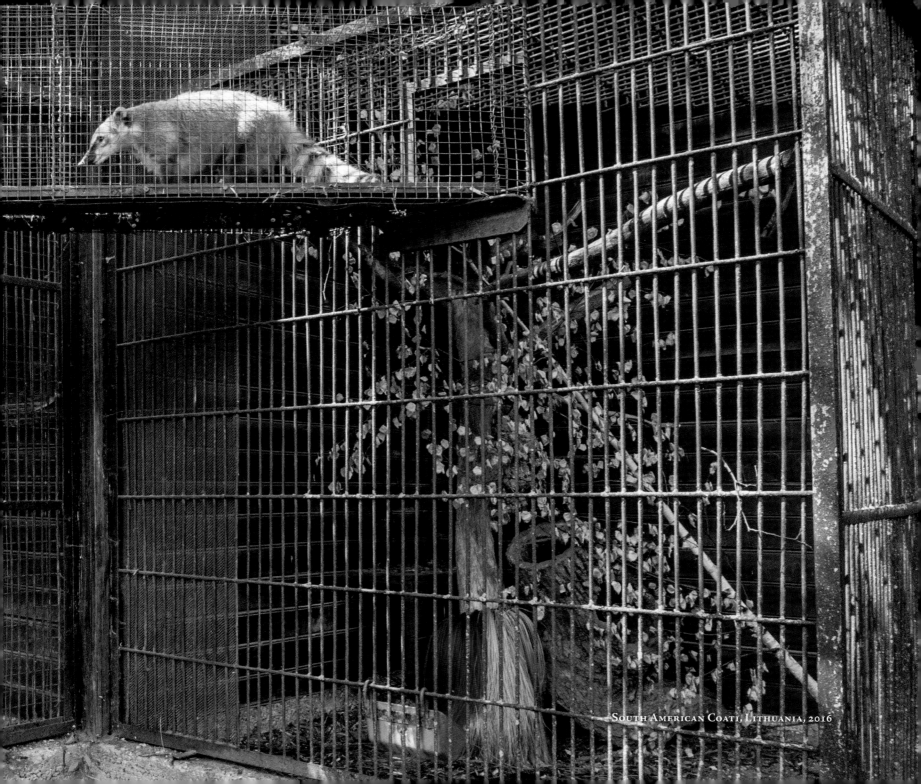

South American Coati, Lithuania, 2016

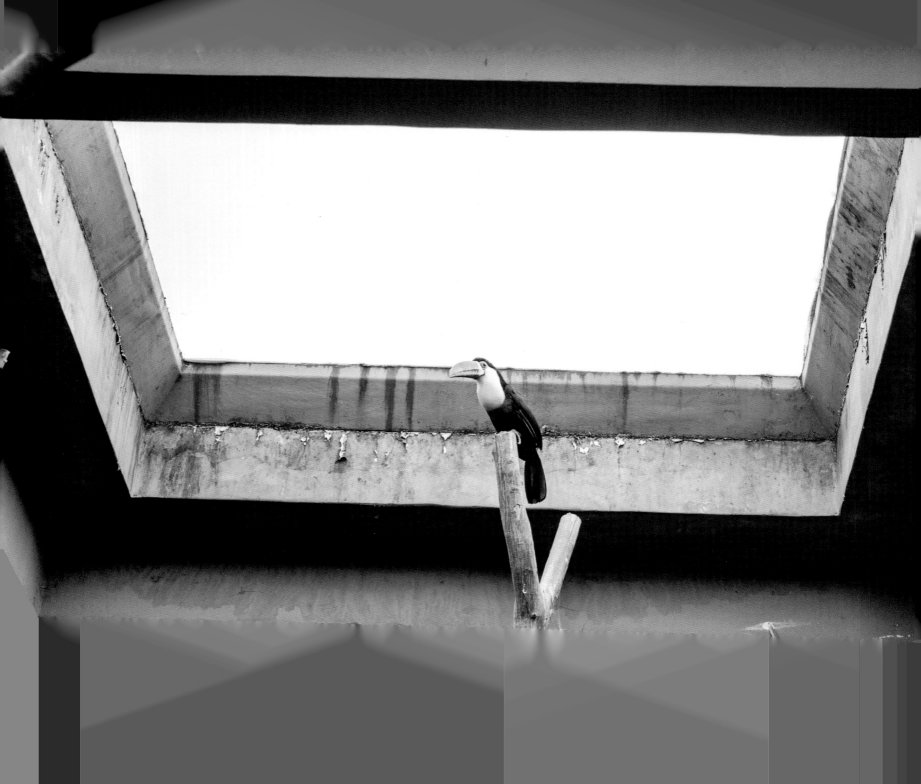

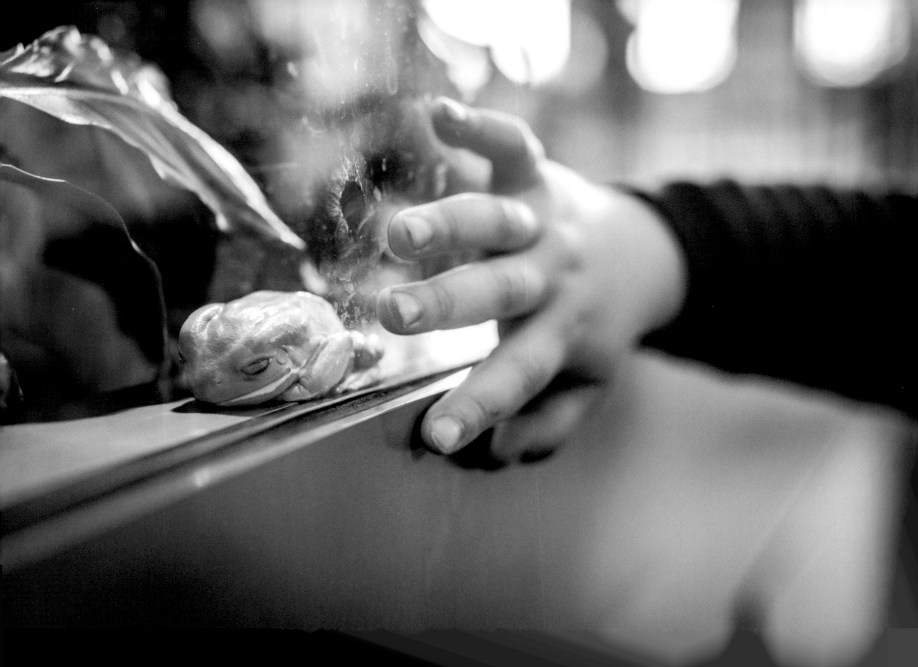

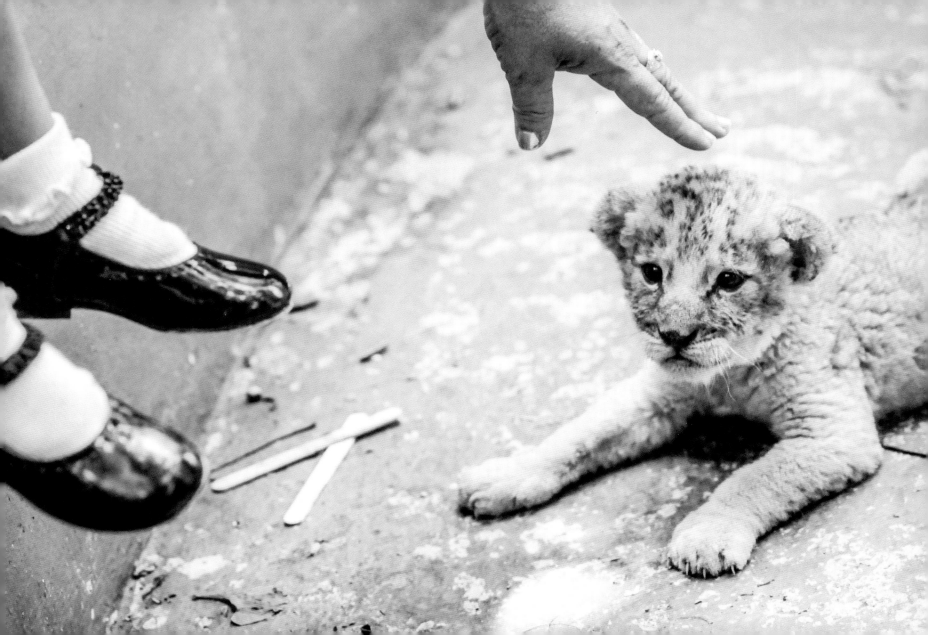

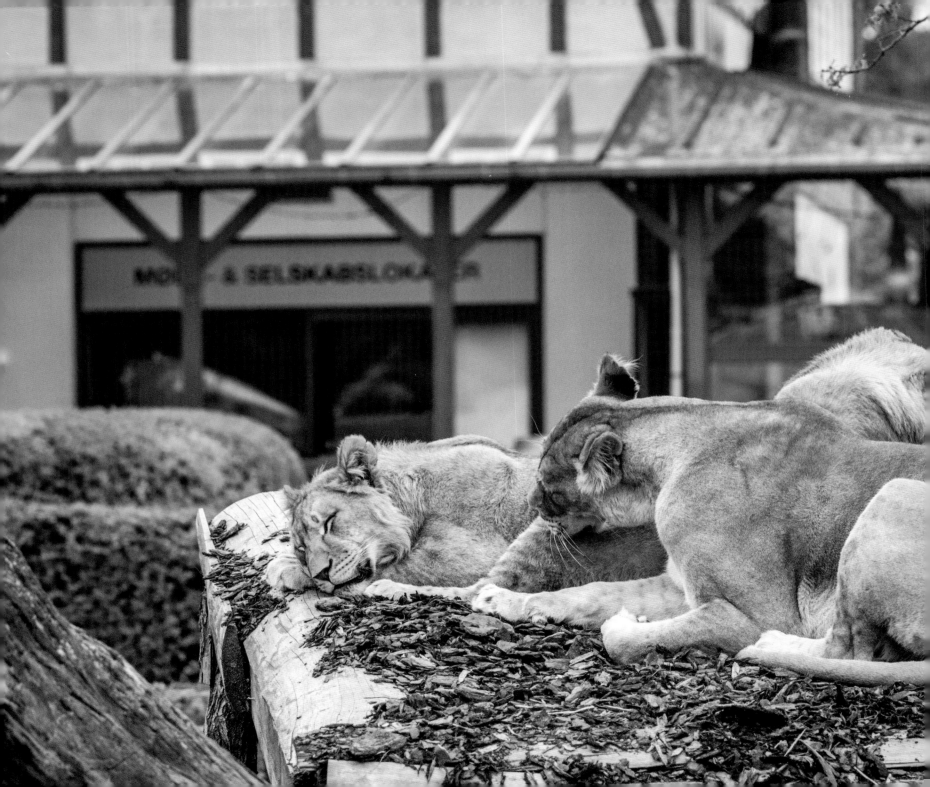

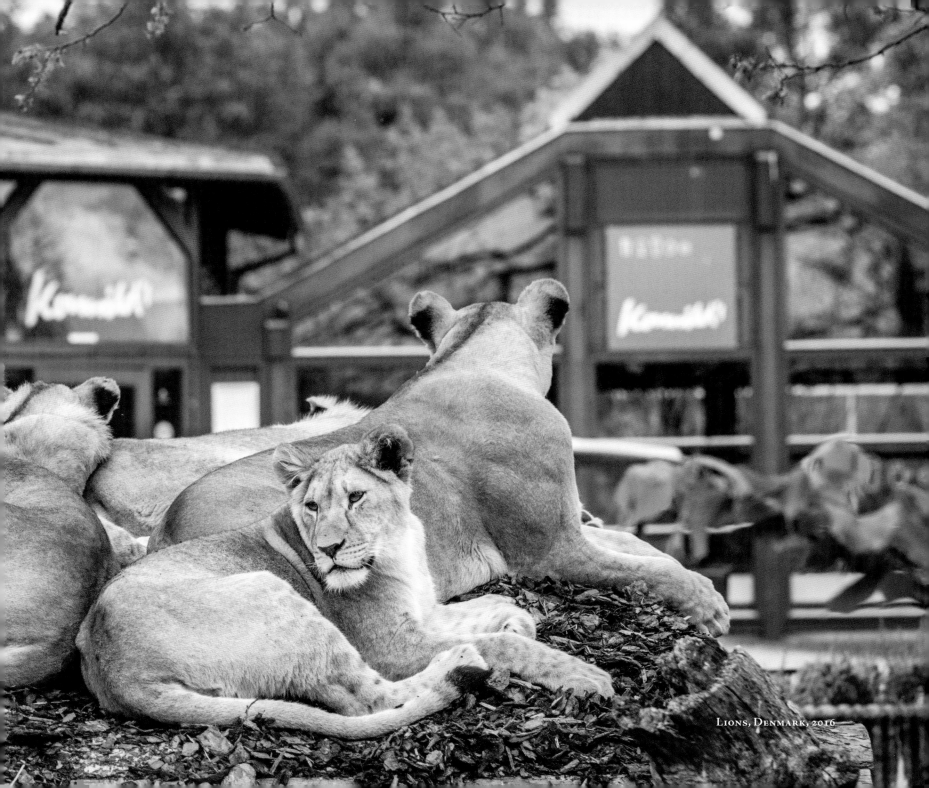

Lions, Denmark, 2016

IN THE FIELD

I.

A new day of training my camera's focus on yet another pacing animal. Photographing a moving animal through thick, scratched acrylic, and fencing as well, is challenging, and I have few options for good vantage points here. I've come all this way. I need to do the best possible work while maintaining the guise of a benign tourist. Zoo staff cast sidelong glances, especially when I'm there alone again for a third consecutive day with my big camera lenses. I close my eyes in a long blink, to catch a moment of repose. I lift the camera again and resume bearing witness, doing my best to document the moments that will help show captivity without the window-dressing. If I don't do my job well, I've done it for nothing. I want people to see captivity through an empathic lens, as well as from the point of view and perspective of the captives.

Seeing intelligent, sentient fauna in sterile and small enclosures is unbearable. Watching them again the next day, and the day after that, is even worse. I've had the luxury of leaving, choosing what I will eat for dinner, socializing with whom I please. I return, only to find the captives again in their godforsaken "exhibits", doing the exact same thing as they did the day before: taking the exact same steps, flaps or swings. I see why the dirt paths under their feet are packed down from wear. I observe the things that become apparent only when you spend more than sixty seconds at an enclosure.

If you stay a minute to watch the gibbon's beautiful display of swinging and climbing on the ropes of his exhibit, the elegance and joy seem spectacular. If you remain five minutes, however, or what can become an endless, heart-wrenching twenty minutes, your heart will sink. The gibbon's routine is no different from that of the elephant at the zoo who wears down a circular path in the dust. They move purposelessly and precisely. Each motion seems like muscle memory; there are no decisions to be made. ��

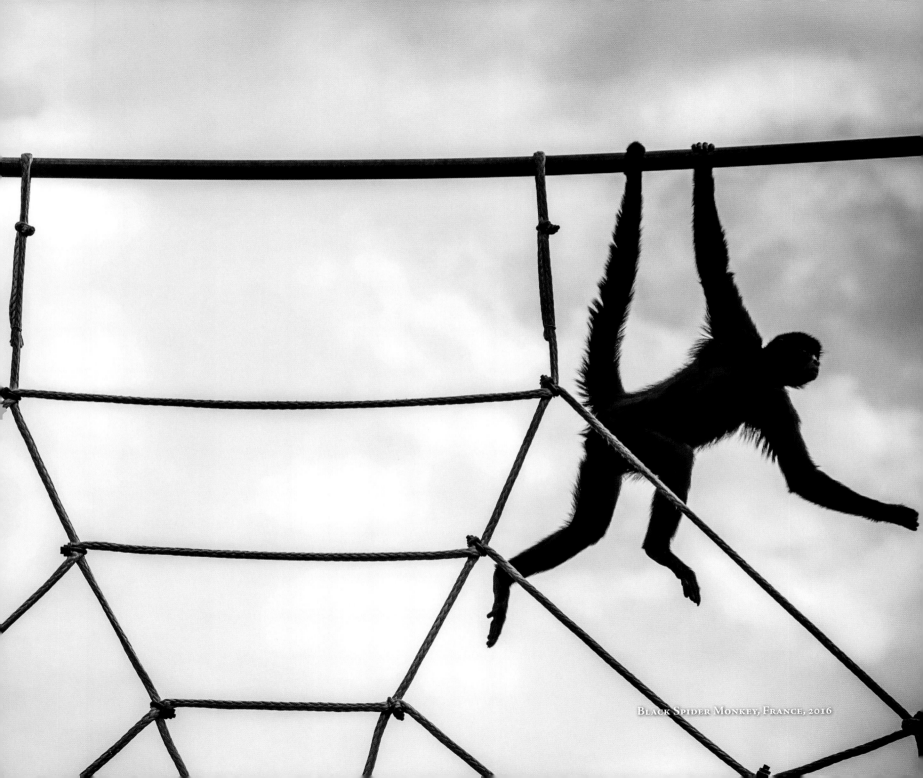

Black Spider Monkey, France, 2016

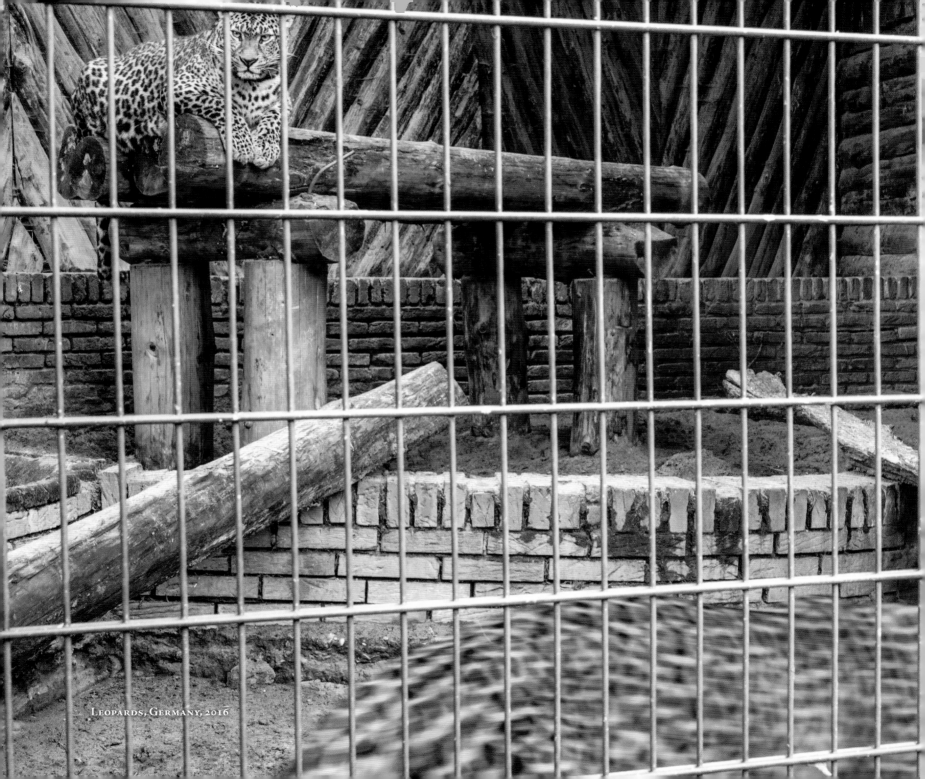

Leopards, Germany, 2016

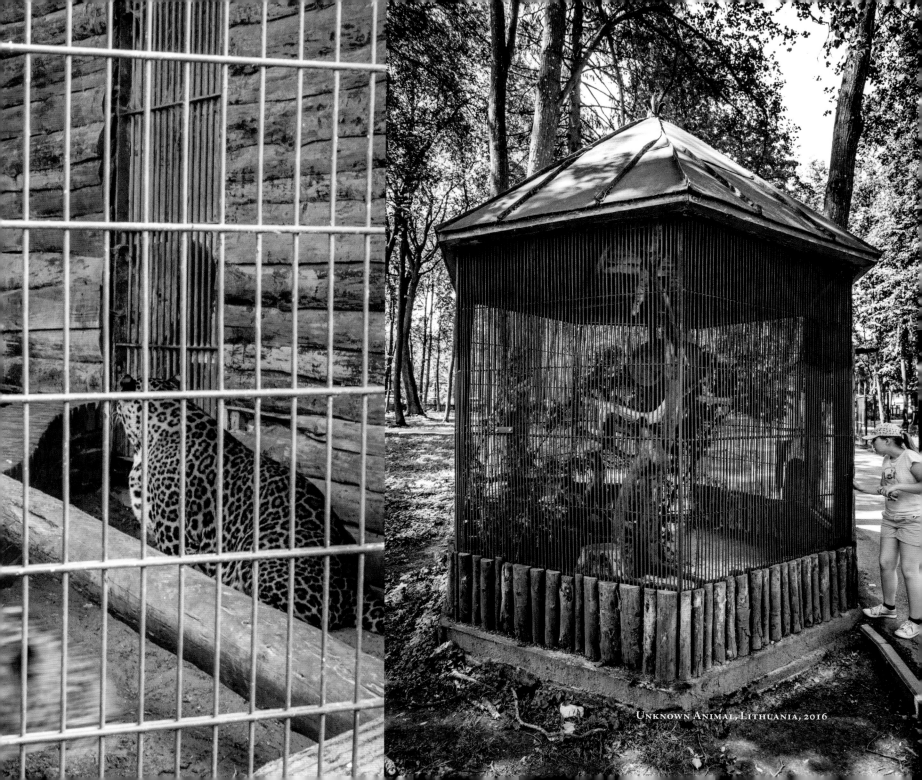

Unknown Animal, Lithuania, 2016

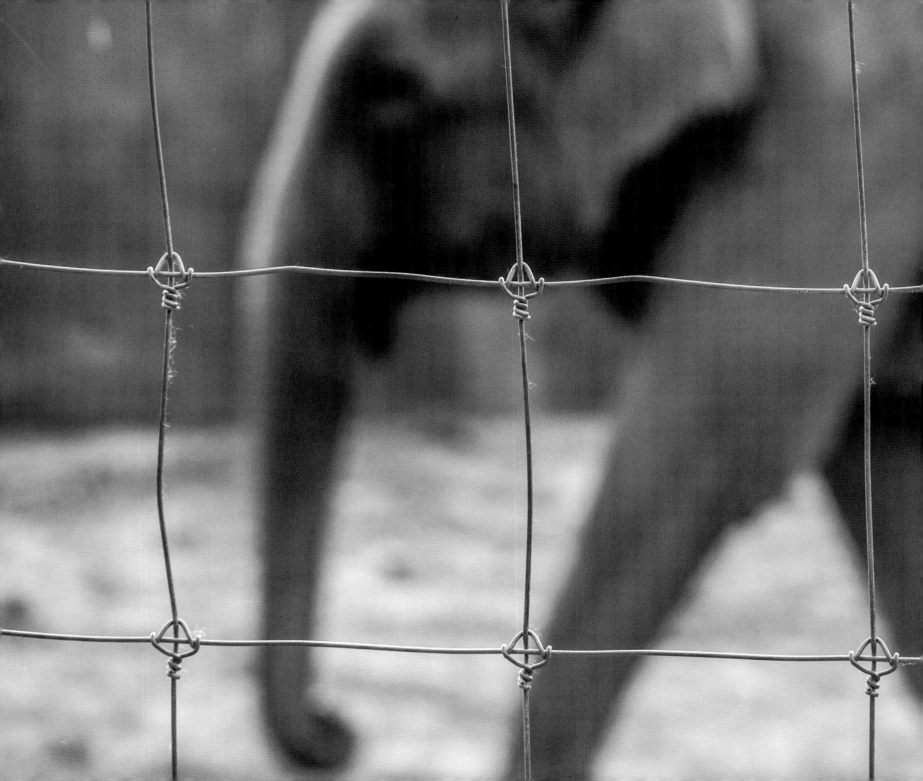

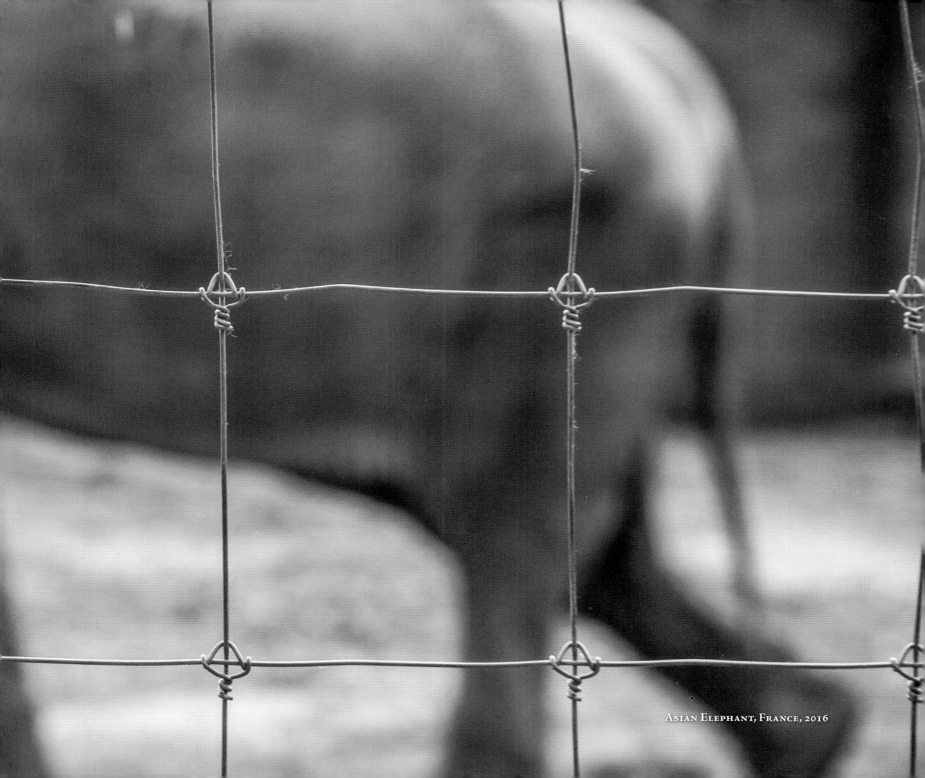

ASIAN ELEPHANT, FRANCE, 2016

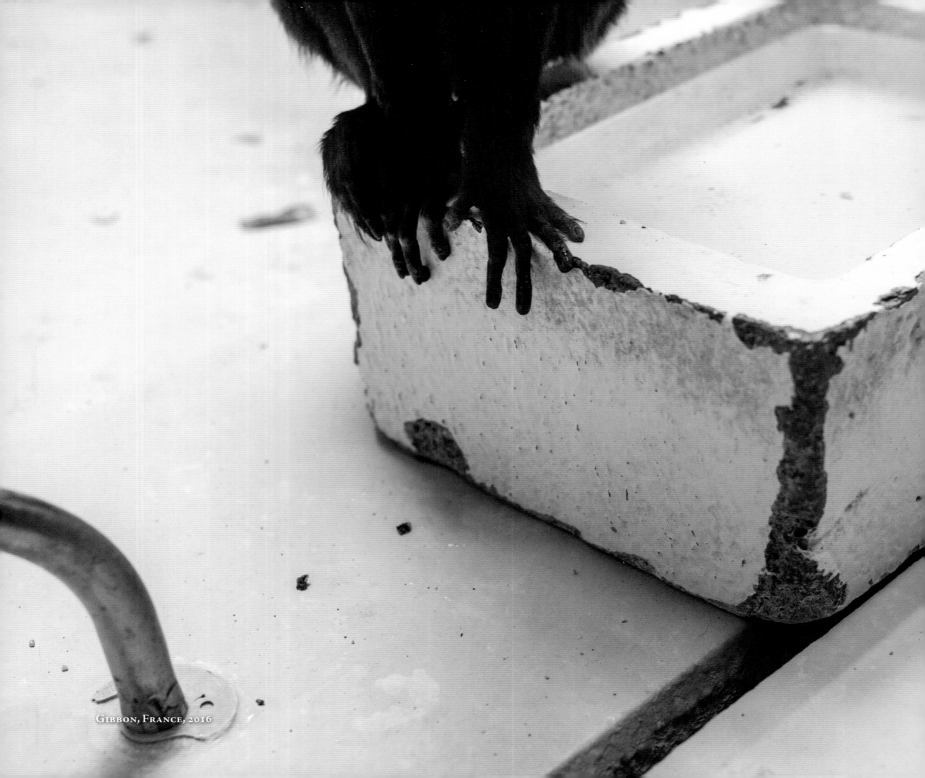

GIBBON, FRANCE, 2016

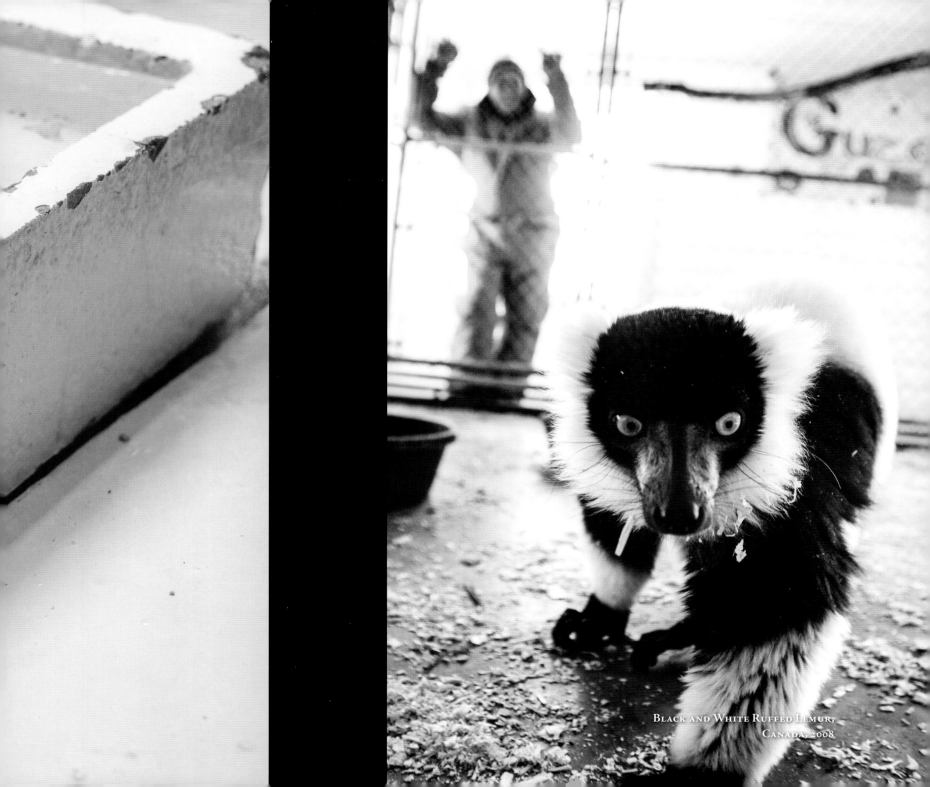

BLACK AND WHITE RUFFED LEMUR,
CANADA, 2008

II.

After years of documenting captive animals, I've seen too many of them living with inadequate or no enrichment. They exist without choice: on cement floors, next to cement walls, and under our rule. Sometimes, the captives are too despondent to move. I wonder again why it's 2017 and I'm still fighting this battle, still among a minority of people appealing for change. The photos I leave with are my contribution to that change. My goal, as always, is a difficult one: to get people to look, and to not turn away. To face this cruelty, after all, is to confront our own complicity in that cruelty. And like the cruelty to animals we see, our involvement in it is a painful thing to bear.

I spend weeks travelling: hostels and hotels, spare rooms, planes, trains, buses, and car rentals. I wait for long hours in the unpleasant heat of the afternoon sun, when the animals are hiding in shady corners anyway, making them hard to photograph. Then come the days of rain showers, as I try to keep my equipment dry. I feel depressed, standing alone day after day before these lonely animals. Like them, I feel solitary amidst the hordes of people apathetically walking by—sometimes just taking a selfie, other times throwing a baguette, or a coin, or a rock.

One can't help but overhear the commentary of passersby, and watch their interactions, or lack thereof, with the animals on display. Recently, our obsession with social media has further degraded any meaningful interactions we might ever have had with the animals; as a result, this book is filled with images of we animals being engaged only with one another or ourselves. For many parents, a trip to the zoo is the default outing for their young children, where the goal is largely to get the kids out of the house. At the zoo, the adults capitulate to the children's demands for junk food at the concession stands, manage a tearful outbreak or two, and exit through the gift shop with a new plush toy—a giraffe, or a whale—to take home.

We say that zoo visits are educational experiences. That's true, if what we mean by *education* is that the ideology that animals are here for our use and entertainment becomes further ingrained. True also, if what we mean by *education* is the reinforcement that objectification of the "other" is not indecent.

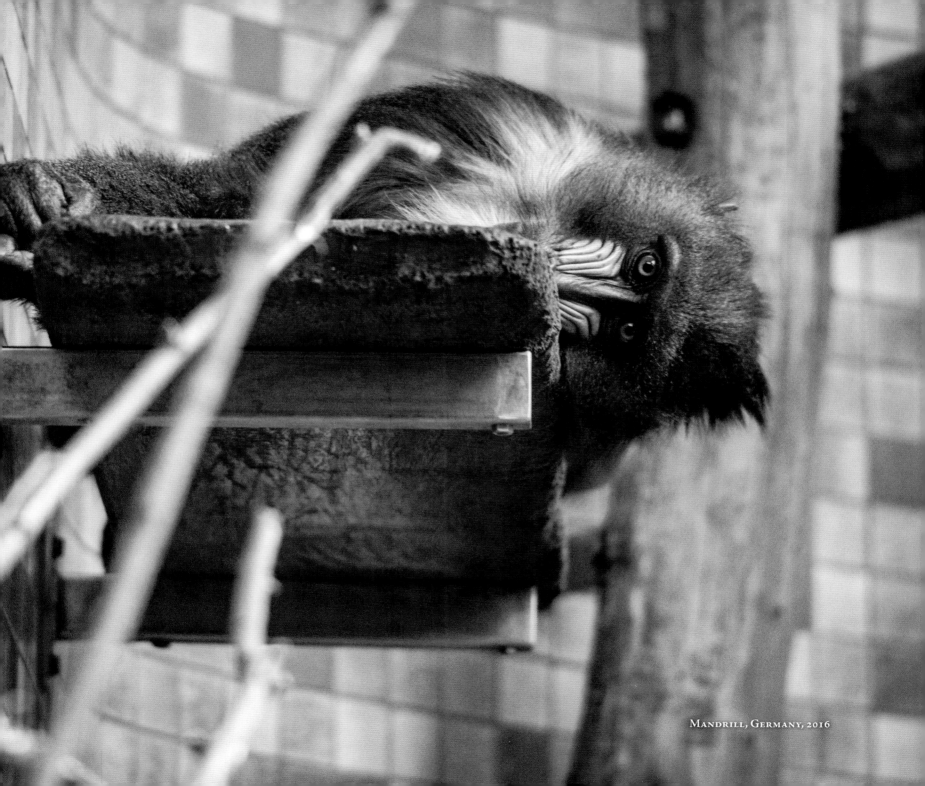

MANDRILL, GERMANY, 2016

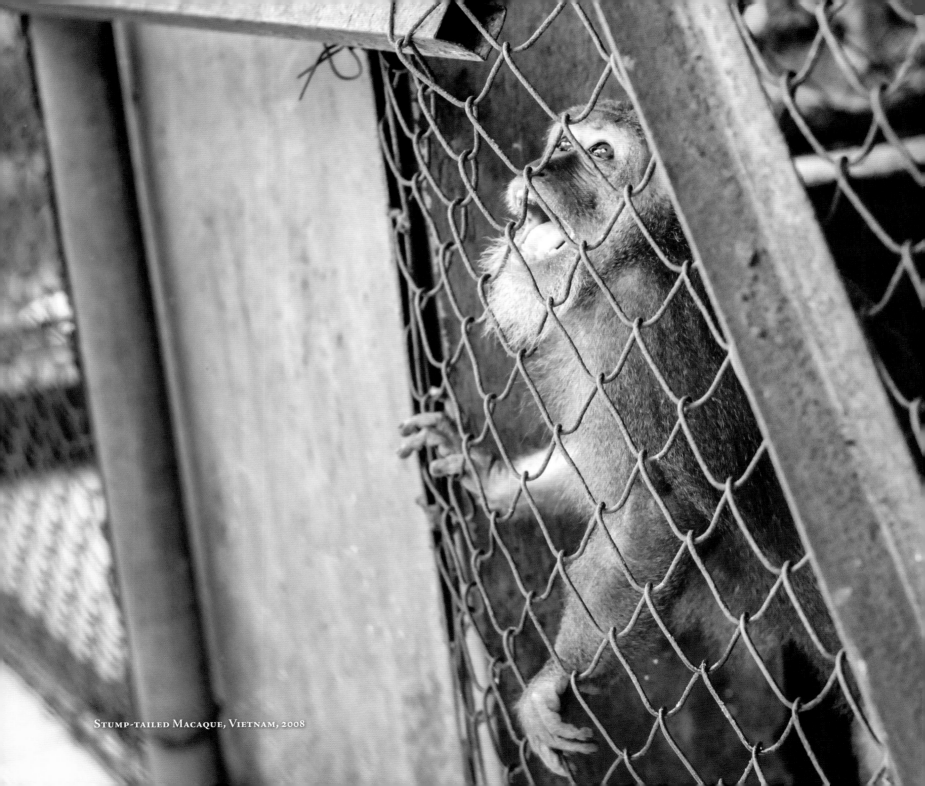

Stump-tailed Macaque, Vietnam, 2008

Nevertheless, we also gaze upon the displayed animals with wonder. We admire their soft, striped coats and marvel at their long snouts and wide toes. We look for a few seconds, perhaps a few minutes. Do we continue on our way, however, feeling enriched and educated, or simply entertained and blissfully unaware of our freedom? Does the sight of these once-wild creatures fill us with the desire to protect them and speak on their behalf?

Only a minority, perhaps those who take the time to read the informative signs, or who see through empathic eyes, leave feeling as though they must do something to help the wild kin of those they've seen. I hear parents whisper sad comments under their breath or out loud. However, to express any sort of critical thoughts would be to ruin a nice day. *We'll speak of it when they're older. If they ask.* We look at the pacing, the boredom, the empty eyes, but we must not speak of it. Wilful ignorance is bliss; addressing hard questions is to open up many others, and there's no time for that. *They are, after all, just animals.*

Both the zoo and the visitors collaborate to ensure that sorrow is hidden in plain sight. Zoos draw our eyes away from the idea that captivity might be wrong, and we agree not to look. If everything is displayed in front of us, it must be ok, right? The rules of society apply at the zoo as well. *We eat what we are fed. We accept what we are shown. We do what we are told.*

Two young women, high on drugs, laugh hysterically as they throw entire loaves of bread to the zebras. Exasperated parents push at strollers, wasting time, passing time. A child has a meltdown over a Popsicle dropped in the dirt. For a place that's meant to bring pleasure, I'm not seeing a lot of that here today from either the visitors or the inmates. ❧

BLACK AND WHITE RUFFED LEMUR, CANADA, 2008

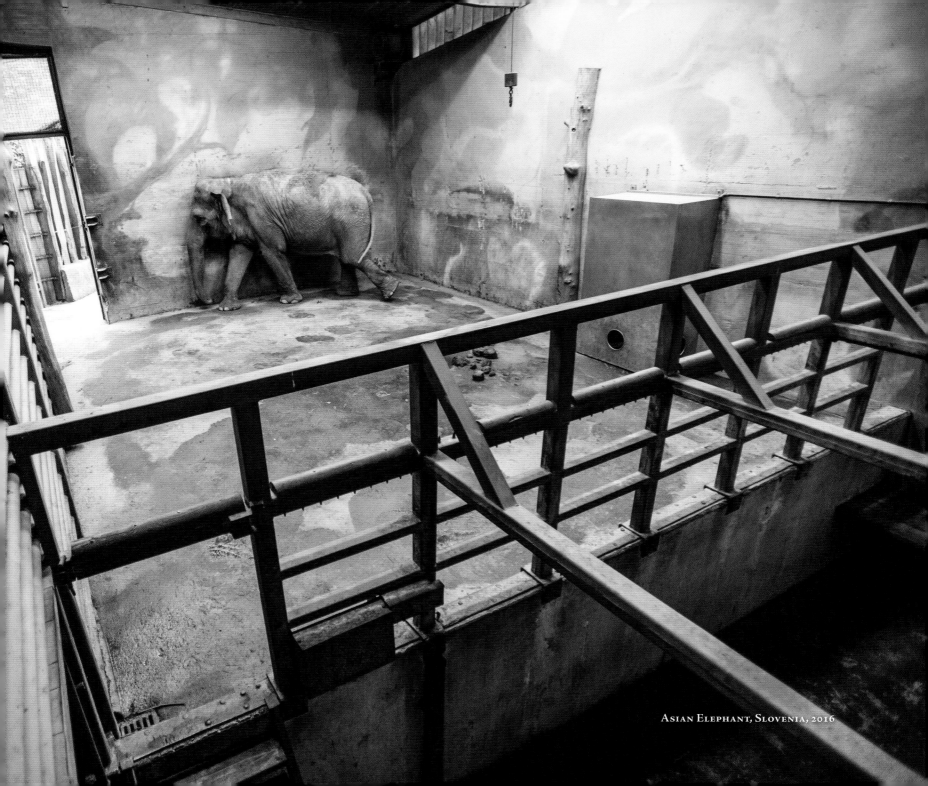

Asian Elephant, Slovenia, 2016

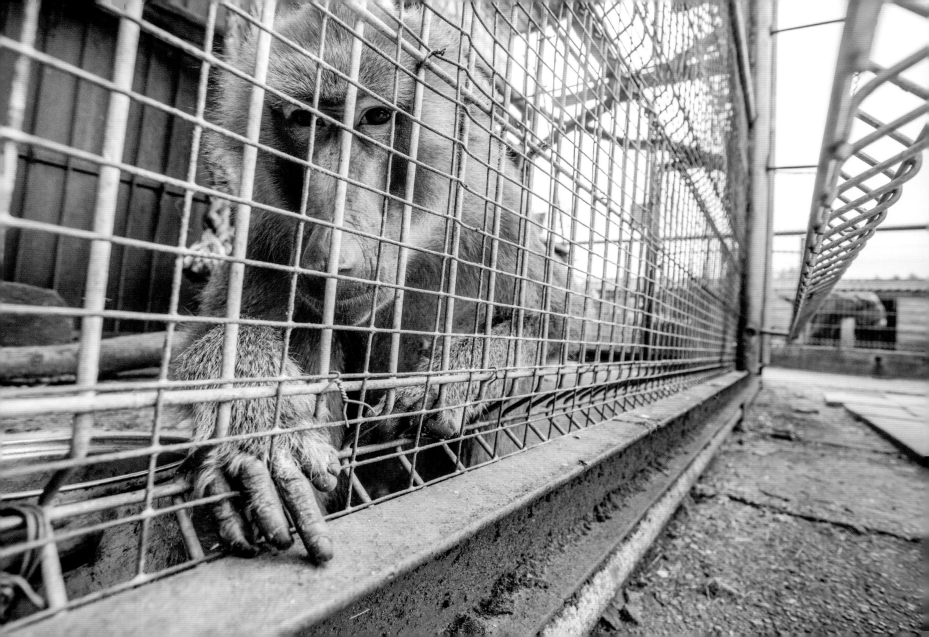

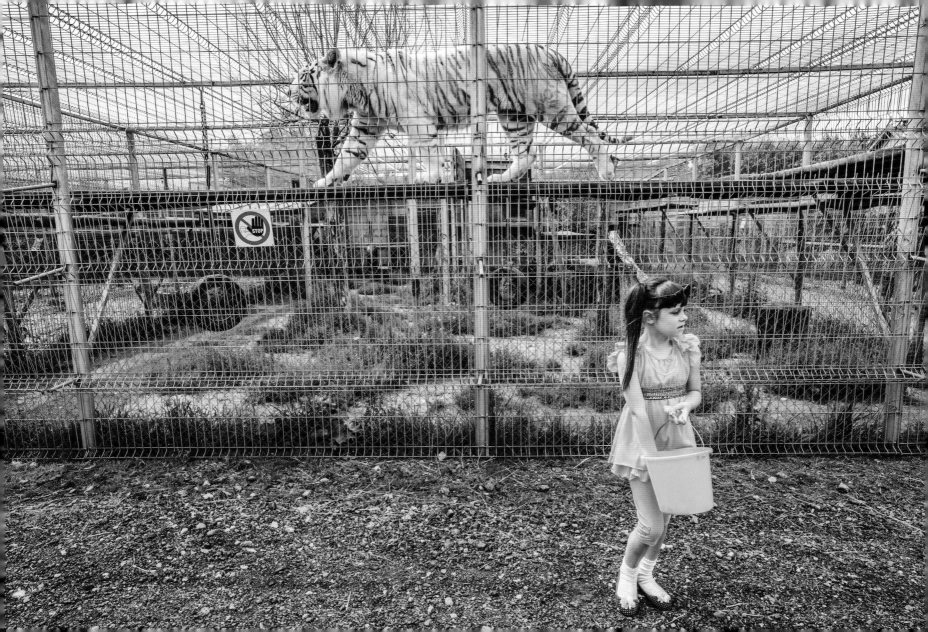

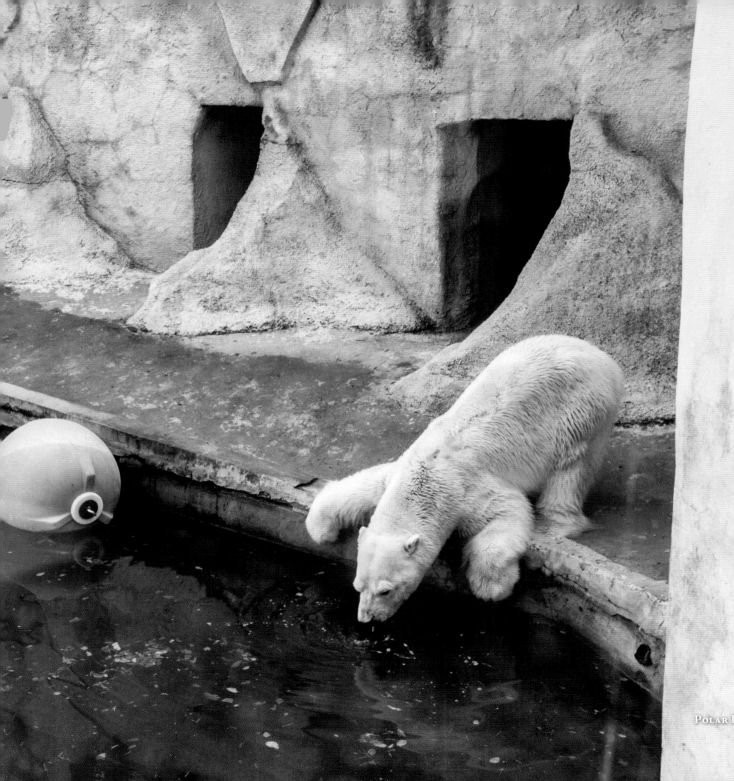

Polar Bear, Latvia, 2016

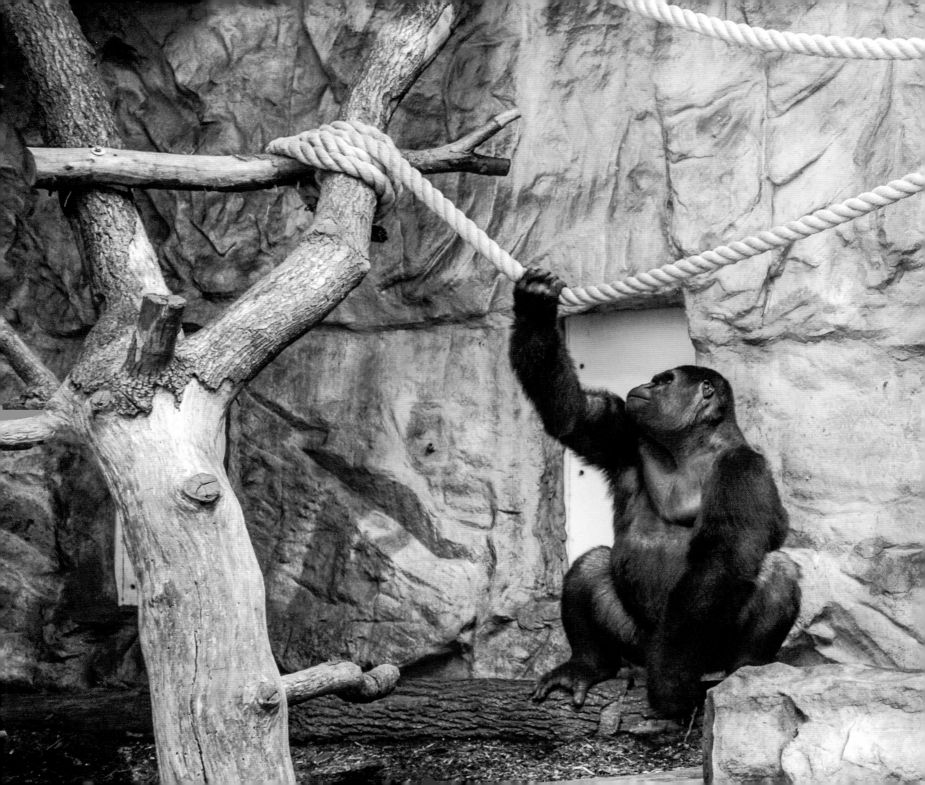

WESTERN LOWLAND GORILLA, POLAND, 2012

ORANGUTANS, THAILAND, 2008

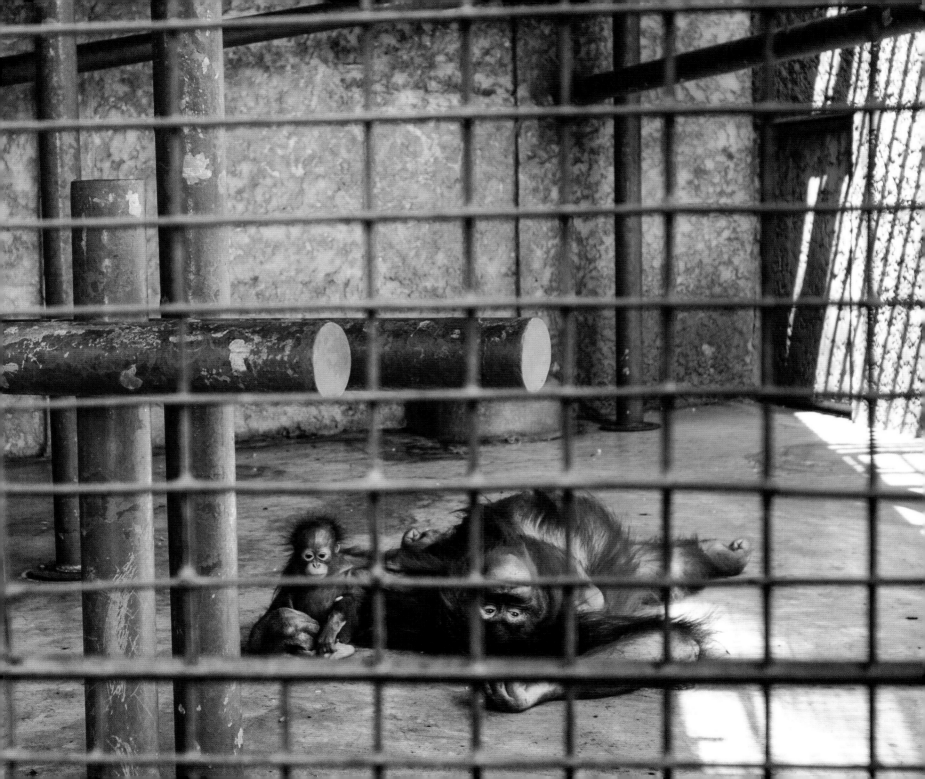

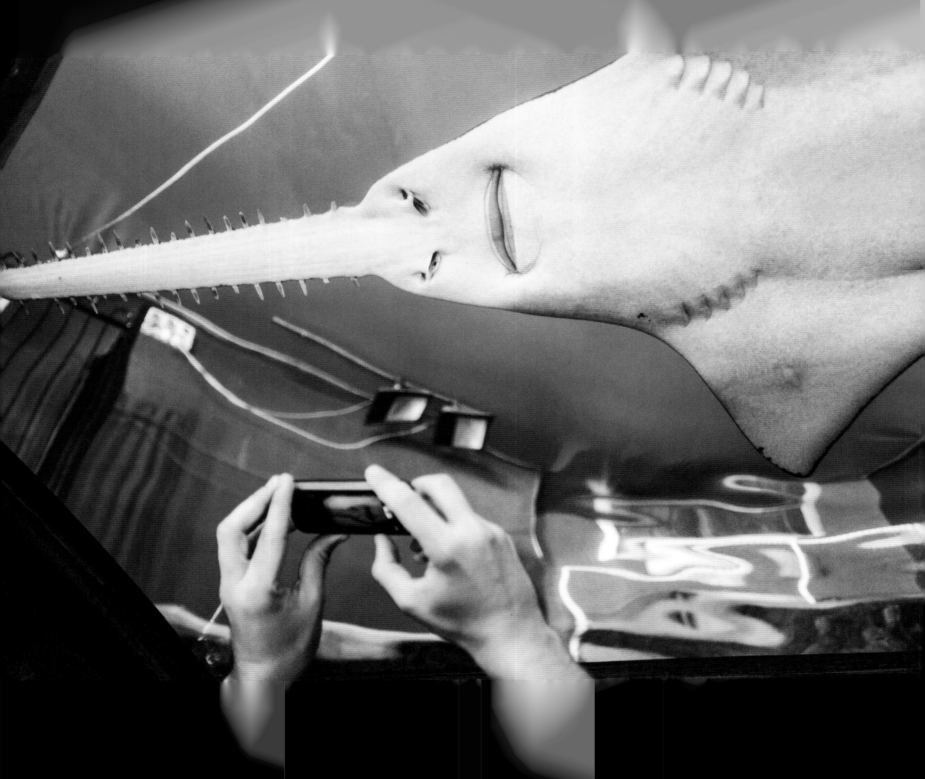

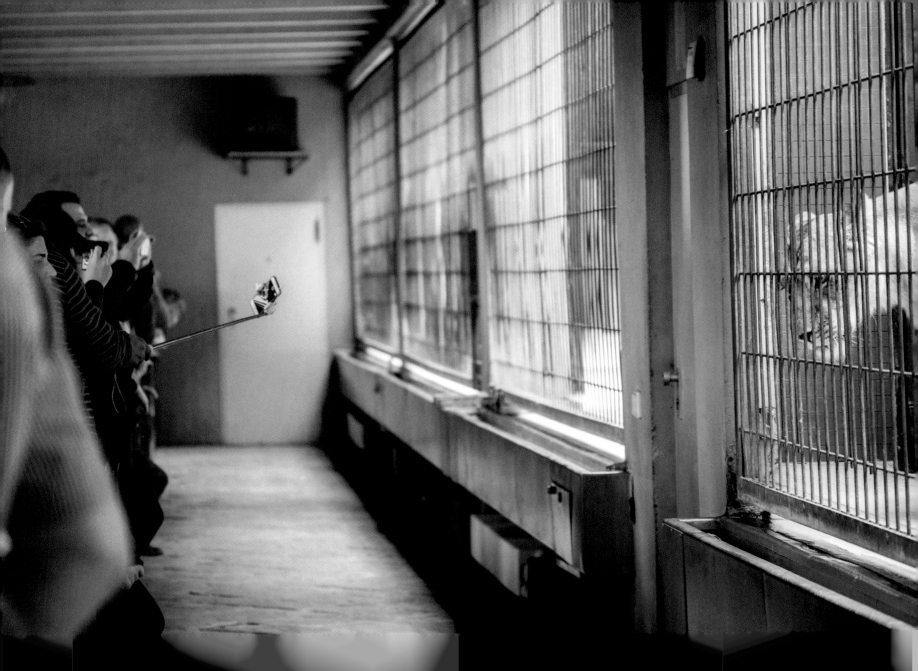

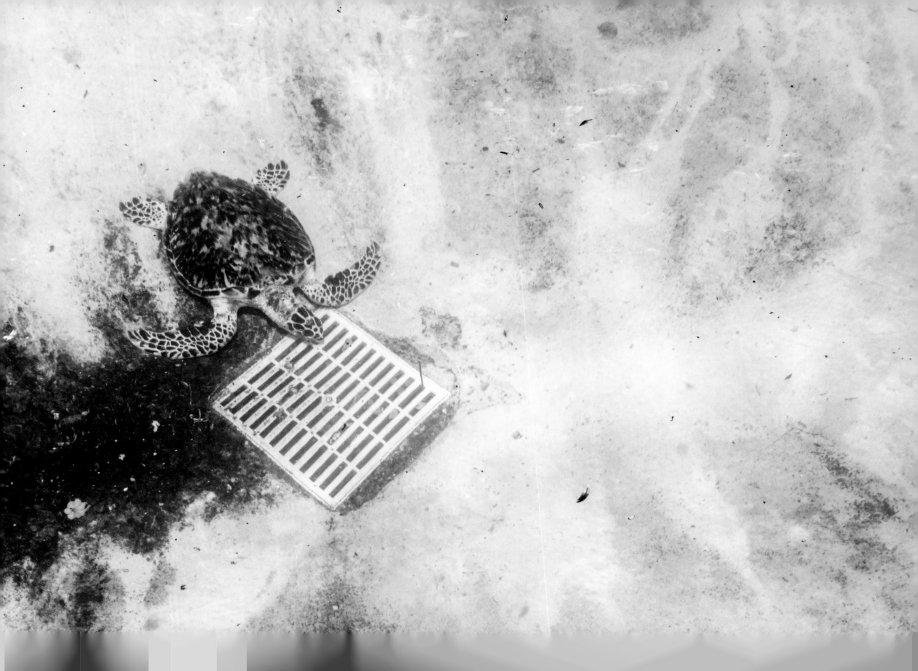

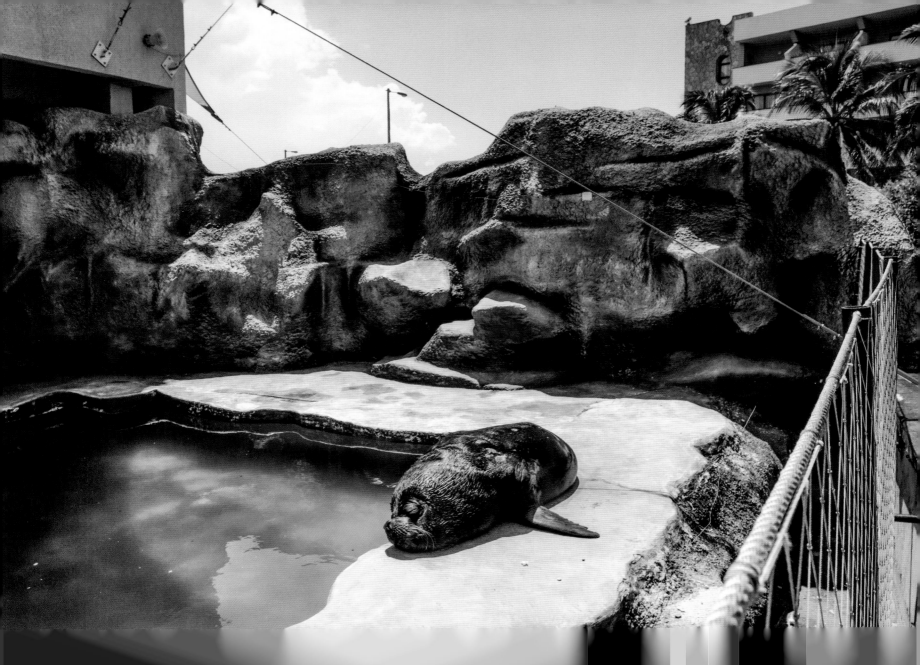

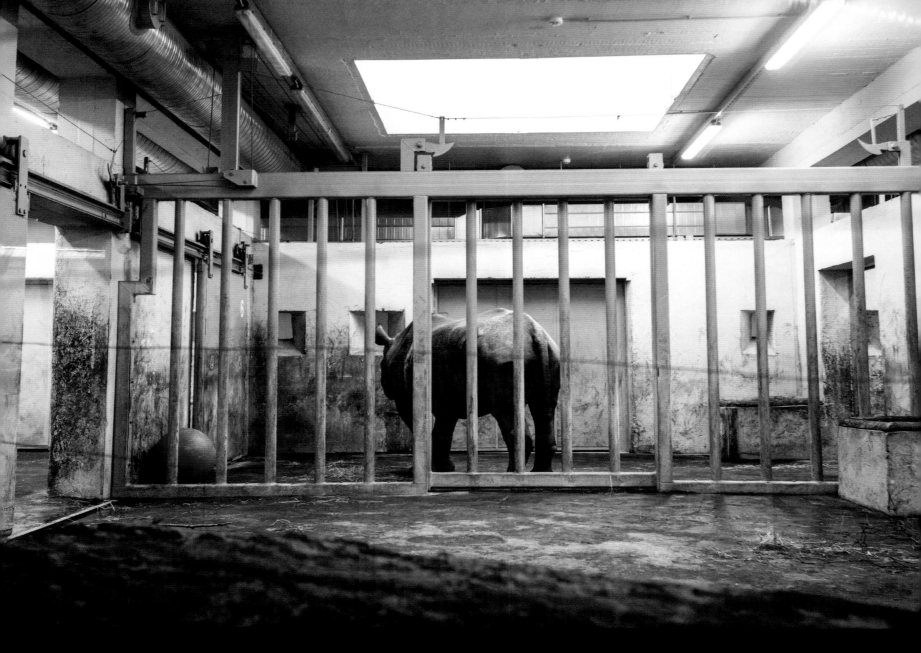

EASTERN BLACK RHINOCEROS, ESTONIA, 2015

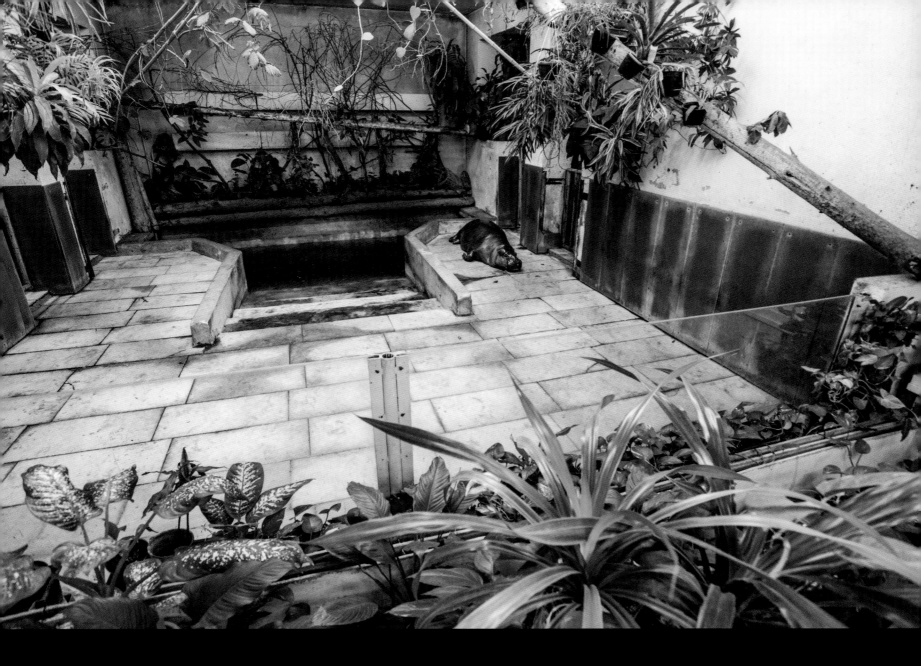

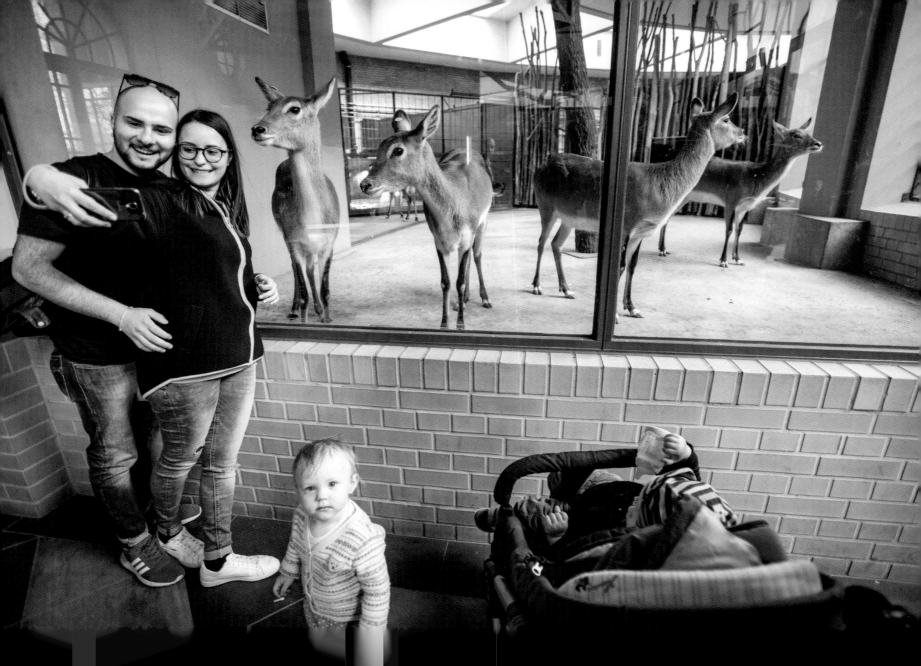

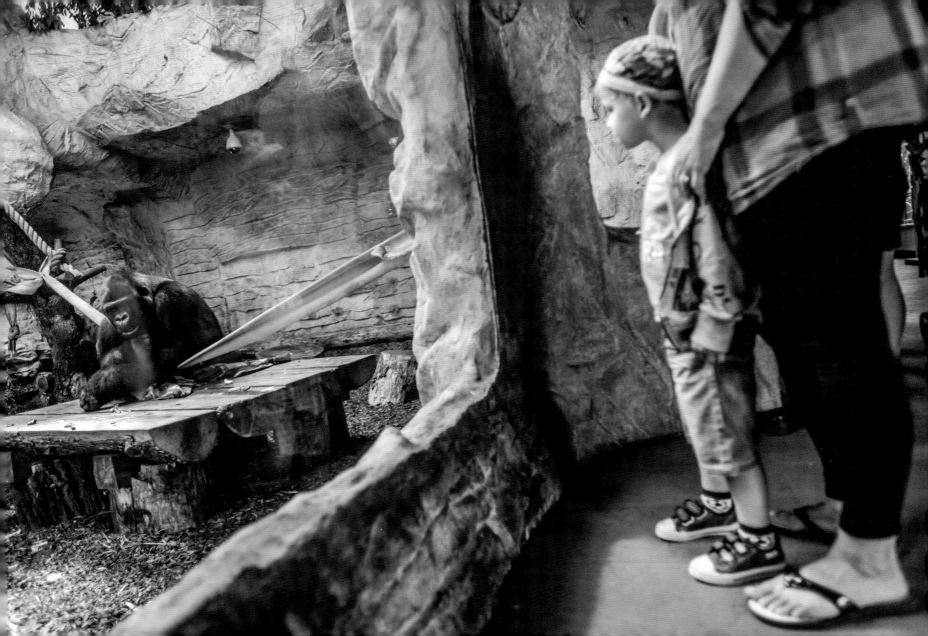

III.

Gina, a lone, fifty-year-old elephant in a barren enclosure with no shade, walks in circles. A young mother takes a photograph and points, laughing, "I think it's a baby!" Gina is not the only elephant at the zoo. She's separated from the male by a high cement wall. They can hear one another; they know the other is there. The male paces back and forth on the other side, trunk raised high along the edges, trying to smell, or feel.

A nearby sign reads that the two were separated because the male became too dangerous to Gina while he was in musth, and so they've been isolated for fifteen years. The zoo one day hopes to move the male, and they hope to find a new friend for Gina. I wonder where they will get this "friend"; from which zoo an elephant will be removed from their own small herd, or whether there's another elephant nearby who's alone, and whether that elephant and Gina will get along. I *don't* wonder why the zoo just doesn't move Gina to a more appropriate location, a sanctuary perhaps. Elephants are a big draw for zoo-goers. To make a decision in favour of Gina's welfare could be a significant economic compromise, a risk that most zoos are not willing to take.

I watch Gina as she circles the tiny enclosure or, on occasion, strains her trunk over the grey wall to reach the crumbs of animal chow that people have thrown her way. Her enclosure is surrounded by lush grass, plants and trees, but the exhibit itself is bare. I know that many zoo professionals have great affection for the animals and hate to see them transferred elsewhere. Despite expertise and the best intentions, however, this is not love; this is a bottom-line, making all involved complicit in the business. Every passing day that Gina is kept at the zoo is a decision against her welfare and *for* her loneliness. Days become months and years. I hope the photographs I take with me will reveal some aspects of the deprived existences of individuals like Gina, and influence the court of public opinion.

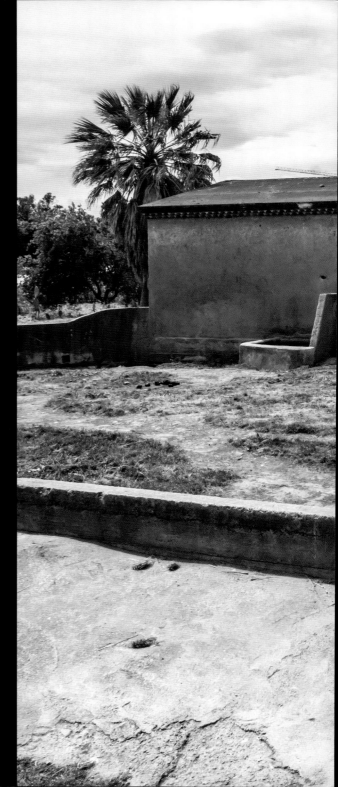

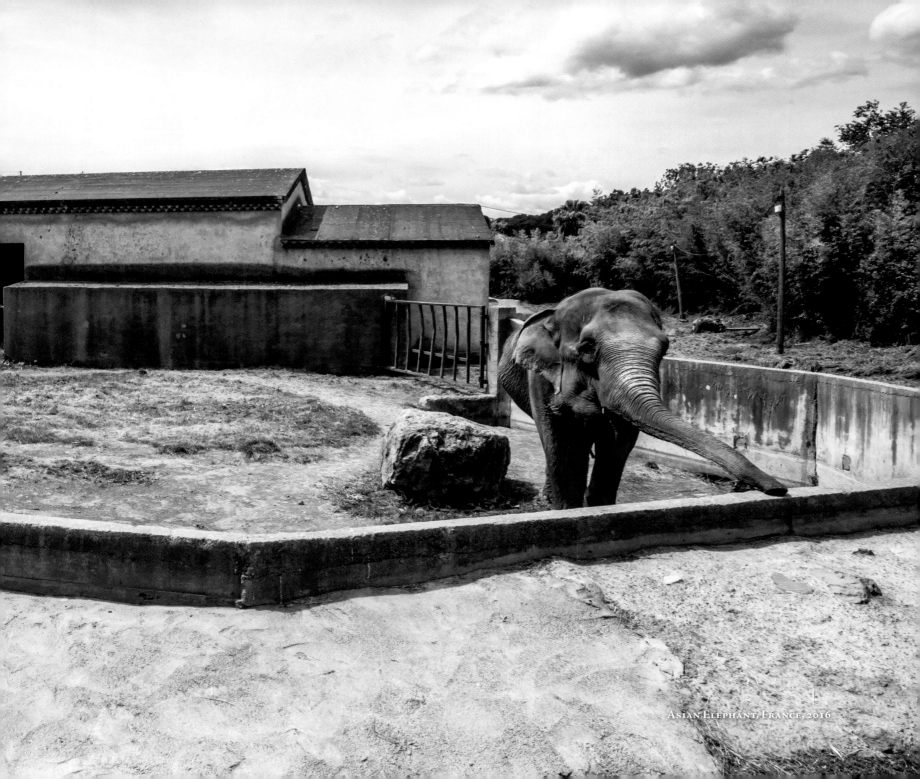

Asian Elephant, France, 2016

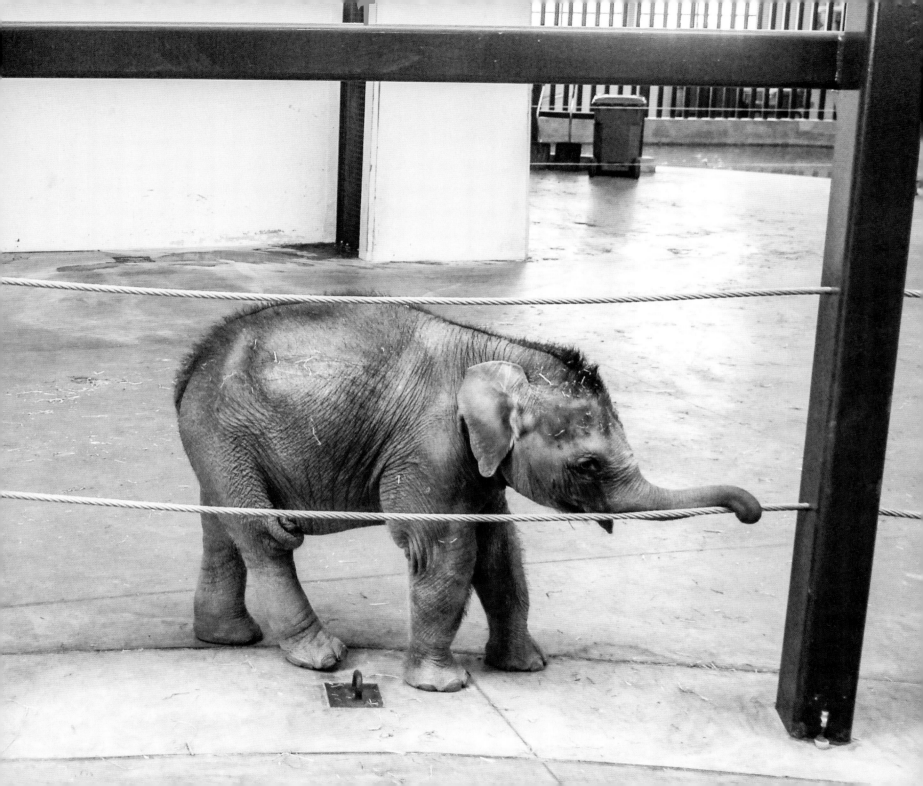

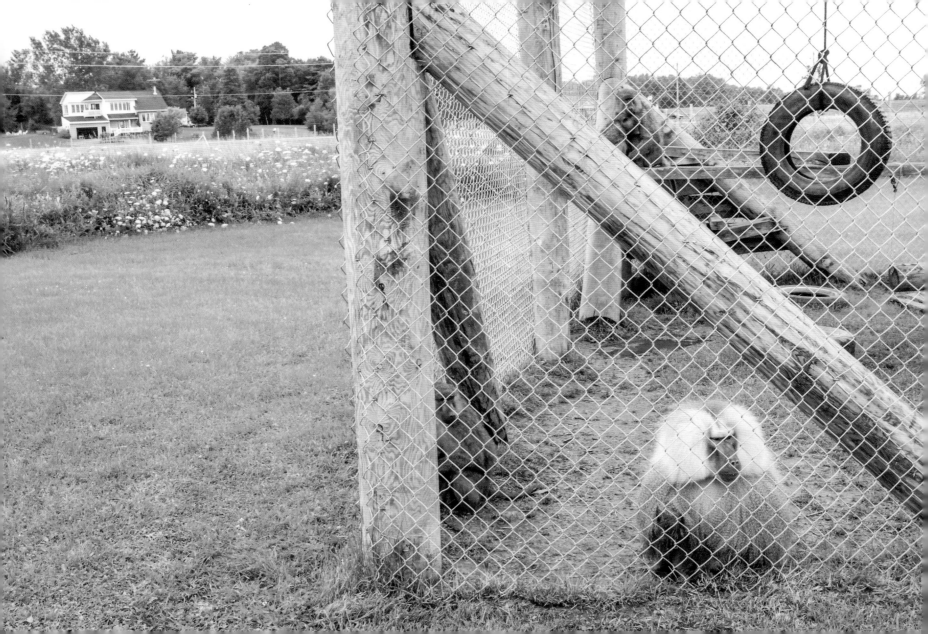

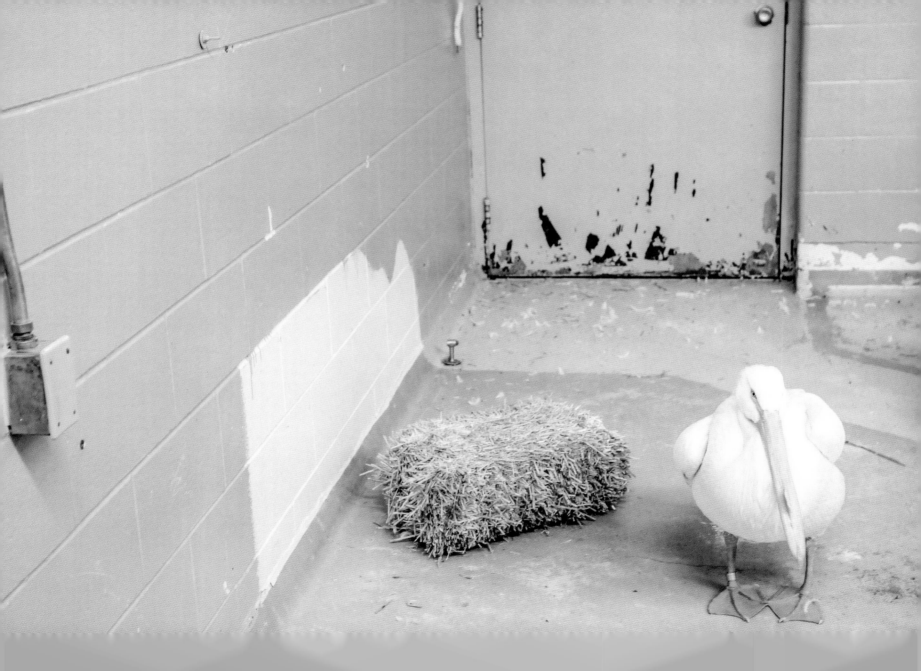

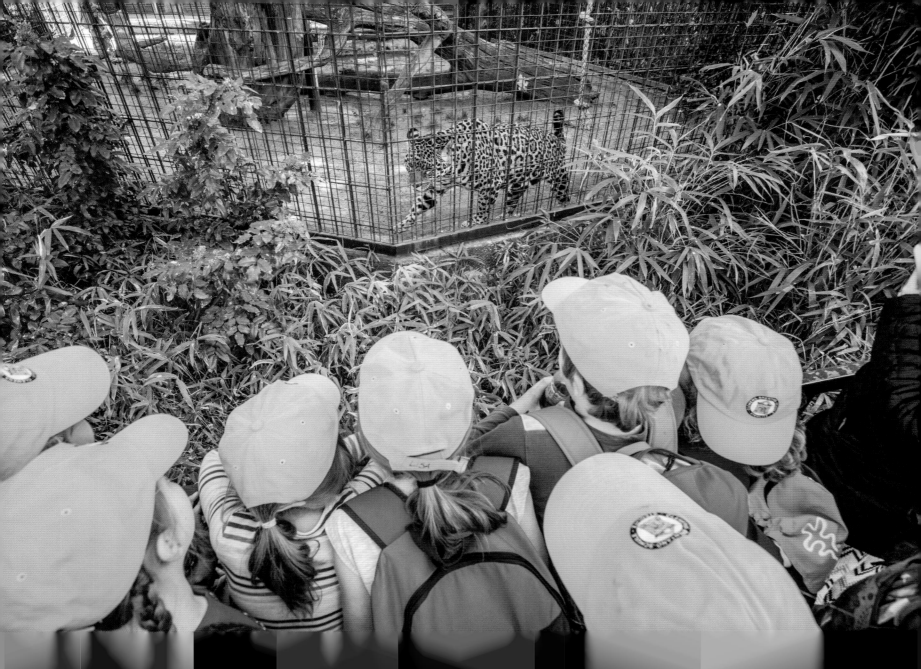

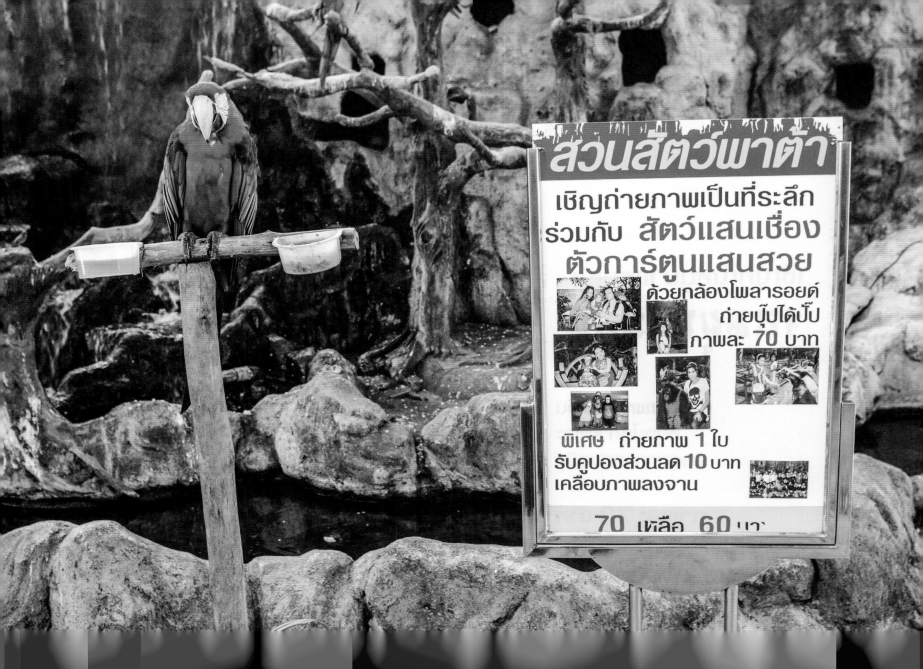

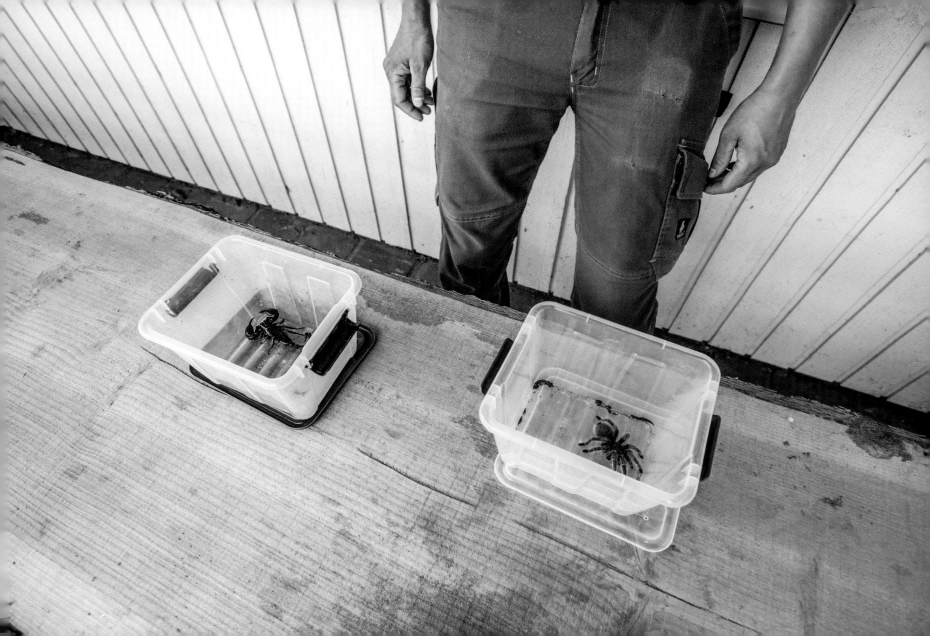

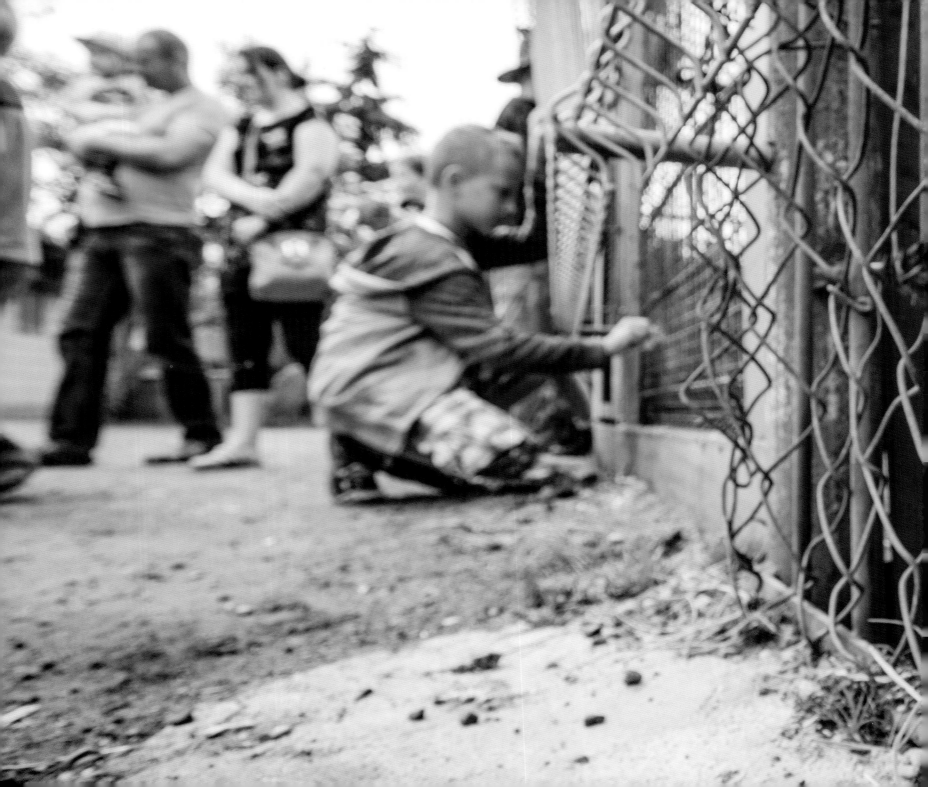

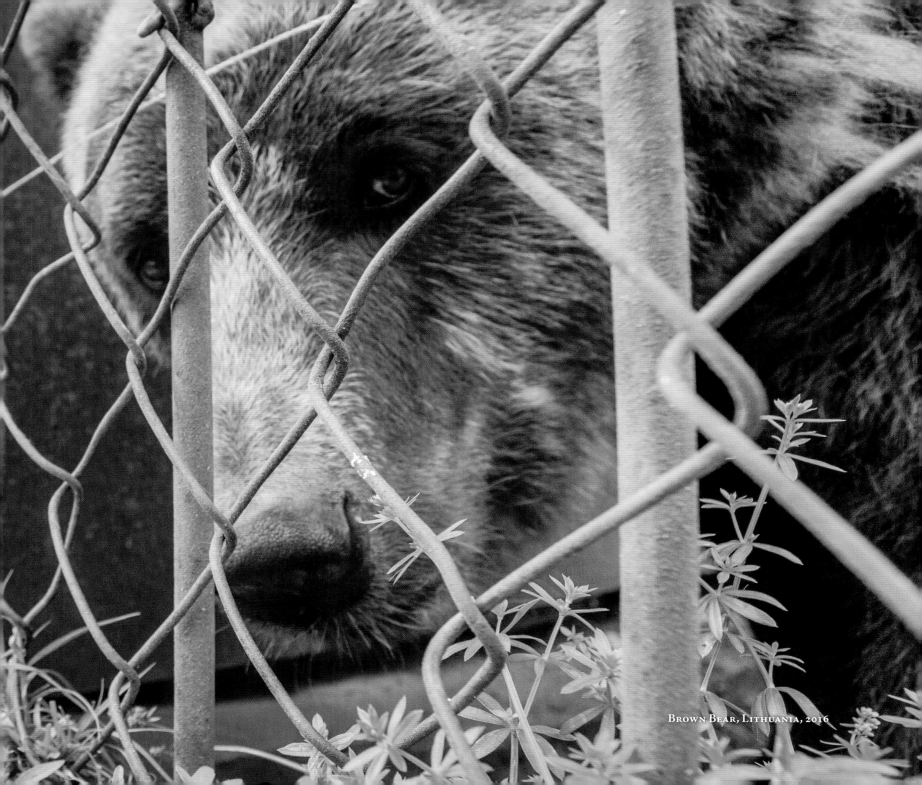

BROWN BEAR, LITHUANIA, 2016

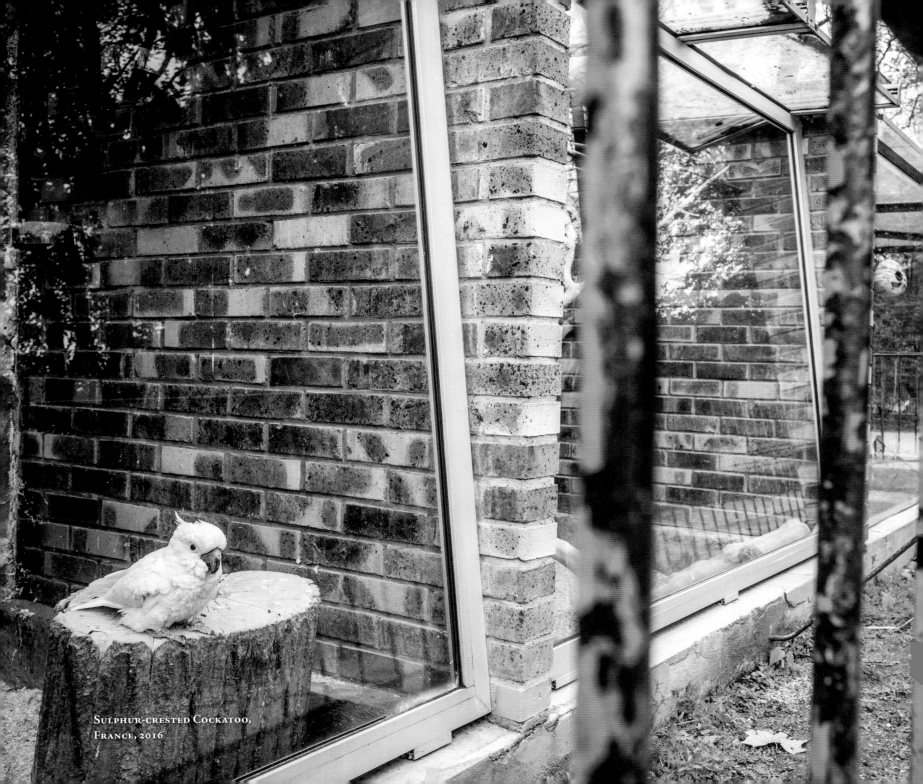

Sulphur-crested Cockatoo,
France, 2016

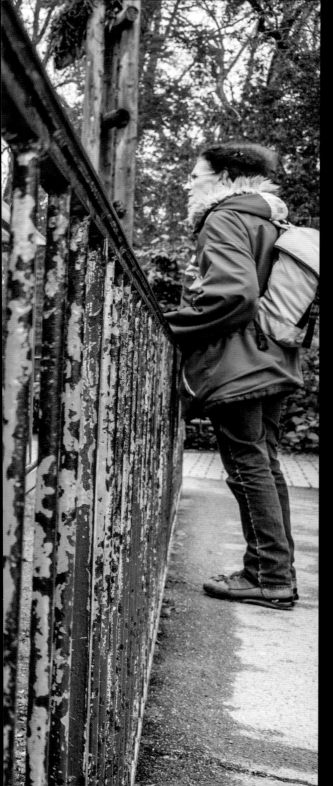

IV.

Exotic birds are held captive in small cages and, ironically, outdoors; their only crime for a life of incarceration is that they are interesting and beautiful to us. Wild sparrows fly in and out of these cages to gorge on seeds that have fallen to the cage floor, or to partake of the uneaten plate of fly-covered fruit. Our human sensory experiences are incredibly limited compared to that of most other animals. Their sense of smell and vision are far more acute. We witness their captivity but fail to imagine what it must be like for them to smell the inaccessible natural world all around them, to be unable to take flight or to follow the subtle currents of wind or water.

Coins are tossed onto the backs of alligators and turtles who lie immobile in small pools of water. Animals watch us watching them, because the stream of humans is the only thing that changes. The nose of a brown bear juts through a hole in a chain-link fence. I take photos close up with a wide angle; he snaps his jaws and misses me by mere inches. A child could easily fit an arm through the hole, and children are doing so with the baboon in the neighbouring cage. I shudder.

The baboon is a long-time resident named Mykoliukas. Visitors know him by name because he's so benign and kind. His hands grip the bars as he tries to make eye contact with people so he can groom whatever parts of them he can reach. I engage. Throughout the day, I return to Mykoliukas' cage so he has someone to connect with, someone to groom, something to do. In a way, though, this is a mistake for us both. I become deeply sad for this lonely soul who so desperately desires the company of others, and who is so demonstrative in his wish for me to come back to visit him. Inevitably, I leave. Watching him climb to the top of his small cage and strain his neck in order to keep me in sight is something I can neither unsee nor forget.

I hear the rhetorical, pro-captivity arguments in my head while I photograph these animals. *How will my child get to see the beauty of these animals if zoos don't exist?*

I ask in return, *What right do we have to see displaced animals? What good comes of it? Nothing is learned.*

What about the good conservation work that happens at zoos? is the inevitable follow-up.

My response: *What of it?* I would like these new-found conservation experts to tell me about the hugely successful breeding and reintroduction programs that are happening every day, worldwide. They can't. Examples of success are few and far between.

I face these captive animals, and speak to my imaginary audience about the amazing wildlife film-making we can see instead—the BBC productions, the 3D and 4D theatres—or the incredible variety of nature channels available, where animals were filmed largely unencumbered by us and roaming free. We have options and alternatives. These captives don't. ❧

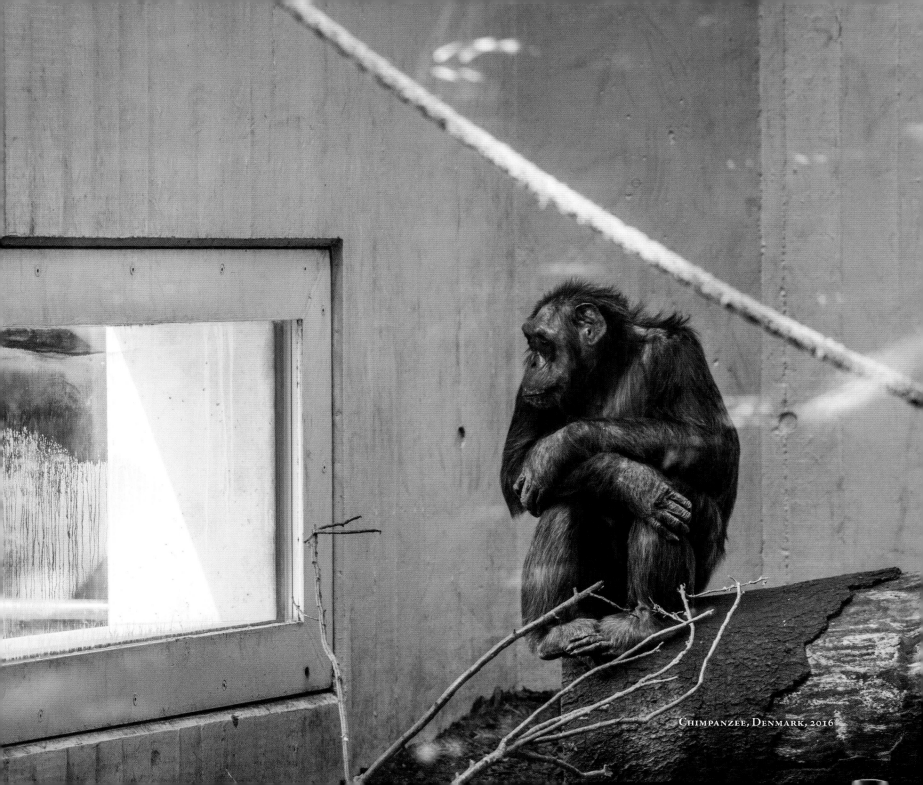

Chimpanzee, Denmark, 2016

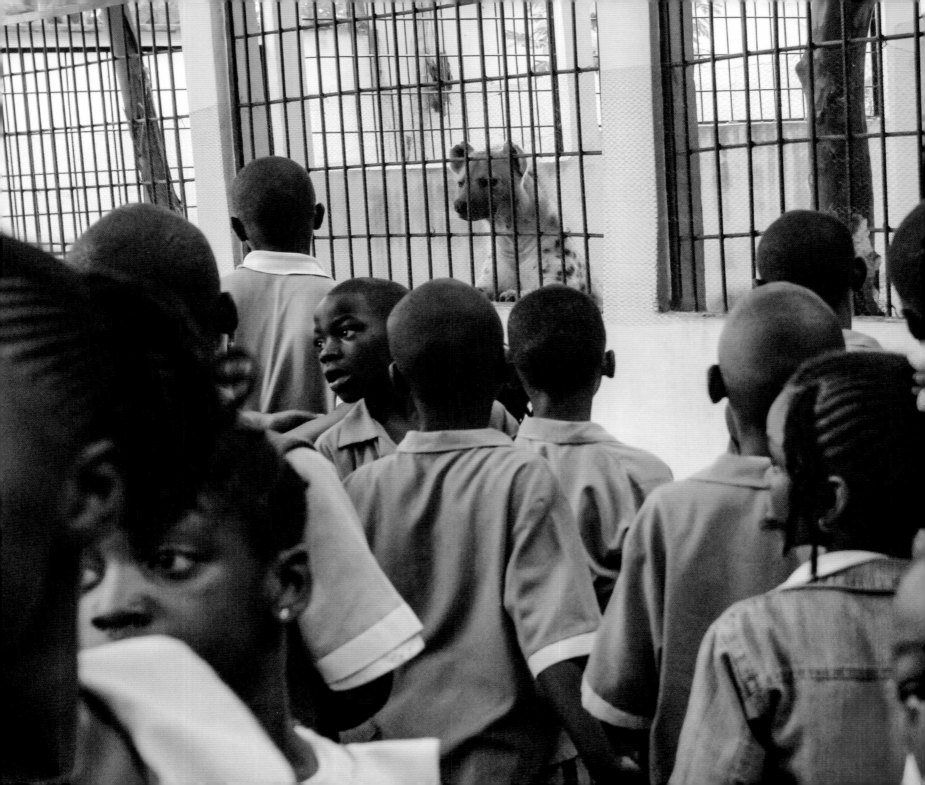

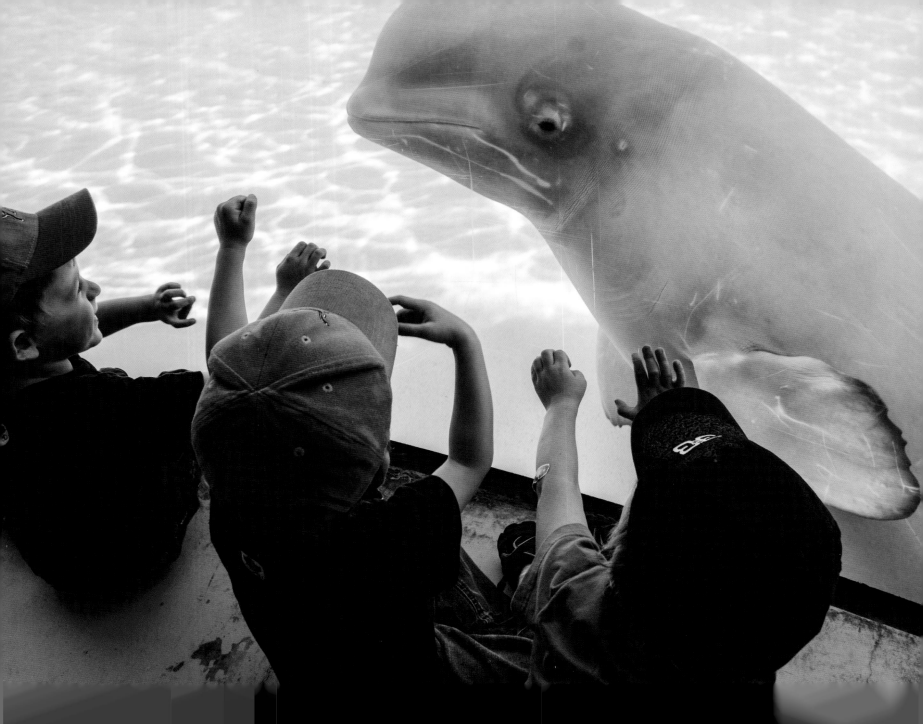

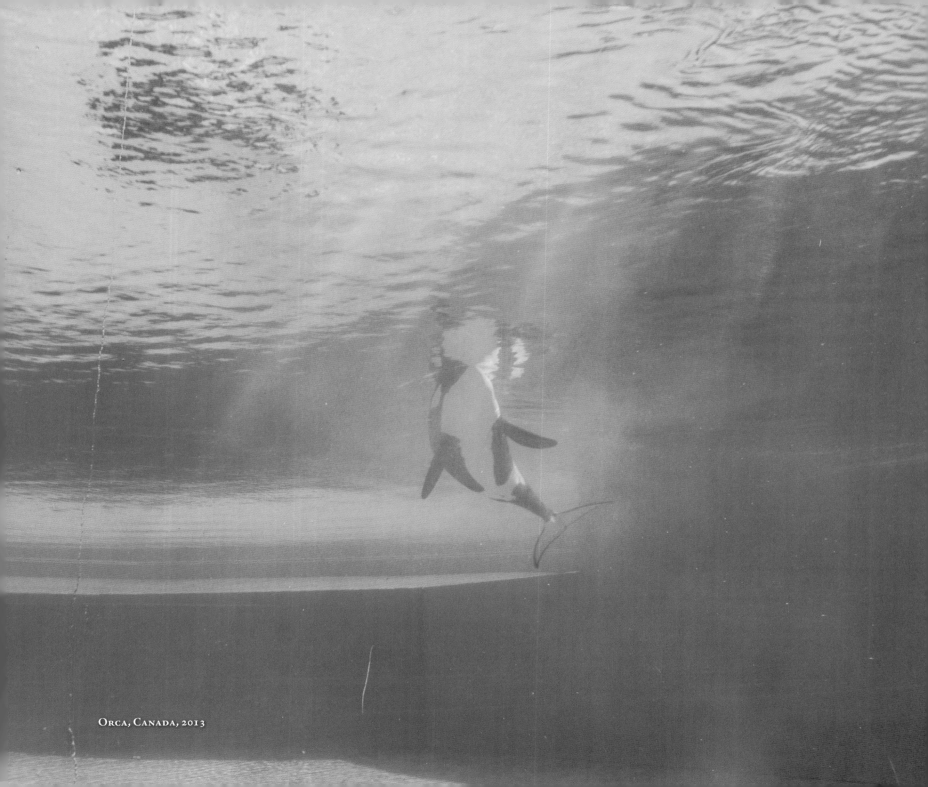

Orca, Canada, 2013

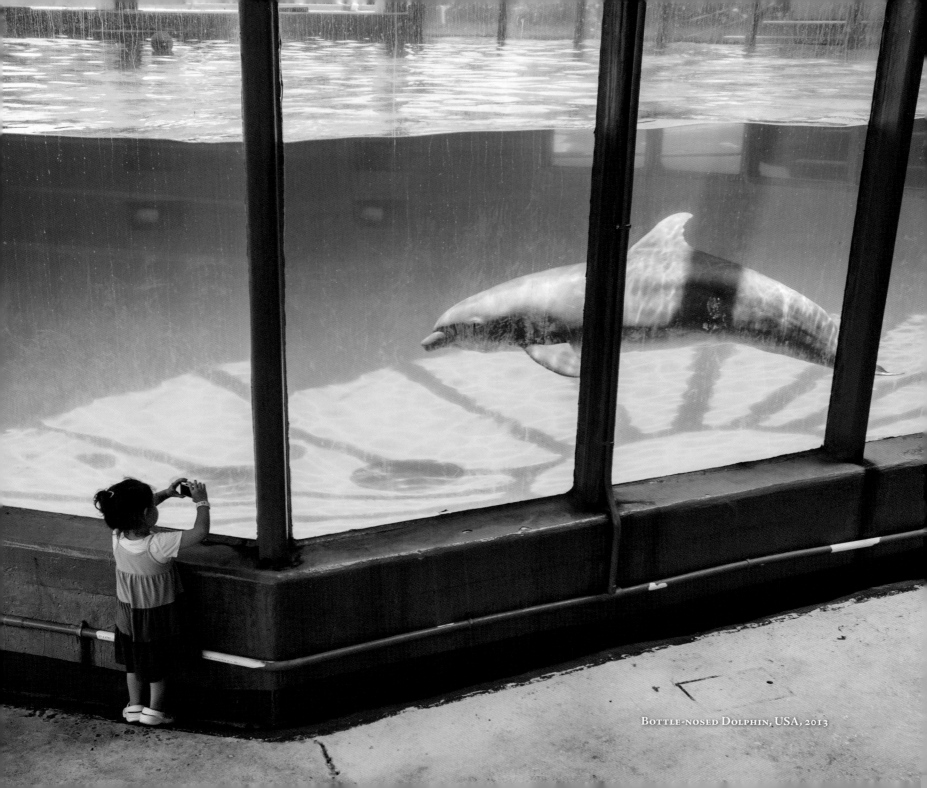

Bottle-nosed Dolphin, USA, 2013

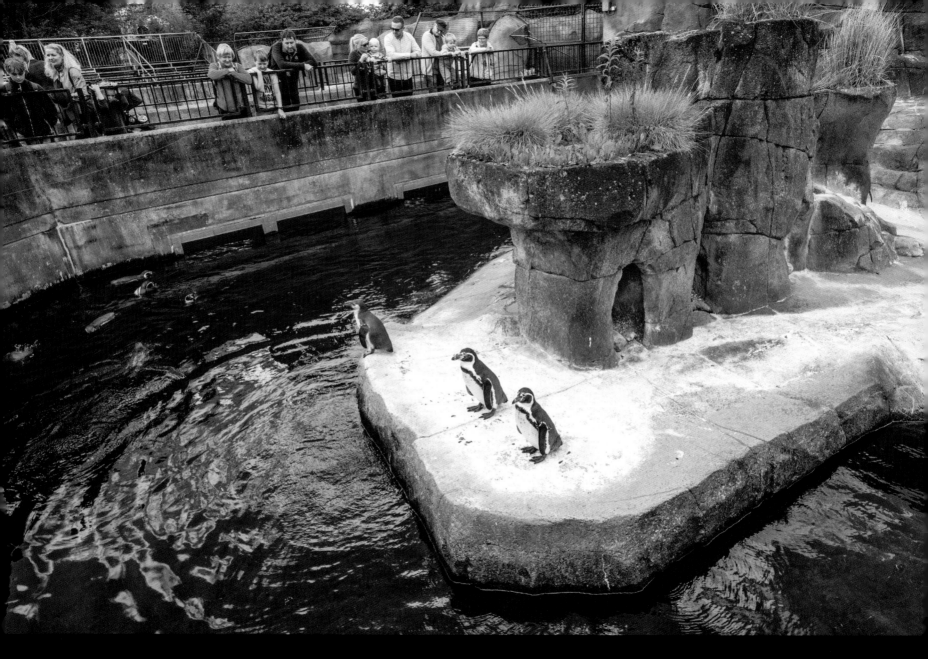

HUMBOLDT PENGUINS DENMARK 2016

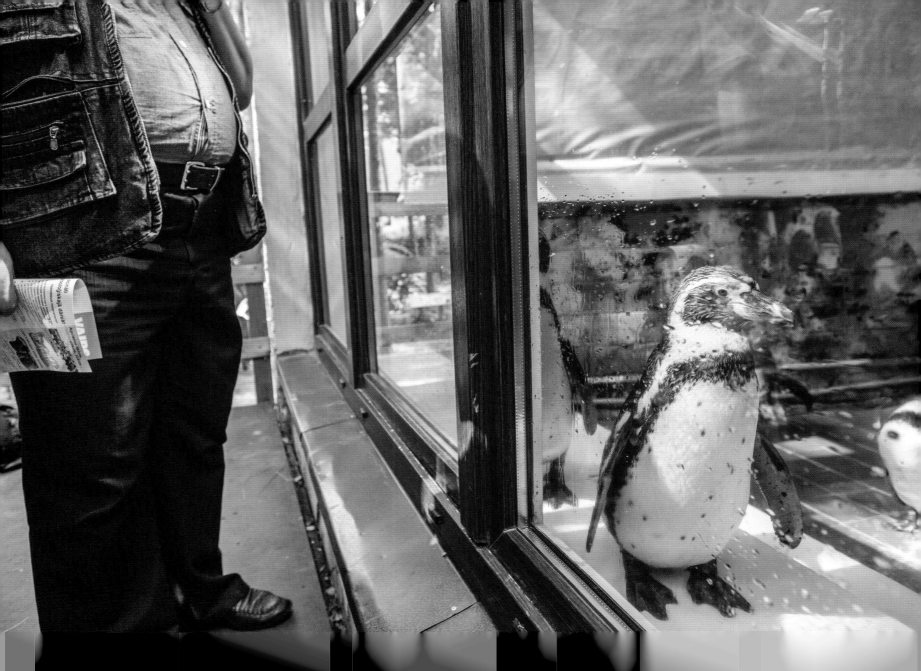

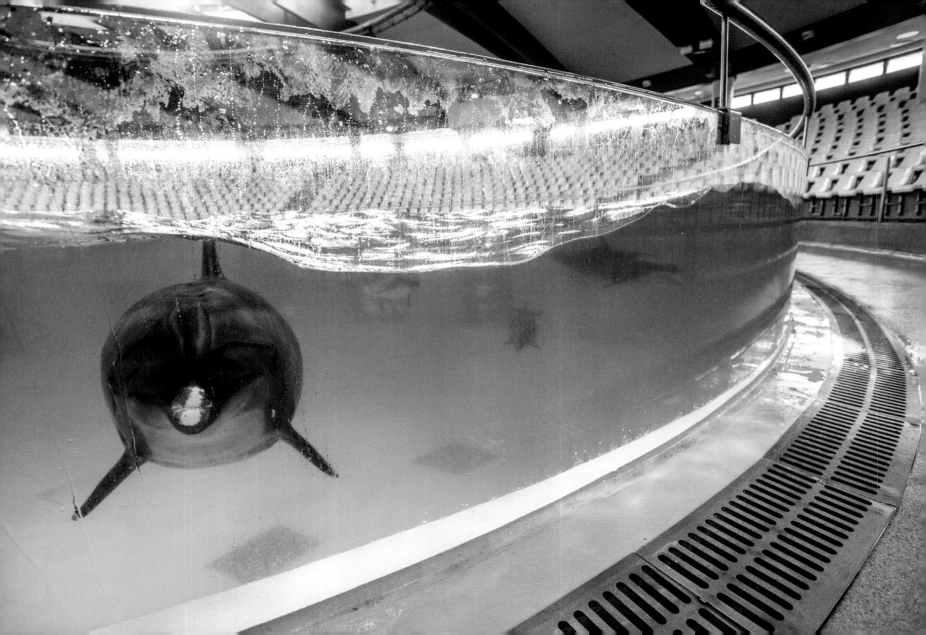

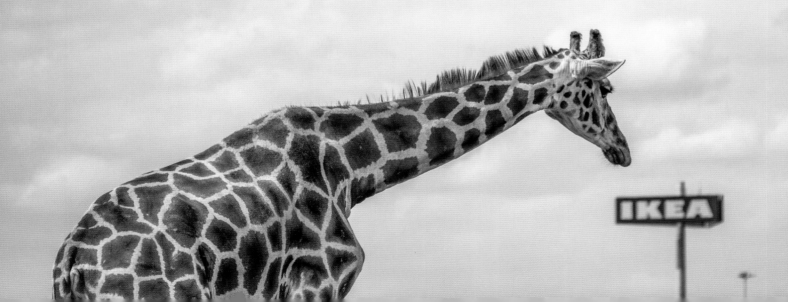

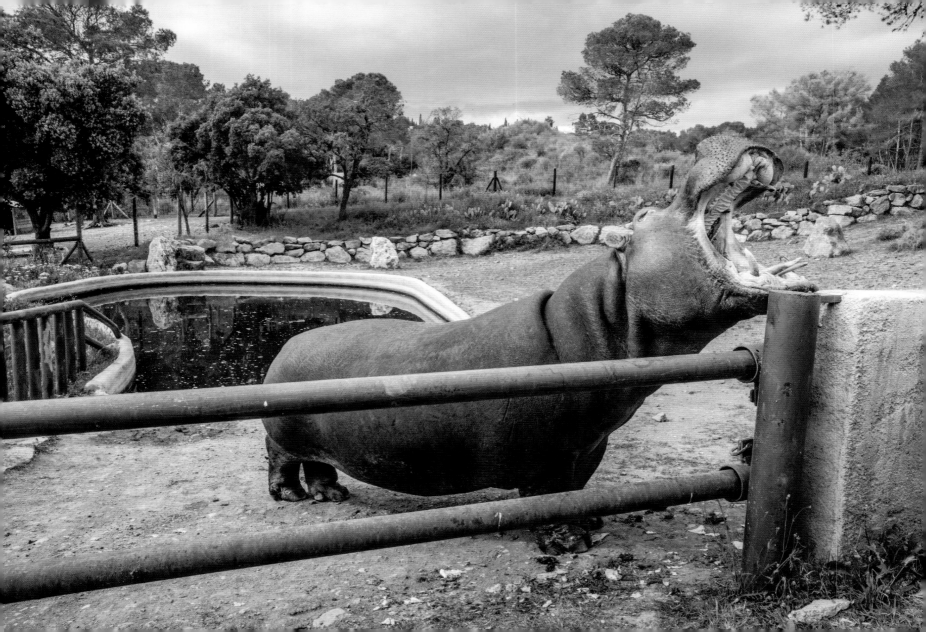

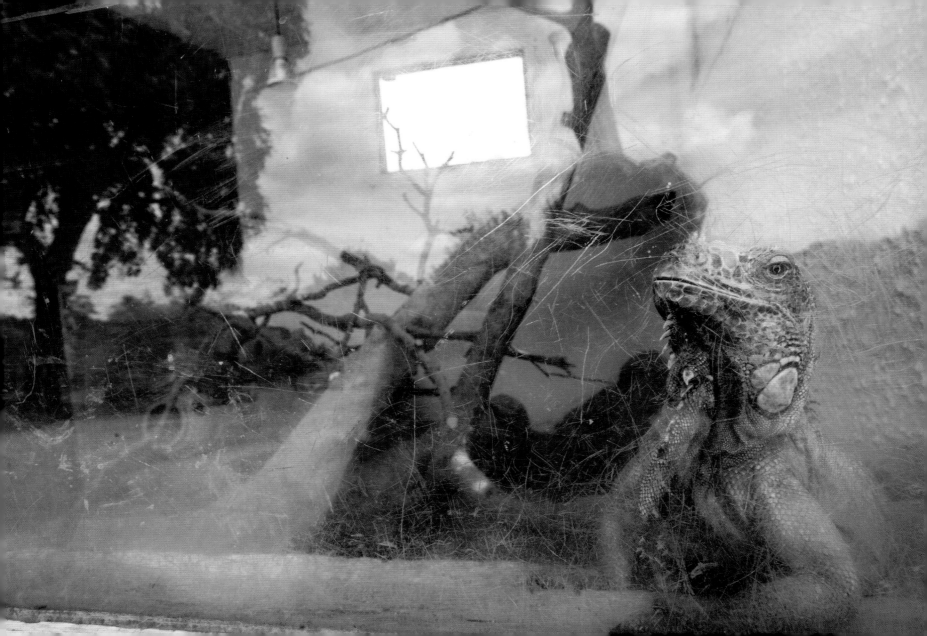

CHIMPANZEES, DENMARK, 2016

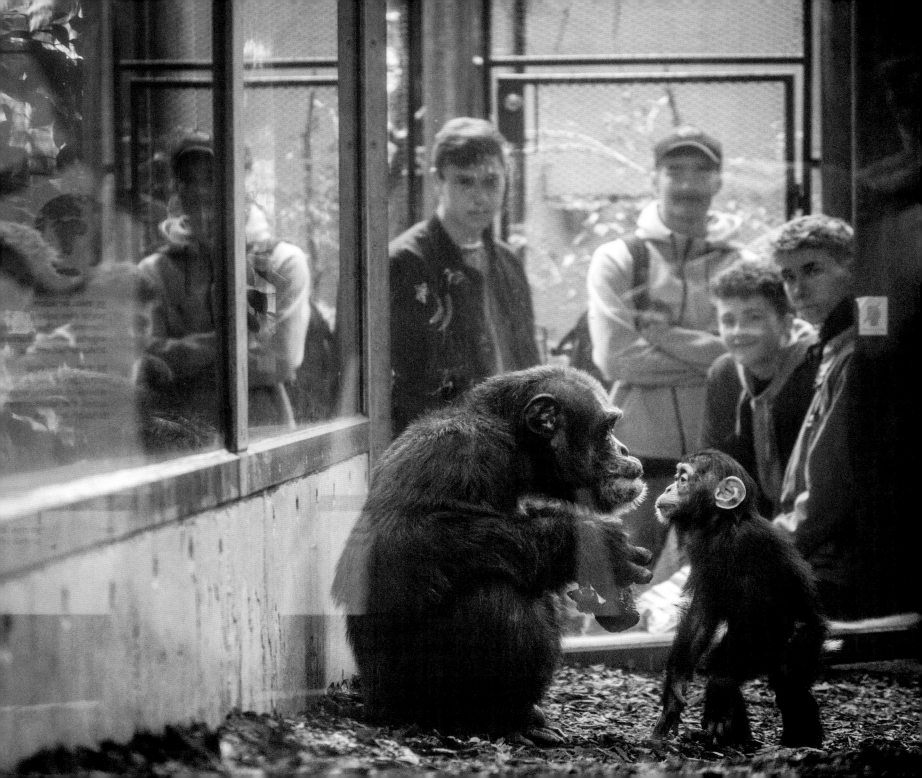

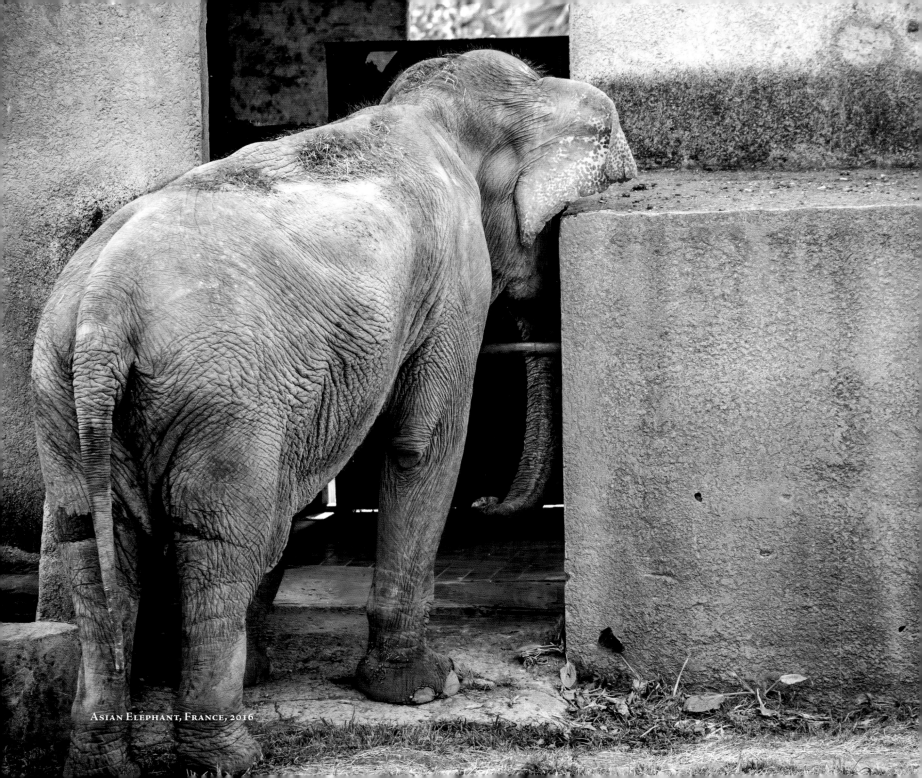

Asian Elephant, France, 2016

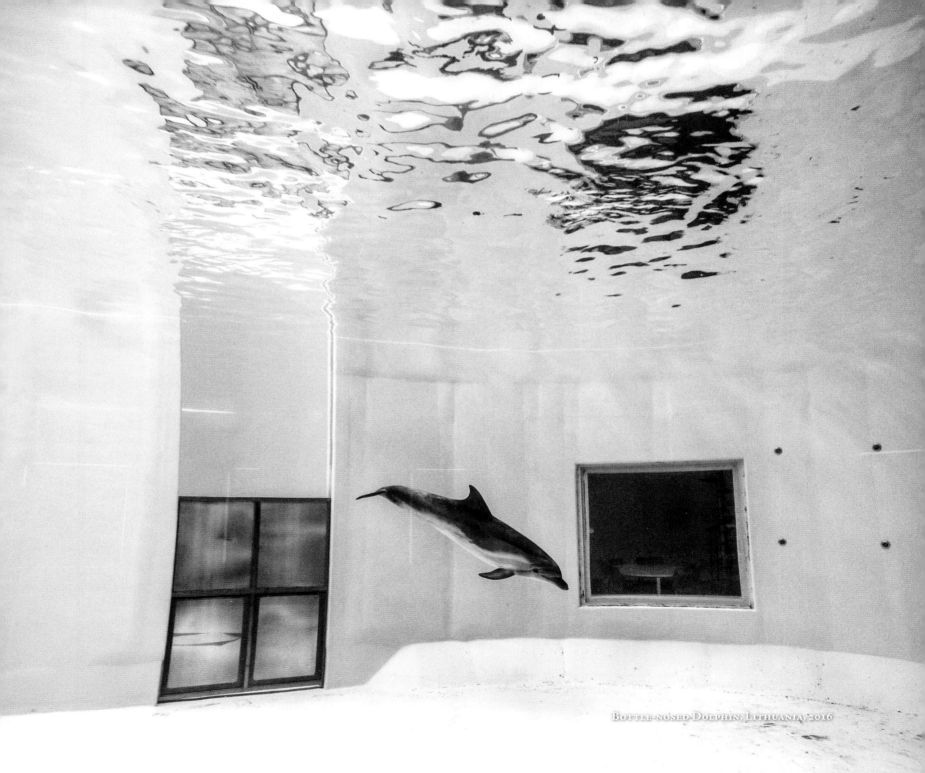

Bottle-nosed Dolphin, Lithuania, 2016

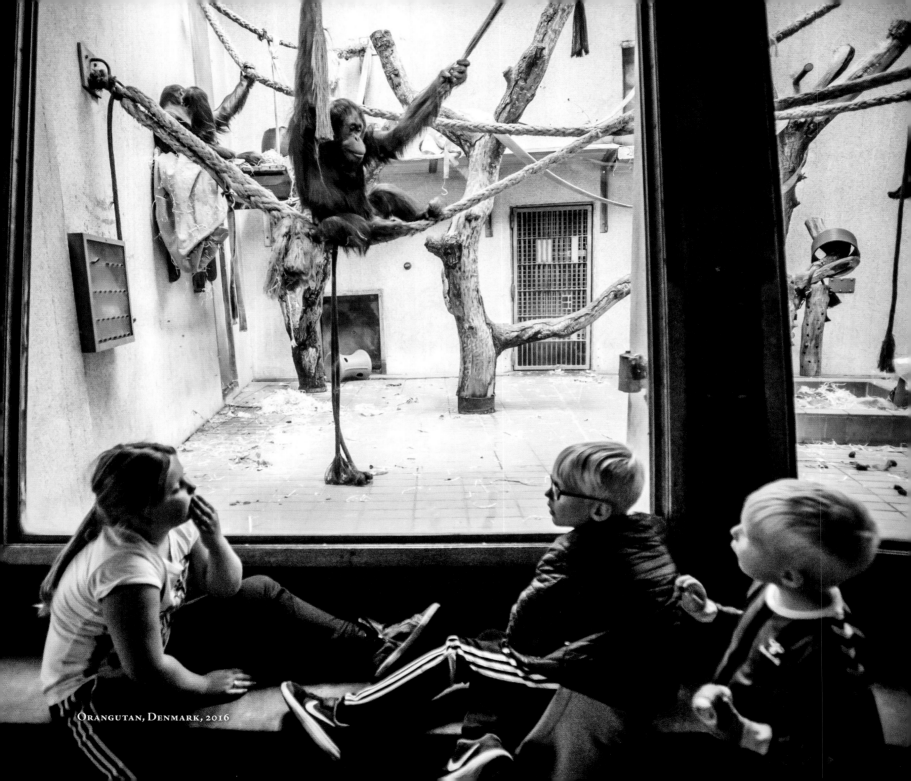

Orangutan, Denmark, 2016

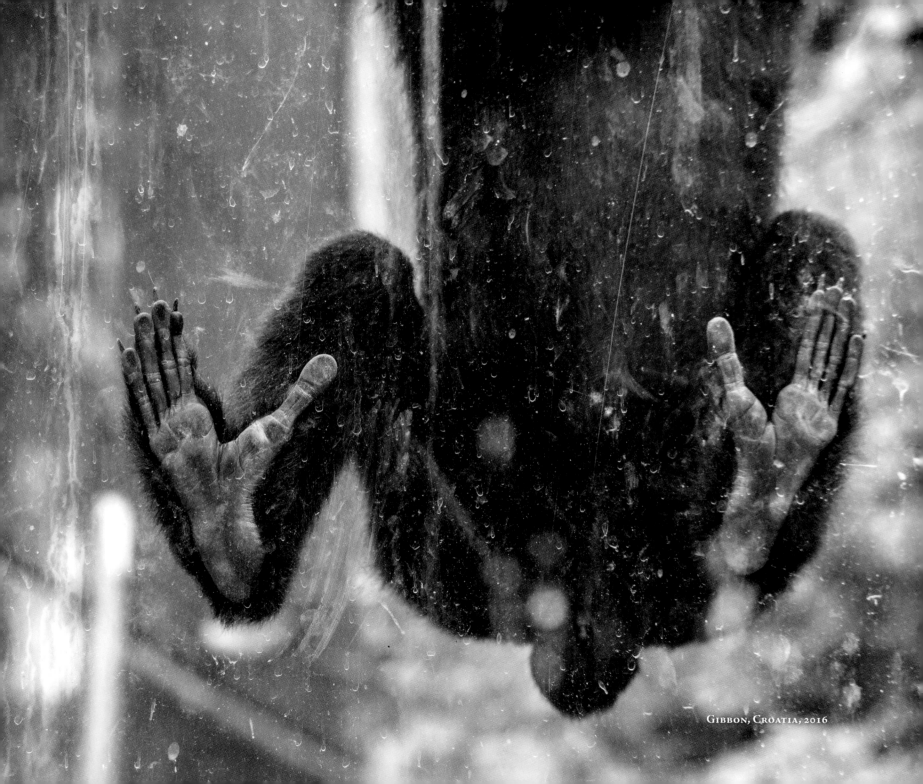

GIBBON, CROATIA, 2016

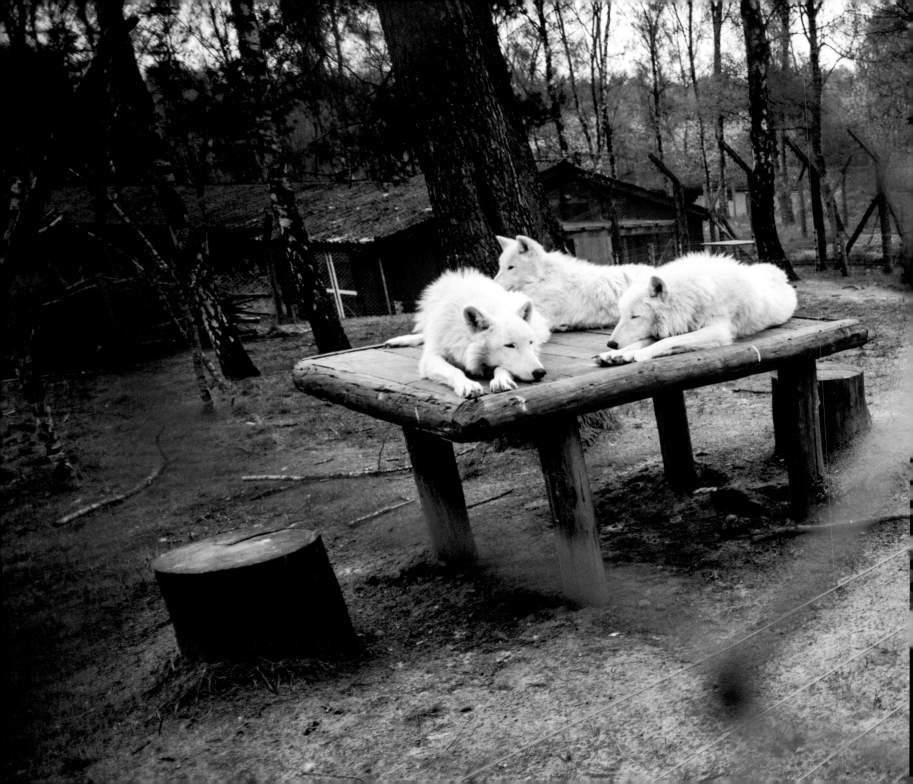

Arctic Wolves, Germany, 2016

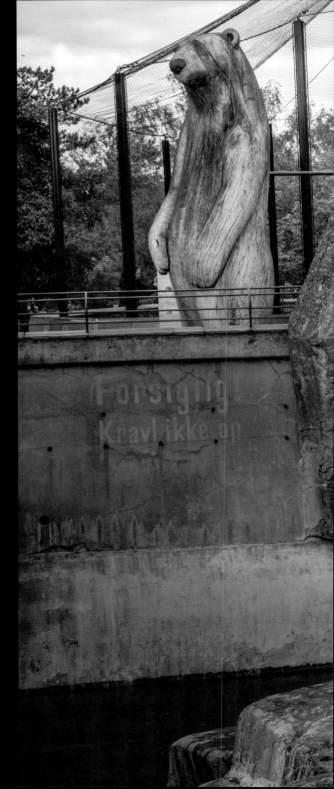

V.

If you'd like to feel, viscerally, the urgency with which we need to remove intelligent, sentient animals from the choicelessness and confinement of zoos, spend a full day at a zoo. Zoo visits typically range from one to three hours. We leave because we're done, we've seen it all, and it's time to go somewhere else we choose to be.

I challenge you to use all of the zoo's opening hours to stay and be with the animals. Spend an hour at the bear enclosure, memorizing her every move. Count the seconds it takes her to pace from one end of the fence to the other. See how long she stands, looking over, before twisting to the right and circling again. Spend time with Kiska, the wild-caught orca at Marineland, as she takes one minute to fully circumnavigate the tank she's lived in for forty years. Don't do the math on how many times she's circled that tank: it will break your heart. It can be unbearable to watch an animal circling, or simply doing nothing, for a few minutes. I challenge you to stay with that animal all day and not leave sensitized to the depravity of captivity. Imagine living twenty, fifty or even seventy years in a cage. No arguments for conservation or education are worth this sacrifice. ❧

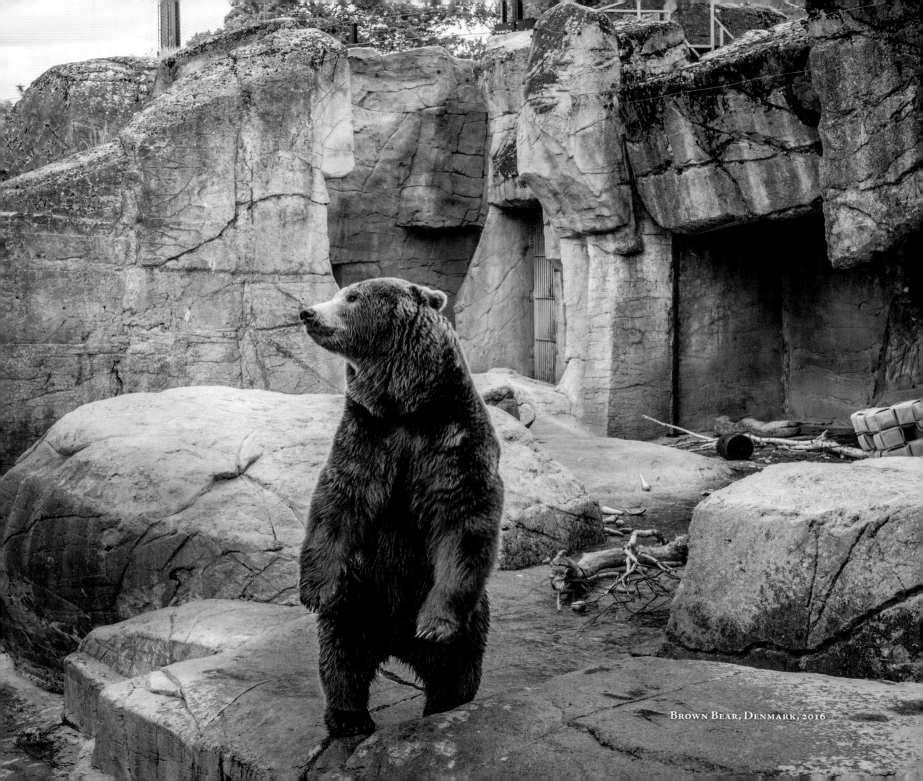

BROWN BEAR, DENMARK, 2016

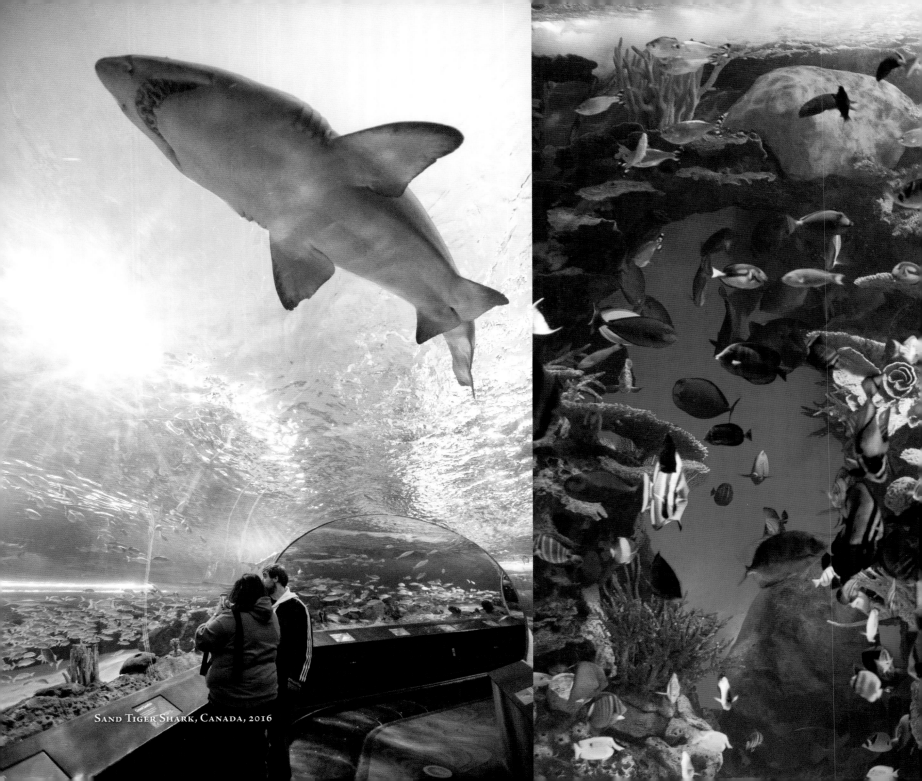

SAND TIGER SHARK, CANADA, 2016

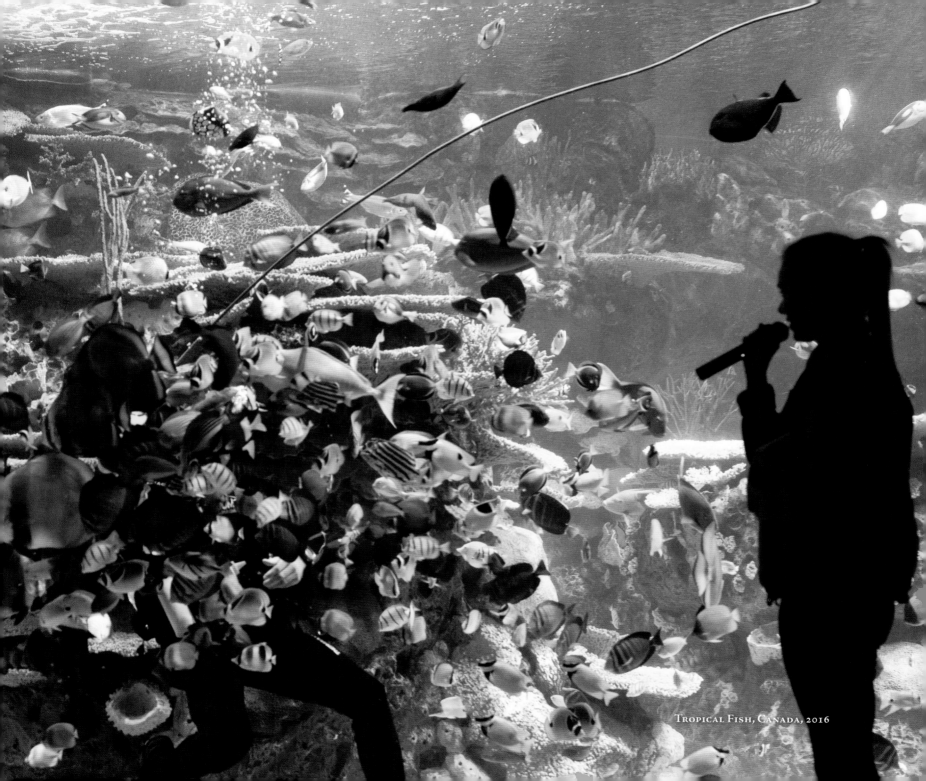

Tropical Fish, Canada, 2016

On Thin Ice.

Penguins are threatened by habitat destruction, oil spills and overfishing of their food sources.

...e of this environment ranges from ...F), while the water temperature ...10 C (45 to 50 F)

King Penguin
Aptenodytes patagonicus

King Penguins, USA, 2011

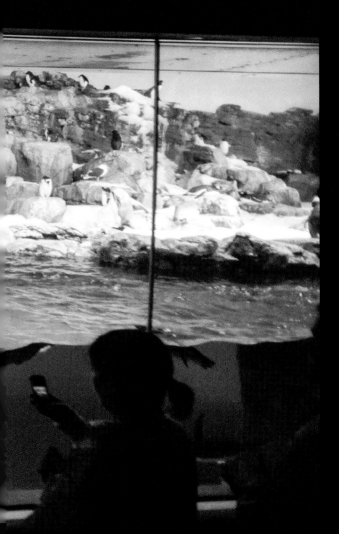

VI.

There will always be a need for places where we can care for animals or practice compassionate conservation—places where the goal is protection and not human entertainment. These places exist and we need more of them. Sanctuaries, wildlife centres, conservation areas: where the needs of animals native to the geography and compatible with the climate are met; where humane education takes place, rather than the model of display and objectification currently in practice.

Some argue that zoos fit in this new paradigm of care. Ron Kagan, CEO at the Detroit Zoo, agrees. His aim is to create a sanctuary model for zoos—housing only rescued animals and providing an experience for both human and non-human animals in which both benefit. Sanctuaries are about providing both care and choice to their inhabitants. Kagan believes this can be achieved for zoos if a primary focus is put on creating natural environments.

The Detroit Zoo houses two rescued polar bears who live in a thoughtfully designed habitat of four acres. These bears, unlike in virtually all zoos, have the option of staying out of sight of the visitors. People complain, but this provides the staff with an opportunity to explain about choice and autonomy for the animals. Over the years, the Detroit Zoo has rescued more than 30,000 animals on their own and with countless conservation and animal welfare groups, People for the Ethical Treatment of Animals and the Humane Society of the United States among them. The zoo has an unparalleled humane education program and its goal is to trigger *biophilia* (to use biologist Edward O. Wilson's term for a love of the natural world) in all visitors.

I asked Kagan whether he'd even thought of creating a new name for this type of establishment, as it moves away from the antiquated zoo model. He had considered it at length, he said, but preferred

"rebuild rather than rebrand." If the needs of an animal cannot be met, he added, then the circumstance for the animal has to be changed. The zoo moved all their remaining elephants from the icy city of Detroit to a more climate-appropriate sanctuary in California, run by the Performing Animal Welfare Society. With fewer animals and more space, zoos can better be involved in genuine conservation. Furthermore, nothing is stopping them or other "good" zoos from participating in conservation from afar, where the animals can be protected in their natural habitats or in sanctuaries. In these programs, it seems, there *can* be an evolved role for zoos in animal care.

In their current form, zoos and aquaria need to be reformed or abolished. Underfunded, tiny, roadside zoos need to be shut down and animals should never again be made to perform for us as they are still forced to do. It's time for zoos to be courageous and move beyond their present and historical construct. More and more, this is the desire of the public, and I know it to be that of zoo staff as well.

During a recent visit I made to an aquarium, a staff-member gave us a presentation about fishes: their habitat, what they eat, and their life patterns. She stated that the main threat to fishes and their habitats worldwide was trawling. During a short question-and-answer period, I pointed out that to assign blame to trawling was to abdicate us of our responsibility; that *we* use trawlers to meet *our* demand for fish. As an aquarium and supposed fish-education centre, I inquired, could they not suggest we eat fewer fishes? She replied to the audience that, as fish are a part of the human diet, the aquarium could not advocate for that.

Once the crowd had dispersed, my conversation with her and another staff-member continued. With the present and undeniable emergency of the depletion and pollution of the oceans, I mused that it was the responsibility of aquaria like theirs to be courageous and educate the public about ideas they may not want to hear. In the privacy of this conversation, they agreed, and emphatically encouraged me to write a letter to the aquarium about it. They felt muzzled by the business they worked for, one that purportedly aimed to raise awareness about the animals in its care. Zoos and aquaria must not forgo opportunities to do better. 🖎

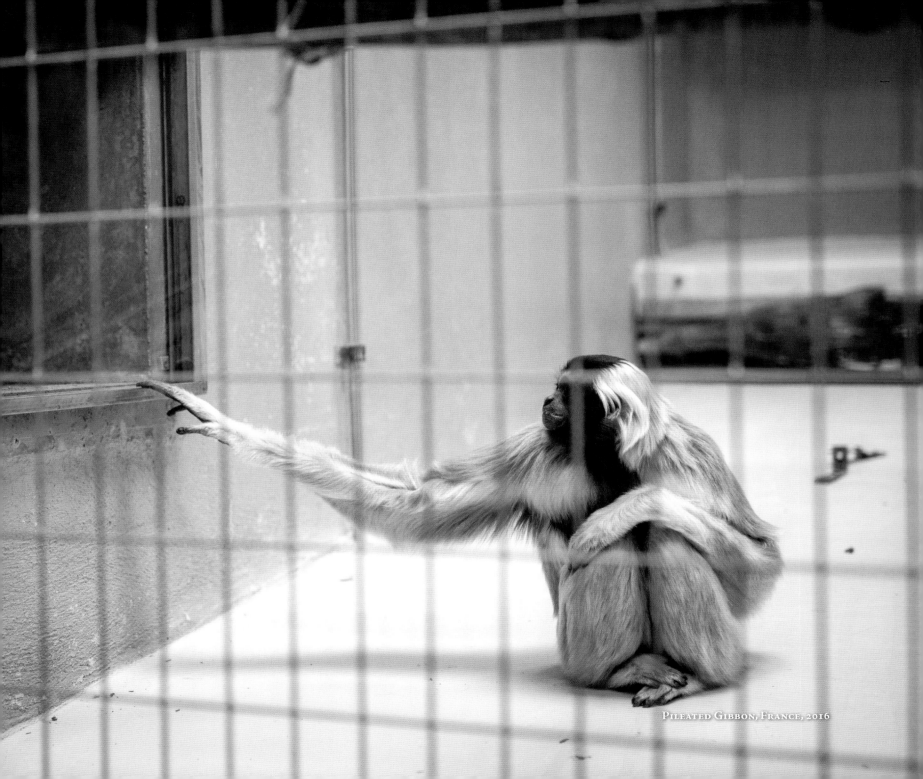

PILEATED GIBBON, FRANCE, 2016

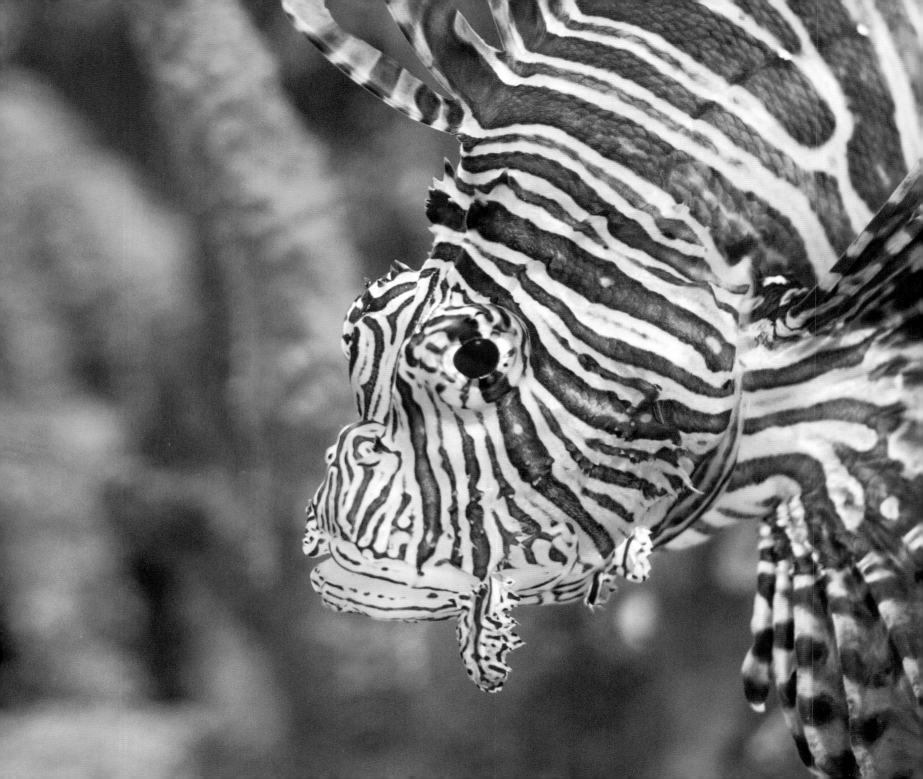

Red Lionfish, Canada, 2016

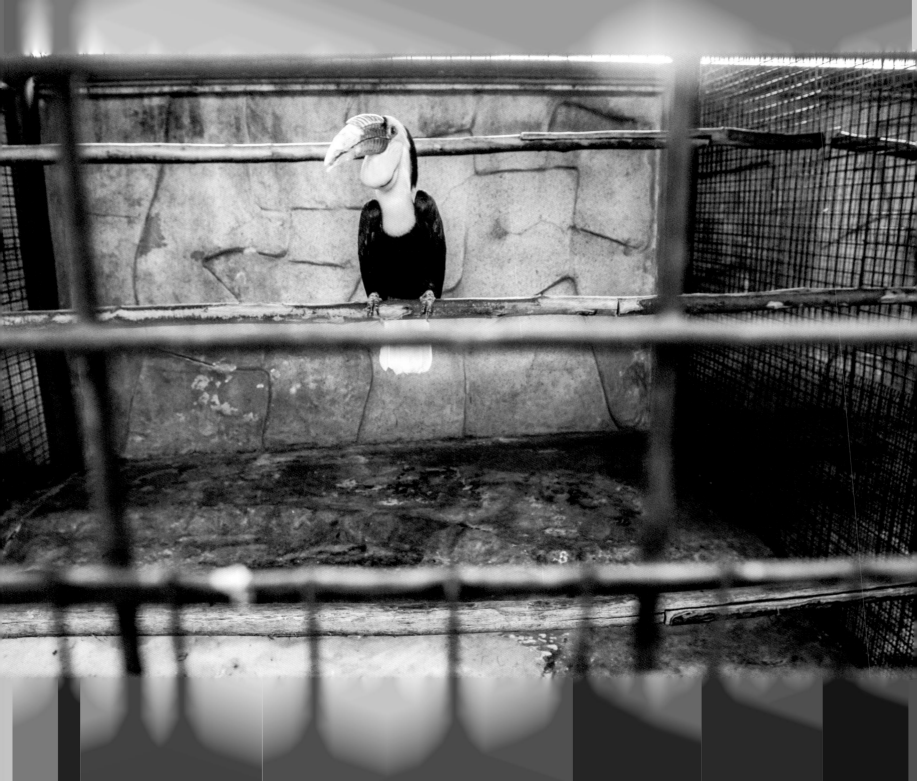

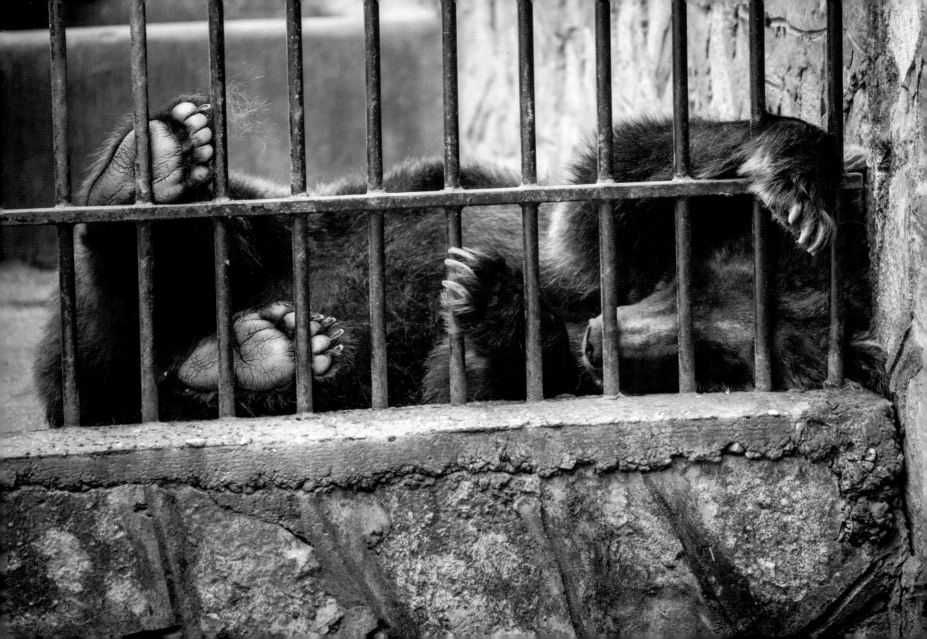

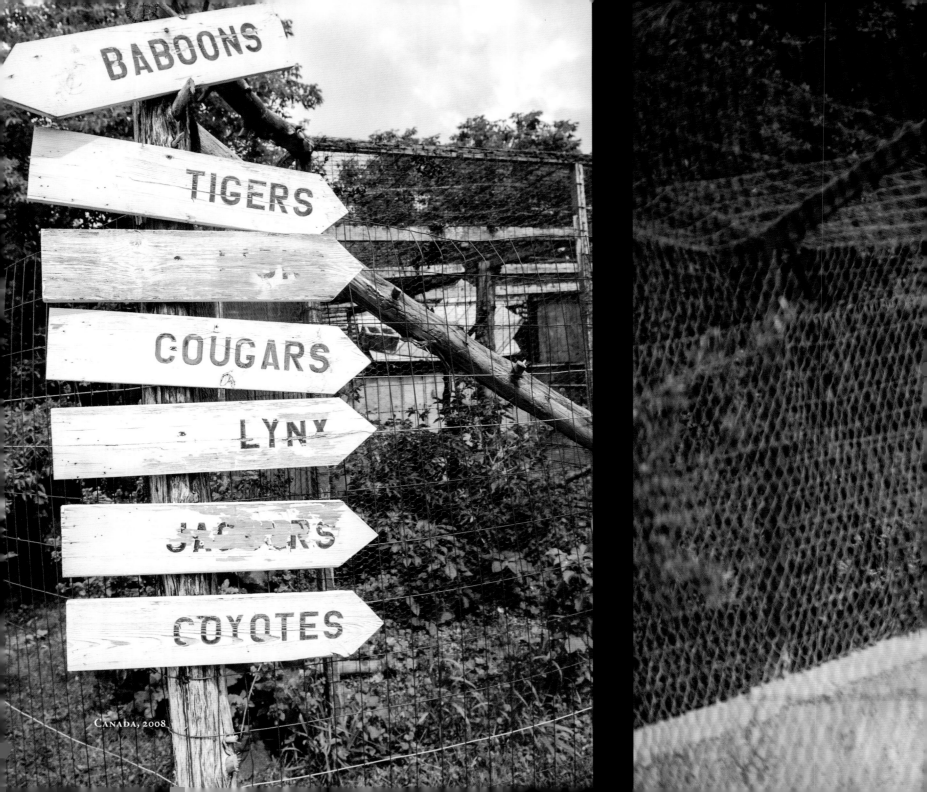

BABOONS

TIGERS

COUGARS

LYNX

JAGUARS

COYOTES

Canada, 2008

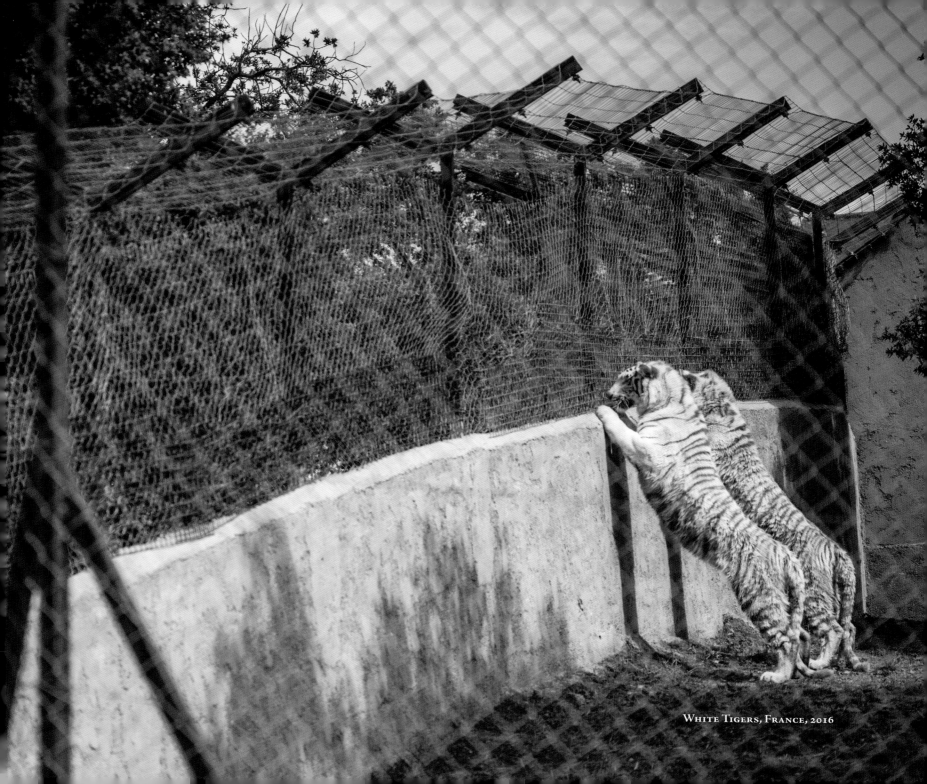

WHITE TIGERS, FRANCE, 2016

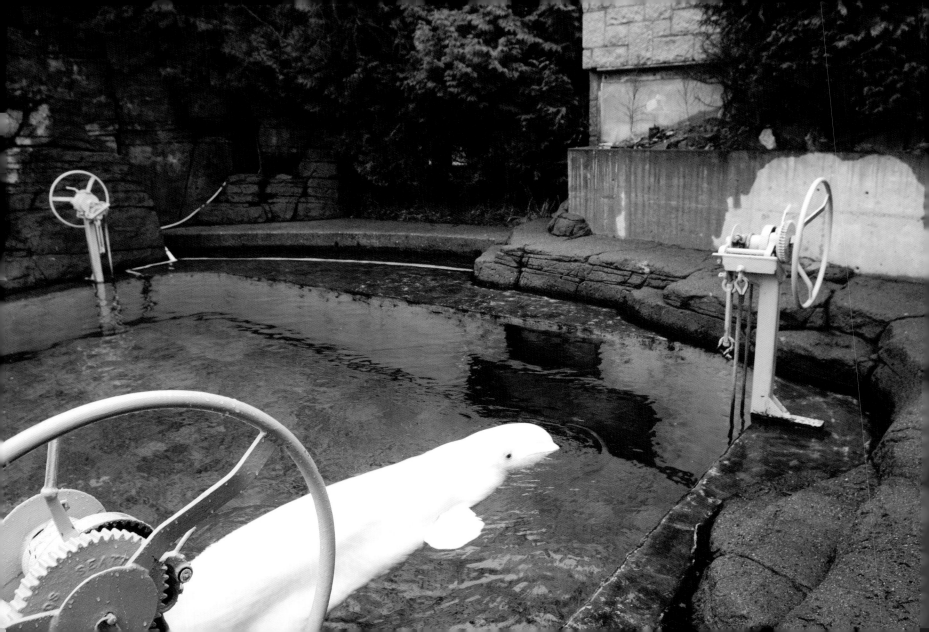

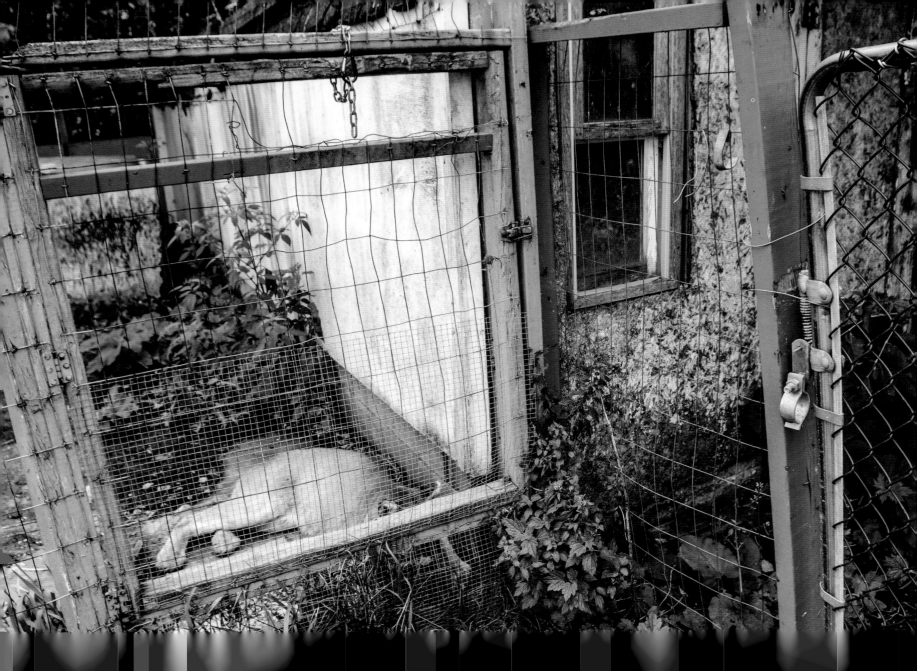

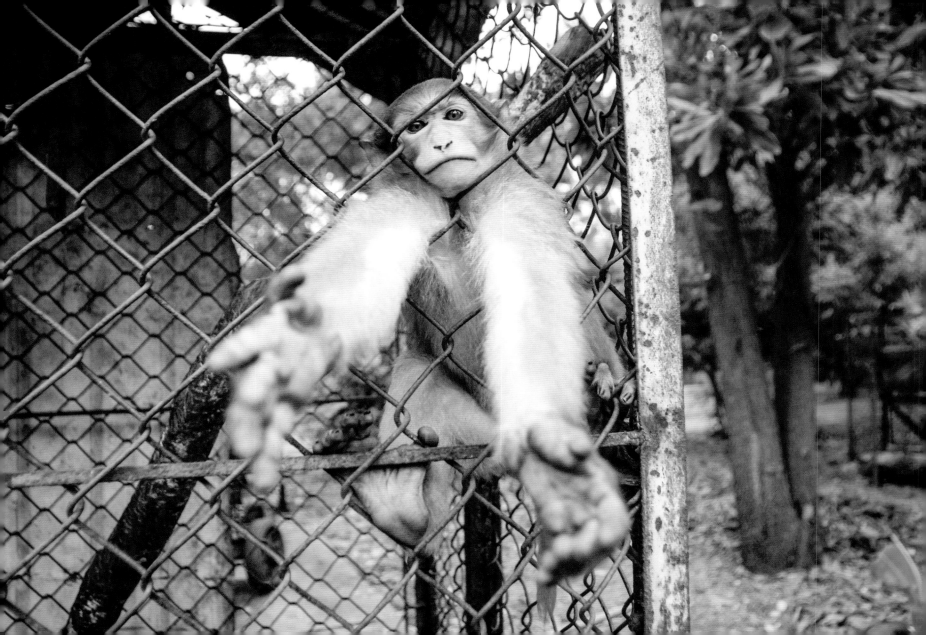

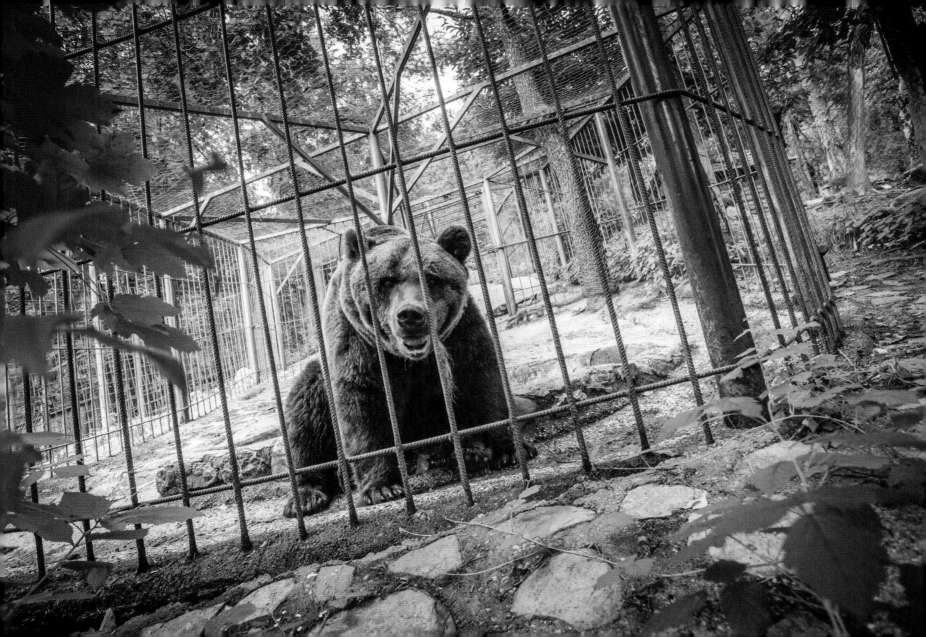

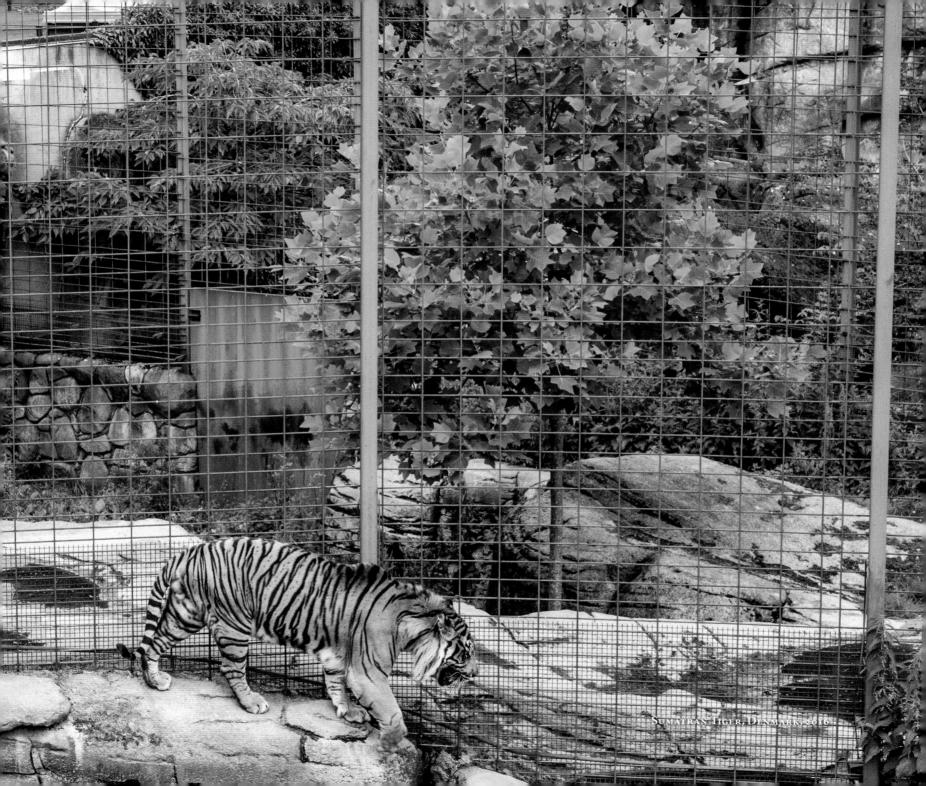

Sumatran Tiger, Denmark, 2016

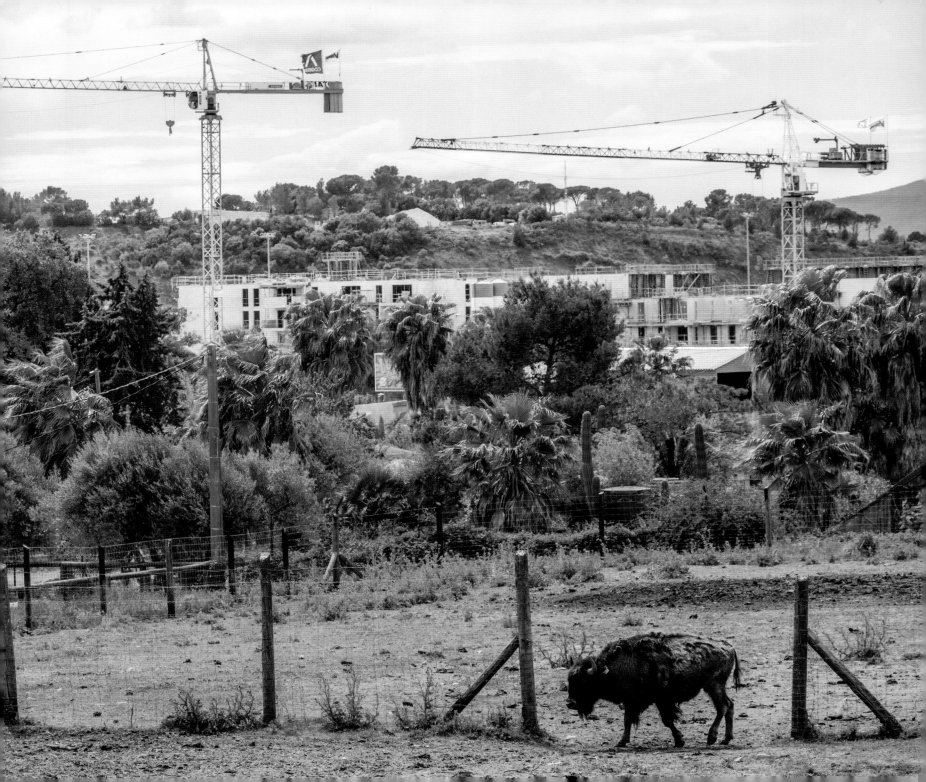

Et stort næb

Tukanen har et stort næb, der fylder en tredjedel af fuglens længde. Men selvom næbbet er stort, er det faktisk meget let. Det er lavet af keratin, som også hår og negle er lavet af. Det store næb hjælper tukanen til lettere at kunne nå hængende frugter eller nå ind i huller i træer for at finde føde.

A large beak

The toucan has a large beak that is one third of the length of the bird. Although the beak is large it is actually very light in weight. It is made of keratin like hair and nails. The large beak helps the toucan to reach hanging fruits or to reach into holes in trees more easily.

Kæmpetukan	Sydamerika	Vægt: 500–860 g
Ramphastos toco	Skovbryn, krat, lunde	Alg: 3–4
Toco toucan		Levealder 16 år
		Føde: frugt, bær, æg, insekter

Toucan, Denmark, 2016

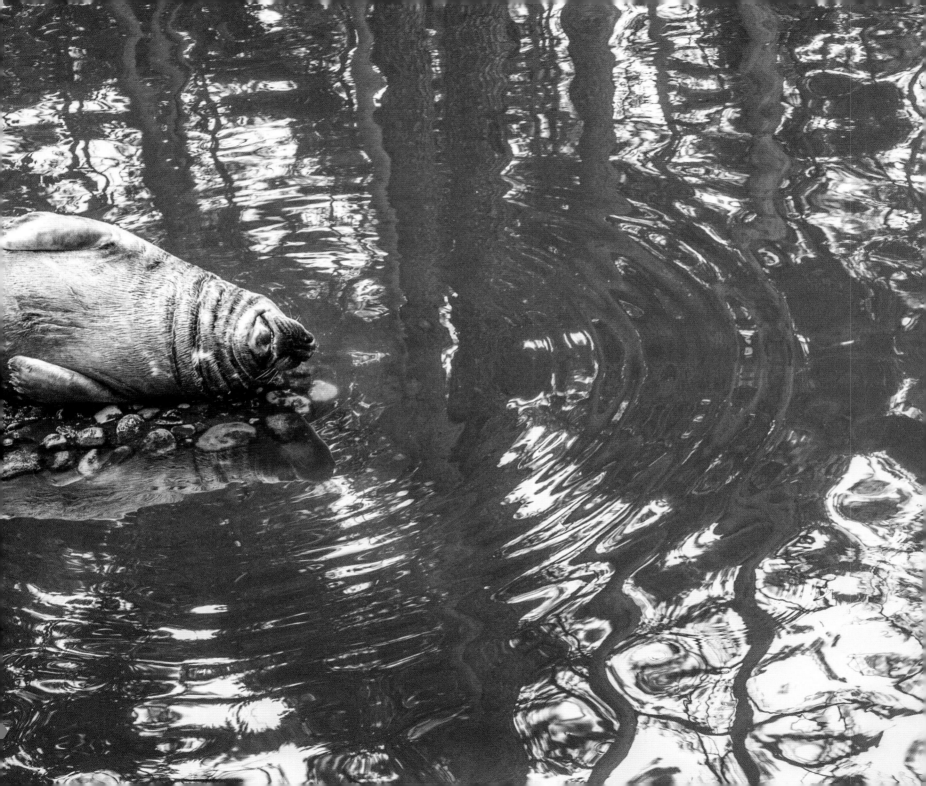

Baltic Grey Seal, Latvia, 2016

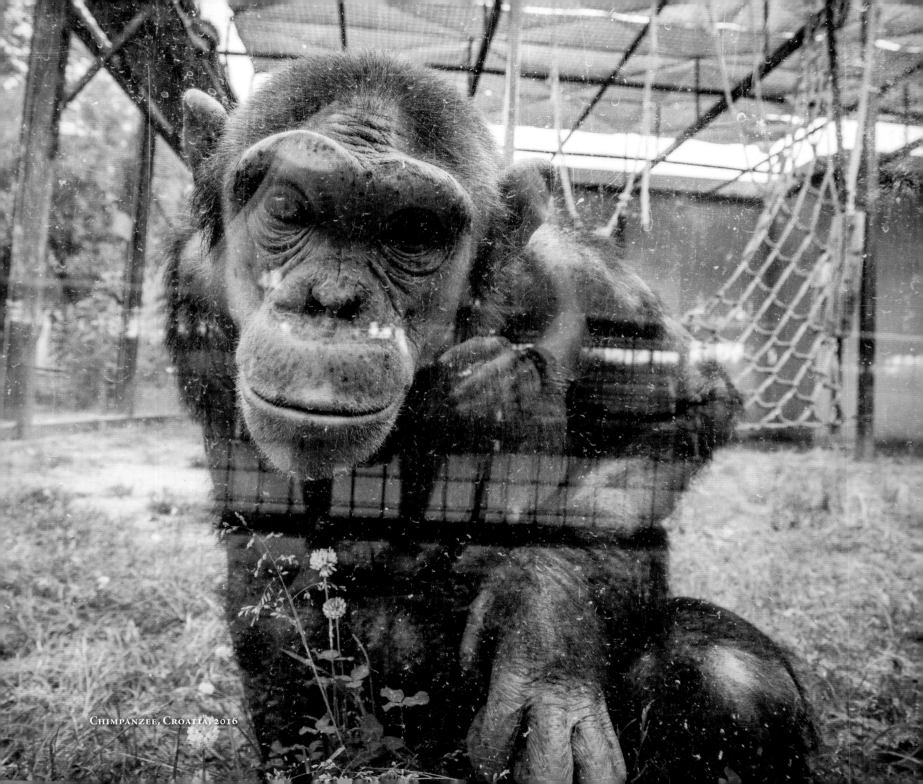

CHIMPANZEE, CROATIA, 2016

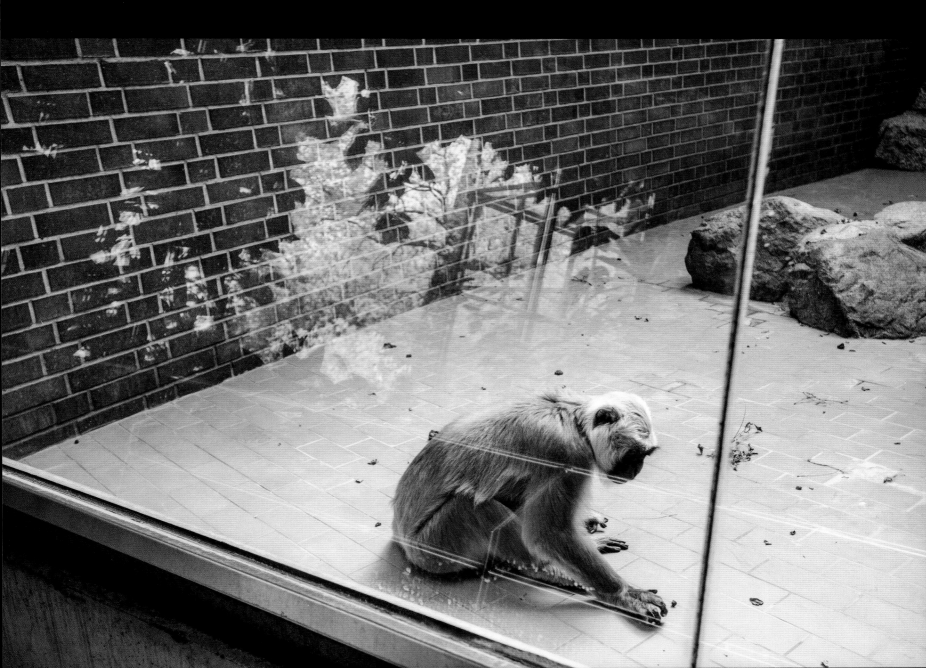

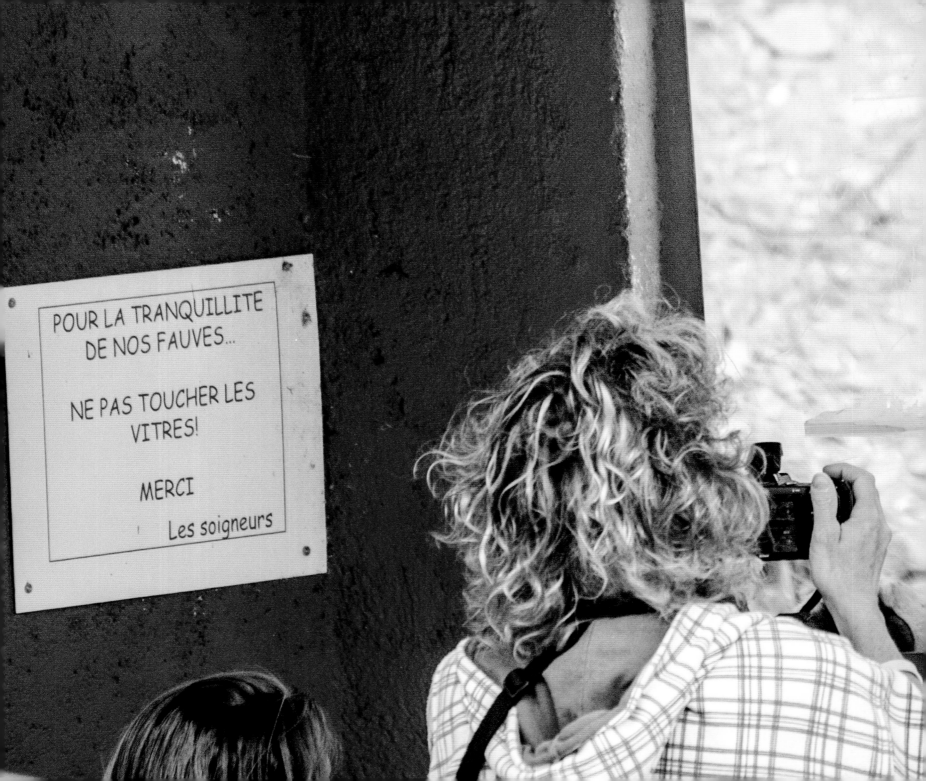

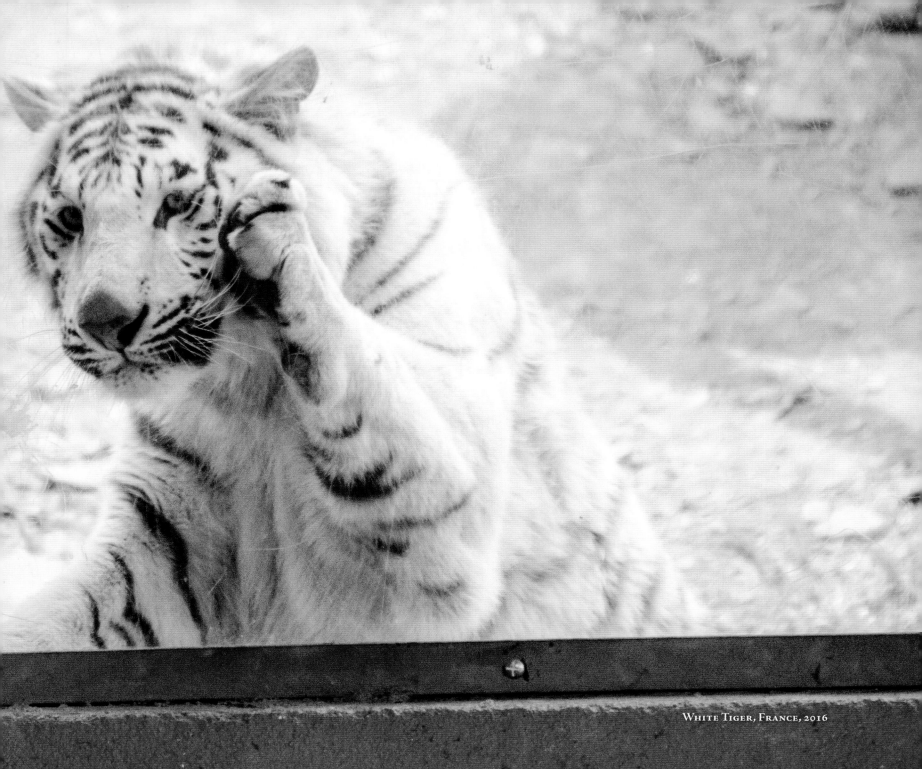

White Tiger, France, 2016

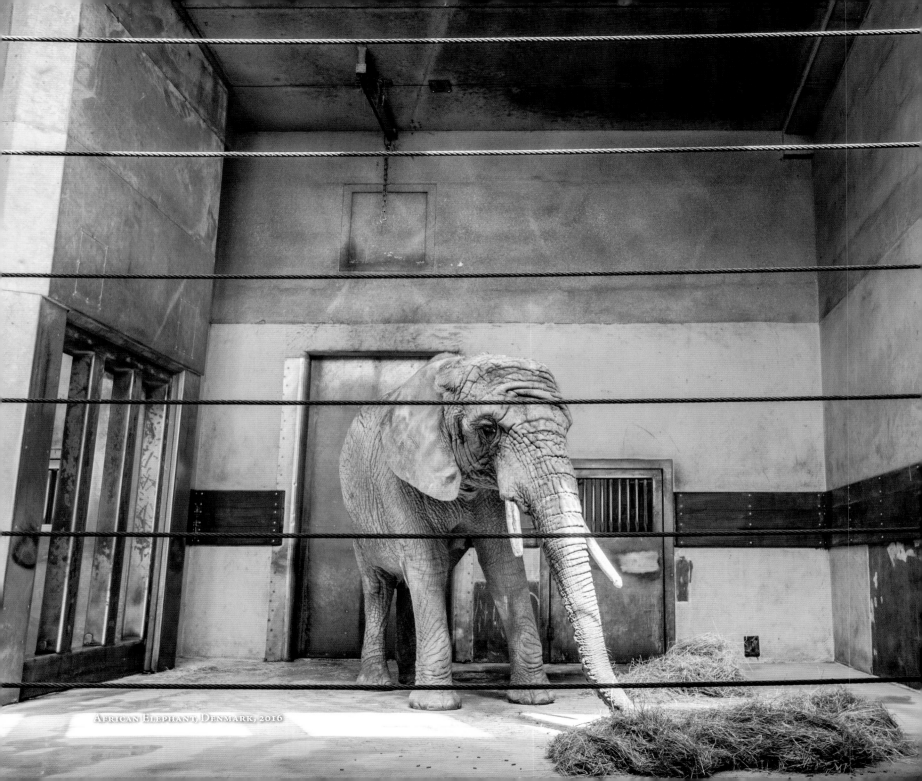

African Elephant, Denmark, 2016

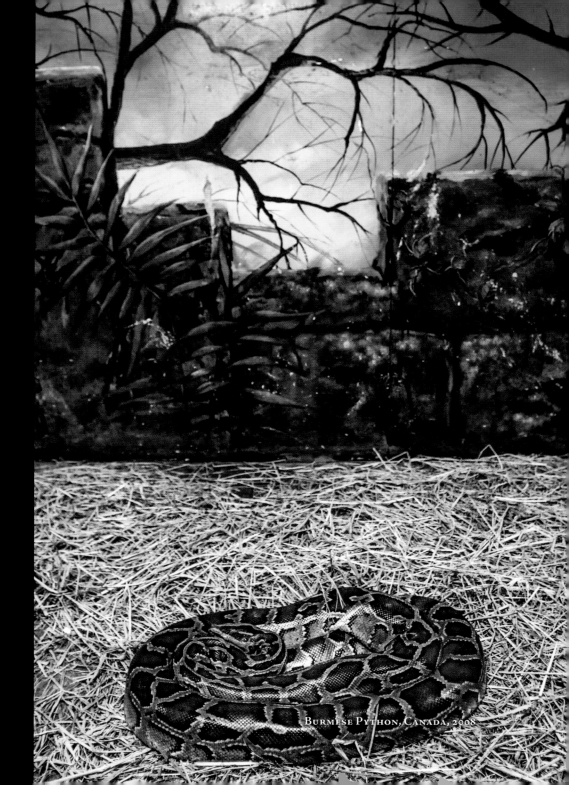

Burmese Python, Canada, 2008

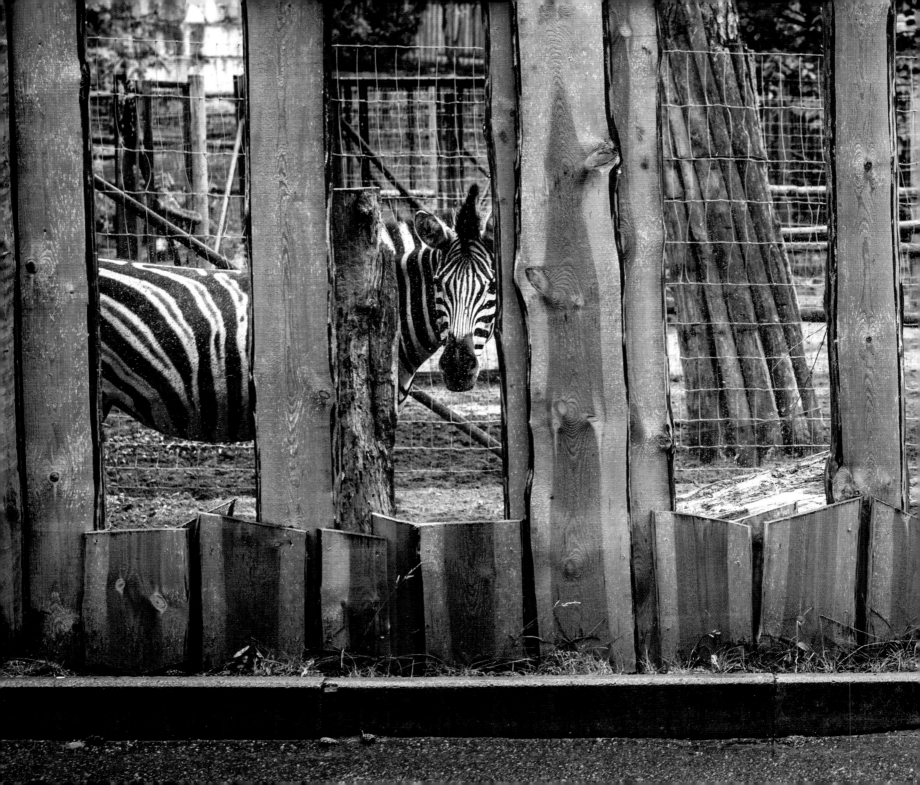

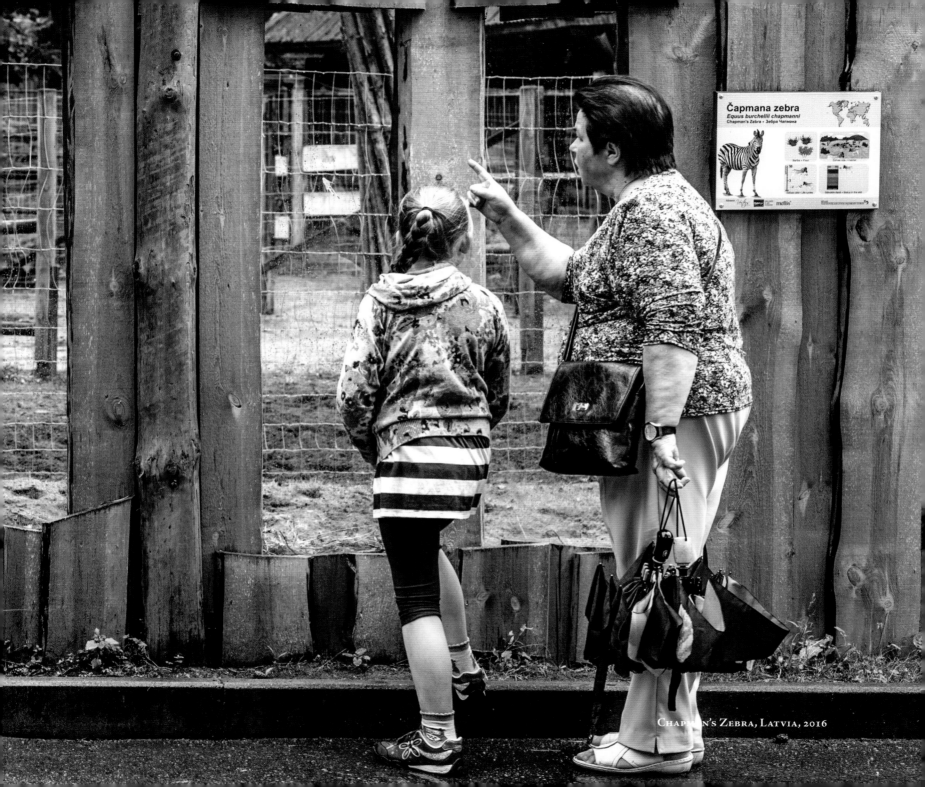

Chapman's Zebra, Latvia, 2016

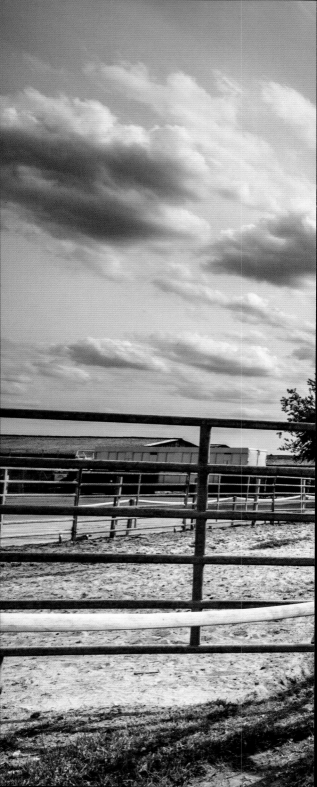

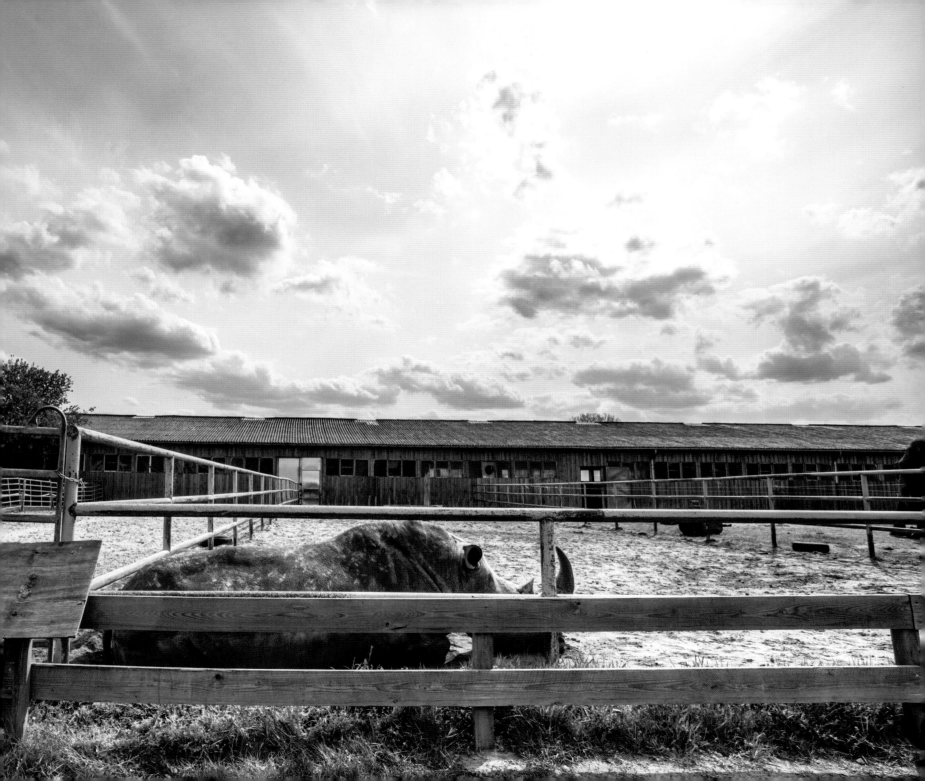

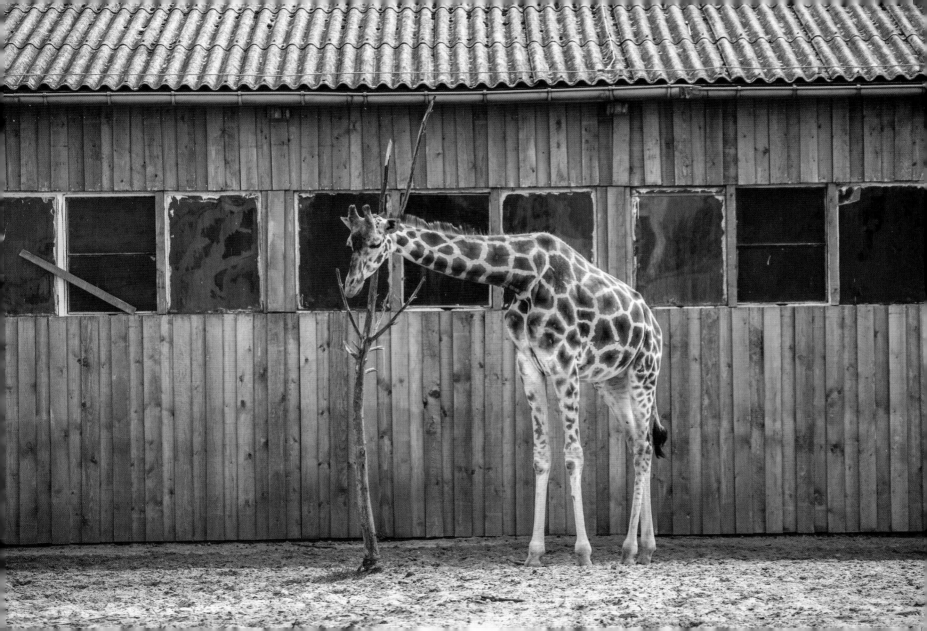

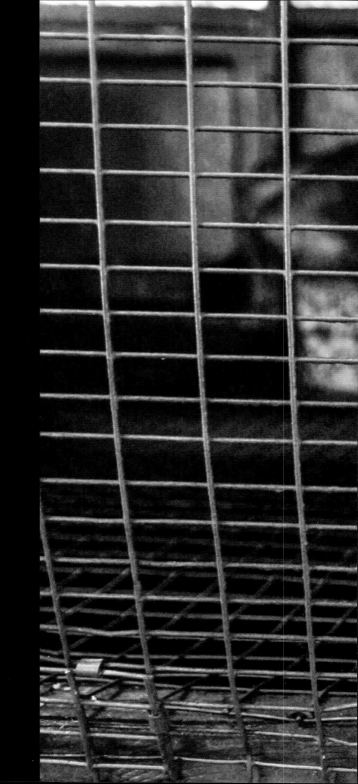

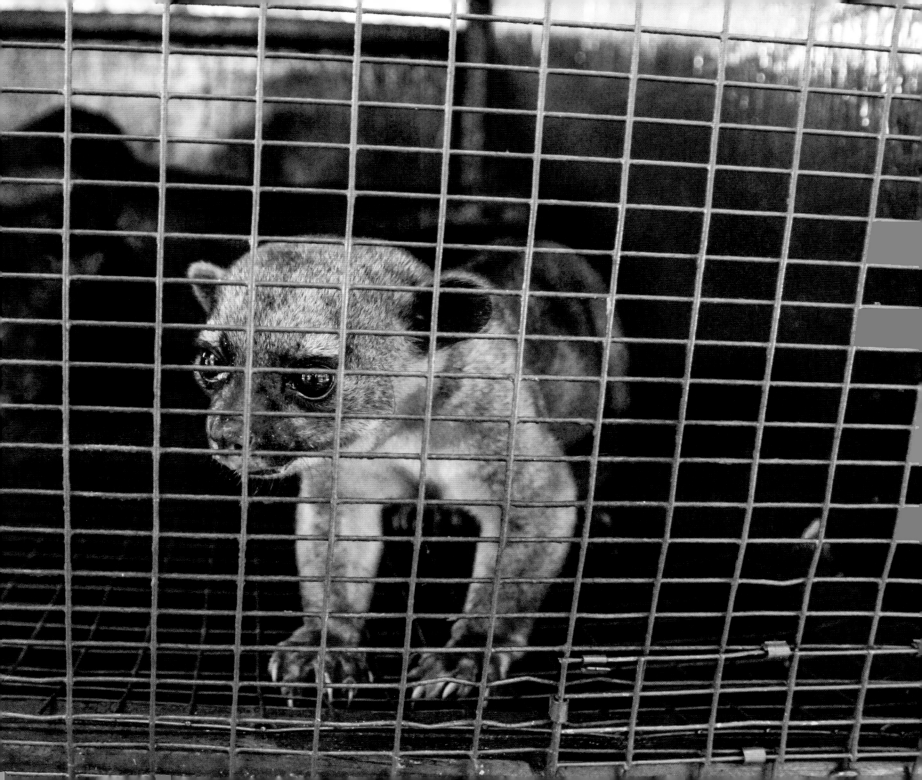

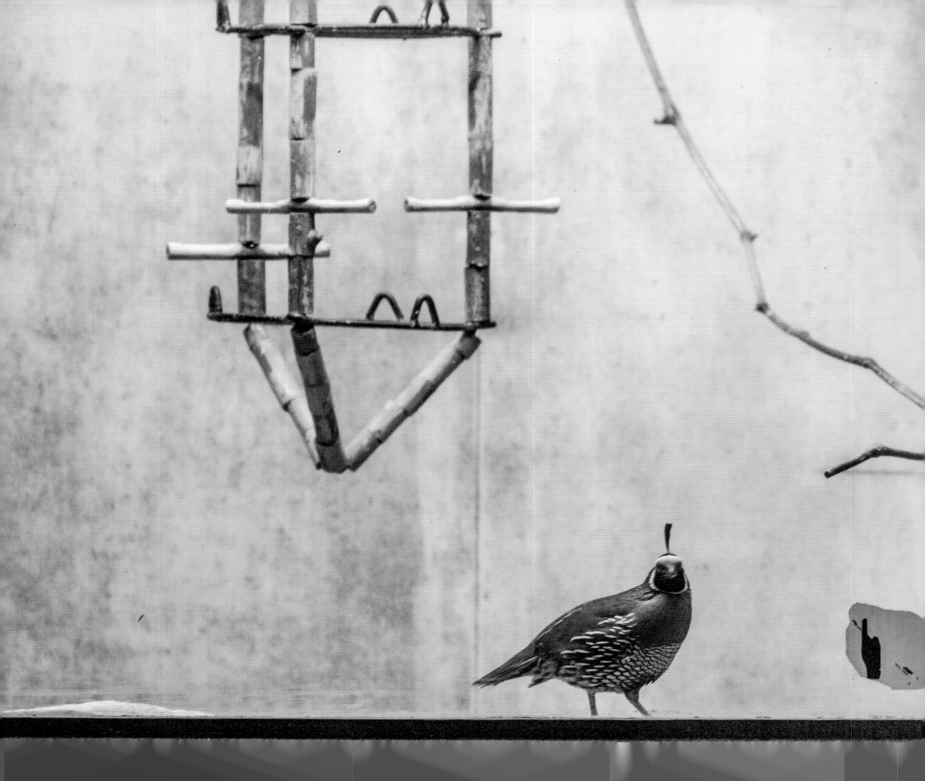

California Quail, Lithuania, 2016

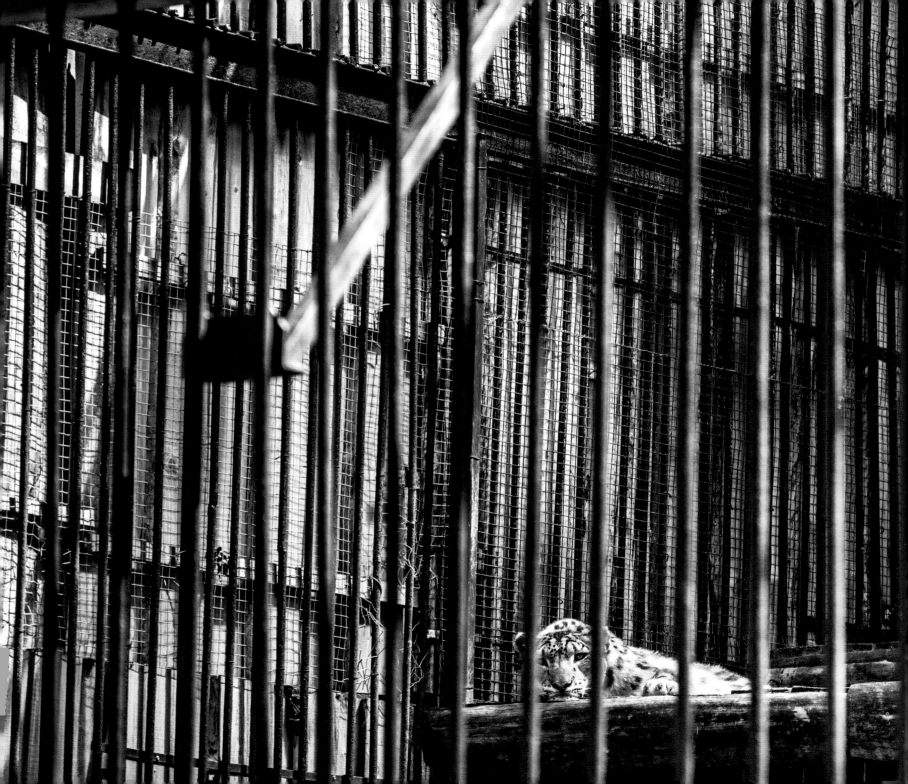

SNOW LEOPARD, LITHUANIA, 20

VII.

Like all animals, we wish for autonomy. We wish to be with our own and to explore our world. We flee from harm and we seek shelter. We desire to build our lives and make our own way. We hate forced confinement and we succumb to despair if we have no prospect of freedom.

I'm not an ethologist or a psychic. I have no special insight into the souls of animals. Yet I see what I see and I record it with my camera. And I know I am not alone. If you worry that you're being tricked into an anthropomorphism that you don't agree with, then I ask you simply look again. Do we really think the despondency and desperation we observe are not real? Do we really believe that the paw reaching through the bars, or the defeated body sprawled on the concrete floor, offer no insight into what these beings are experiencing? Where else do those primary emotions come from, if not from our mutual experience as vulnerable animals, subject to the joys and suffering of a body that lives and dies?

The zoos I visited and have depicted in *Captive* are not immutable or inevitable; they are human constructs for human pleasures that belong to an age when we knew little to nothing, or cared about, the inner lives of other species. As the field of ethology—the observation of animals in their natural settings—continues to gain its footing in the scientific discourse about sentience and welfare, it will become inevitable that compassionate choices are the only paths forward. We can encourage zoos to conserve species in the wild—like the Aalborg Zoo in Denmark is doing by working with the Black Mambas (an all-female anti-poaching unit in South Africa) to protect rhino and elephant populations, and like the Detroit Zoo is doing with those looking after highly endangered Grauer's gorillas at the Gorilla Rehabilitation and Conservation Education (GRACE) centres in the Democratic Republic of Congo.

We can provide more resources for improved habitats for rescued animals who would not survive in the wild. We can close down all unaccredited and poorly run institutions. There are a lot of things we can do. And of this I am certain: places of exploitation, domination and objectification have no place in an enlightened society. They can become sanctuaries, wildlife centres and places for compassionate conservation. It's time for us to be courageous and build a relationship between we animals and those animals based on respect and care. It's time to evolve and leave captivity behind. ❧

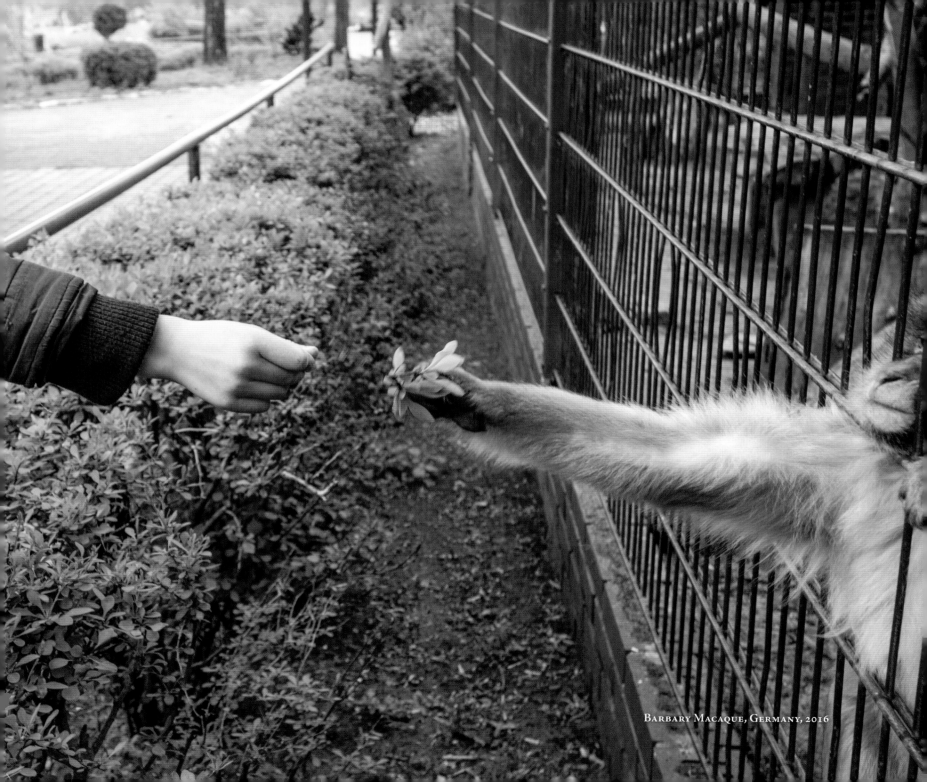

Barbary Macaque, Germany, 2016

ACKNOWLEDGEMENTS

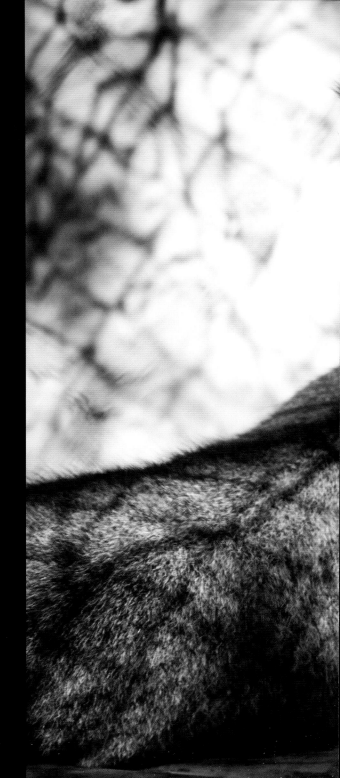

A collaboration with the Born Free Foundation in 2016 led to the making of this book. I'm tremendously grateful for having worked on Born Free's *EU Zoo Inquiry* with Daniel Turner, Samantha Goddard, Tarnya Knight and Britta Jaschinski. I'm also extremely thankful to Rob Laidlaw and Julie Woodyer at Zoocheck in Canada for inviting me to work with them in 2008. To both organizations, thank you for your tireless and important work on behalf of both wild and captive animals.

It's been an absolute blessing to team up with editor and publisher Martin Rowe and his colleagues at Lantern Books for *Captive*, as it was with *We Animals*. Thank you for all the time you've put into this book. The same goes, as well, for *Captive*'s designers, Paul Shoebridge and Michael Simons at The Goggles, who know how to make a project the best that it can be.

A huge thank you to Virginia McKenna and Lori Gruen for your important and inspiring essays for *Captive*.

To Vanessa Garrison, my teammate, friend and photo editor: thank you for your discerning eye and for always bringing out the best in my work. Thank you to Anna Pippus and Sayara Thurston for your insight, enthusiasm and attention to detail, and to Geoff Regier for the invaluable help with research. Love and gratitude to my family for always having my back when it comes to my work for animals, and to Jan Sorgenfrei, my favourite sounding board and my home away from home.

I'm so happy to thank the hundreds of individuals who supported the making of *Captive* by pre-ordering it through our Indiegogo campaign. This book could, quite literally, not have happened without you. My appreciation also extends to the family of We Animals supporters, who help me daily via their sponsorship of my work through Patreon and other means. I'm able to focus on animal stories full-time because you're helping me to do so. My deepest thanks to you all.

Finally, thank you to the Publishing Partners who made such a difference in the creation of this book: Your support of my work and your commitment to nonviolence shine through, and I am honoured by the trust you've placed in me.

BORNFREE.ORG.UK

Brighter Green
Equity. Sustainability. Rights.
BRIGHTERGREEN.ORG

a well-fed world
nourishing people / saving animals
AWFW.ORG

Jouni Valta

Leila Boujnane
HYPERBIO.NET

Lisa Kramer and Mark Kamstra

Petri Aasma of Lunis
ABLUNIS.SE

Tonja and Julian Robertson

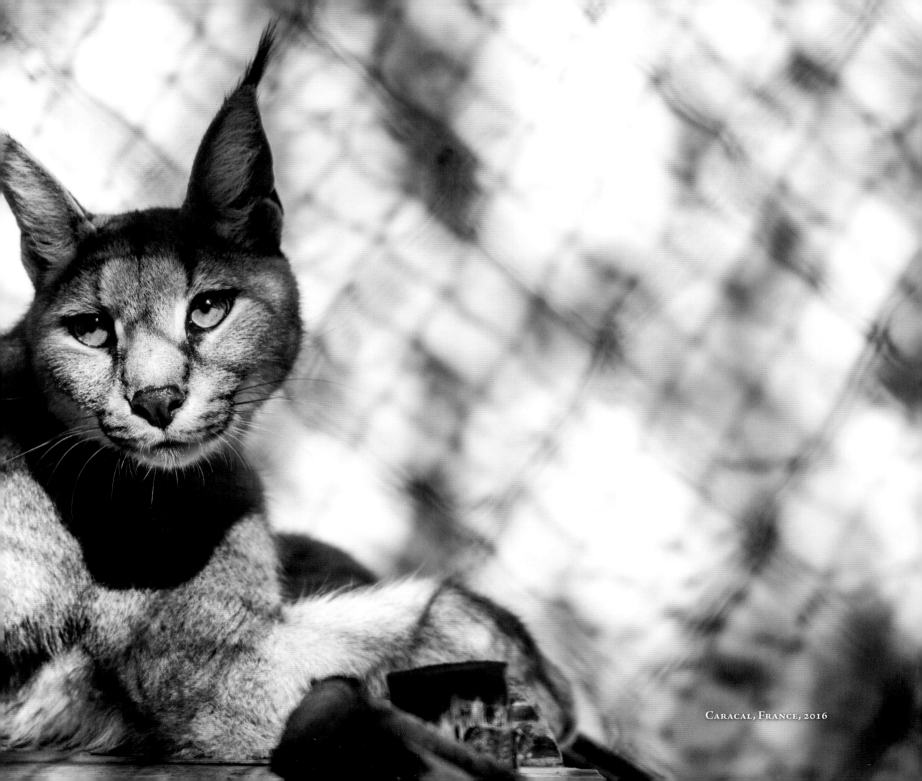

CARACAL, FRANCE, 2016

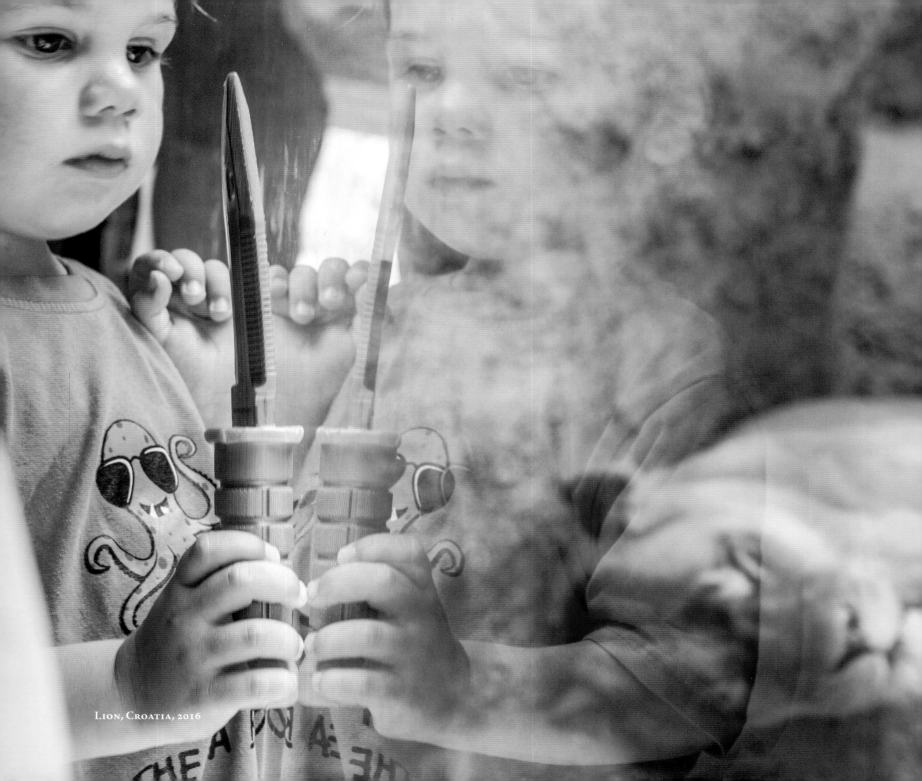

Lion, Croatia, 2016

AUTHOR'S NOTE

Many photos in this book, and in my work as a whole, depict children and their parents or caregivers as they encounter non-human animals. I show them because zoos and aquaria actively encourage children and their caregivers to come to be entertained or educated. In bringing children into the frame, I'm not criticizing any particular individual or group: all of us are in some way complicit in the maintenance and condition of these institutions. I document animals, but truly, these photos are a sociological study of we animals. Inevitably, my images reflect how varied are our reactions to the other animals: fascination, indifference, amusement, boredom, fear, even awe.

Increasingly, our experiences with others and the world around us are mediated through screens. Whether those experiences are public or private, intimate or collective, self-effacing or self-promoting, the camera has now become the recorder, disseminator, framer, and imposer of ourselves upon the world. My photos reflect this reality as well, and are, inevitably, complicit with it. ❧

PHOTO CREDITS